Fine Arts in Cleveland

The Encyclopedia of Cleveland History: Illustrated Volumes
Edited by David D. Van Tassel and John J. Grabowski

■

Cleveland: A Concise History, 1796-1990,
by Carol Poh Miller and Robert Wheeler

Sports in Cleveland: An Illustrated History,
by John J. Grabowski

Fine Arts in Cleveland: An Illustrated History,
by Holly Rarick Witchey with John Vacha

■

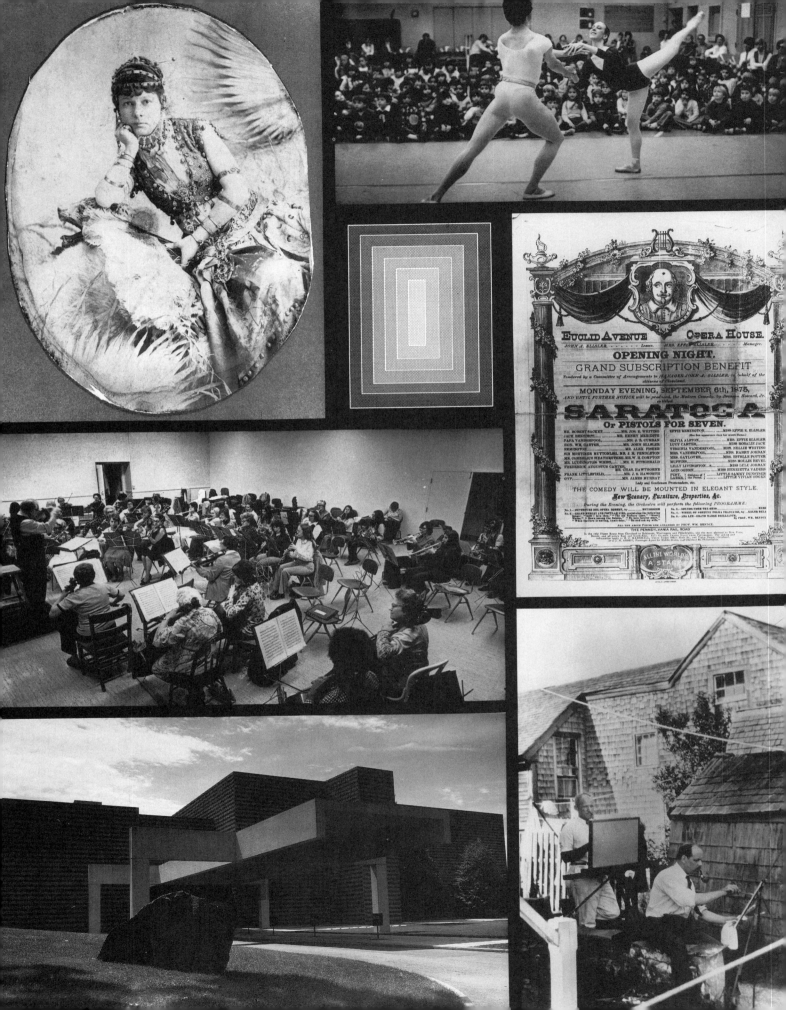

Fine Arts in Cleveland

An Illustrated History

Holly Rarick Witchey
with John Vacha

An Encyclopedia of Cleveland History Project

Indiana University Press
Bloomington and Indianapolis

The paper used in this publication meets the minimum requirements of American National Standard for Information Sciences—Permanence of Paper for Printed Library Materials, ANSI Z39.48-1984.

Manufactured in the United States of America

Library of Congress Cataloging-in-Publication Data

Witchey, Holly Rarick.
 Fine arts in Cleveland : an illustrated history / Holly Rarick
Witchey with John Vacha.
 p. cm. — (The Encyclopedia of Cleveland history ; 3)
 Includes bibliographical references and index.
 ISBN 0-253-31066-0
 1. Arts, American—Ohio—Cleveland. 2. Cleveland (Ohio)—
Popular culture. I. Vacha, John. II. Title. III. Series.
NX511.C64W58 1993
700′.9771′32—dc20 93-99
1 2 3 4 5 99 98 97 96 95 94

TO THE MEMORY OF THE LATE PETER PUTNAM,

WHOSE DREAM OF DEVELOPING A REGIONAL ARTS COMMUNITY

RESULTED IN SUPPORT FOR LOCAL ARTISTS

Contents

EDITORS' PREFACE

While we were editing the *Encyclopedia of Cleveland History*, we made the decision to illustrate the volume with only a limited number of charts and maps. That decision was made in order to preserve space for articles on the many institutions, events, and people who played an important role in the development of the city and who deserved to be included. However, we were conscious that we were missing a form of documentation that has become very important in today's world. Cleveland has an extremely rich store of photographic archives, from the 2,000,000 images in the library of the Western Reserve Historical Society to the extensive *Cleveland Press* Collection held at the Cleveland State University Library, to the extraordinary Cleveland Picture Collection at the Cleveland Public Library. We hope, therefore, to offer a series of illustrated volumes drawing on these collections and focusing on particular aspects of Cleveland's history, from sports and the fine arts to industry and business, as well as many things in between.

The Arts in Cleveland: An Illustrated History follows the earlier publications of *Cleveland: A Concise History, 1796–1990* and *Sports in Cleveland: An Illustrated History* as the third volume in the ongoing series of illustrated histories. The fine arts not only have contributed to enriching the life of Clevelanders through the almost two hundred years of the city's history but in many respects represent the city's finest cultural achievements.

In attempting to limit the scope of this volume, we had to come to grips with a definition of the fine arts. After consultation with our advisory board of experts and others, we found that the term has different meanings for different people; hence, we arbitrarily defined the fine arts as visual art, music, dance, theater, and belles lettres. The popular arts such as journalism, popular music, and cinema, along with architecture, have been excluded except where inextricably linked to the fine arts as defined above.

Holly Rarick Witchey, with the assistance of John Vacha, has produced a rich narrative of the development of the arts culture in Cleveland. Along with profiling the distinctive institutions that have become landmarks in Cleveland's cultural history, they have detailed the role of Cleveland's diverse ethnic population in the development of the musical arts, theater, dance, and visual arts. Above all, this fascinating story of the

growth of Cleveland's cultural community reveals the centrality of education to the mission of each of its major cultural institutions. Many of these educational programs have been pioneering efforts and models for arts education in other cities.

We have carefully selected photographs and illustrations to support the text. Wherever possible, we have chosen images never before published. These illustrations are designed to evoke the flavor and the character of the time as well as to furnish a visual image of outstanding artists, patrons, their work, and their forums.

Although Holly Witchey has written her own acknowledgment, we, as editors, owe a debt of thanks to many people and institutions. First and foremost our gratitude must go to the late Peter Putnam, who initiated this project, and Robert Bouhall, administrator of the Mildred Andrews Fund, who carried out Peter's wishes in partially funding this volume. Also, our thanks go to the Cleveland Foundation, which has supported various aspects of the Encyclopedia project. It supplied a portion of the funding for this volume as well, as did the John P. Murphy Foundation, the Kulas Foundation, and the Treuhaft Foundation. We owe particular thanks to Robert Ginn, a patron of the arts, a lover of history, and one who has supported various aspects of this project. The editors could not have succeeded in producing this volume without the excellent work of Sarah Snock, who not only served as project coordinator but did most of the photographic research and wrote many of the captions. We appreciate also the work of Michael Morgenstern, who served as research assistant, checking and rechecking much of the factual information and running down the more elusive photographs and color reproductions, and Michael McCormick, who did much of the photographic copying.

A number of institutions and their staffs made available to us their archives and photographic collections and gave of their time and knowledge. These institutions include the Cleveland Artists Foundation, the Cleveland Institute of Art, the Cleveland Institute of Music, the Cleveland Museum of Art, the Cleveland Music School Settlement, the Cleveland Opera, the Archives of the Cleveland Orchestra/Musical Arts Association, the Cleveland *Plain Dealer*, the Cleveland Playhouse, the Cleveland Public Library, Cleveland State University, the Dobama Theatre, Janet Century Photography, Karamu House, NOVA (New Organization for Visual Arts), the Private Collection of Elizabeth Flory Kelly, and the Western Reserve Historical Society. Each individual image is credited to the institution that gave permission for its use in this work.

We would especially like to thank the distinguished group of editorial advisors: Ruth Adomeit, patron of the arts; Elizabeth Flory Kelly, former board member of the Cleveland Playhouse; Martha Joseph, founder of the Arts Prize Award of the Women's City Club; Joseph McCullough, former director of the Cleveland Institute of Art; Klaus Roy, retired program annotator and publications editor for the Cleveland Orchestra; Viktor Schreckengost, nationally known area artist; Evan Turner, former director of the Cleveland Museum of Art; and the late Eugenia Thornton Silver, book reviewer and littérateur.

DAVID D. VAN TASSEL
Editor

JOHN J. GRABOWSKI
Managing Editor

INTRODUCTION

On July 4, 1801, some thirty Clevelanders assembled in the log cabin of Lorenzo Carter, Cleveland's first permanent settler, on the brink of the Cuyahoga Valley. It was five years since General Moses Cleaveland had first landed on the site that bears his name, and for a time, Carter and his family had been the only residents. The settlement clung stubbornly to the edge of the "Flats," however, and was preparing to celebrate the Fourth with its first "grand ball." Samuel Jones scratched out the tunes on the first violin the town had ever heard, and thus were the fine arts introduced to Cleveland.

Nearly two hundred years later, a hundred superbly trained musicians from Cleveland were invited to become the first American orchestra to establish a residency at the prestigious Salzburg Music Festival in Austria. Under its sixth music director, Christoph Von Dohnányi, the Cleveland Orchestra would perform the opening concert at the 1992 festival. In a sense, Cleveland was repaying Europe for the long cultural legacy it had borrowed to establish its own fine-arts institutions. The town had come a long way since that Fourth of July shindig in Carter's cabin.

For the greater part of Cleveland's history, its citizens struggled to create a city equal to or better than any other city in the United States, a city comparable even to the great cultural centers of Europe. Today the Cleveland Orchestra, the Cleveland Museum of Art, the Cleveland Play House, Karamu, and the Cleveland Ballet provide solid evidence of their success. The praises of Playhouse Square and University Circle have been sung from coast to coast by proud natives and impressed visitors alike.

As is attested in the origins of so many of Cleveland's cultural institutions, the fine arts were often offshoots of the city's concern for education. Even before hosting that "grand ball," Carter's cabin had doubled as the first schoolhouse. Owing, perhaps, to the New England background of the first settlers, Cleveland became a noted pioneer in educational innovation. The high priority placed on this educational mission may go far toward explaining the basic conservatism of Cleveland's art sponsors and patrons.

Those early New Englanders, however, were later joined by a host of newcomers from every region of the United States and Europe. Each of these groups brought its own cultural specialties with it, and the annals of the arts in Cleveland during the present century reveal a mosaic of exotic names and styles. It is as a result of the influence of the city's many minorities, perhaps, that Clevelanders, while often reluctant to test something "new," are paradoxically more willing to taste anything "different."

More than anything else, it was the city's cultural excellence that enabled its citizens to weather the dark years of the 1970s. In recent years Clevelanders have had many opportunities to reflect upon the city's past history via the restoration and renovation of sections of the city, including Playhouse Square, Public Square, the Mall, Ohio City, and the Terminal Tower complex. This rediscovery of the city proper, and in turn civic heritage, is occurring across the nation. Feelings of nostalgia can and ought to be channeled into something productive for a community. Thus the intent of this cultural history is to help the reader understand and renew connections with the past in order to better understand and prepare for the future.

I would like to thank David D. Van Tassel and John Grabowski, the impresarios of the *Encyclopedia of Cleveland History*'s illustrated series, for giving me the opportunity to prepare the text for the fine-arts volume. Their comments, criticisms, and suggestions were invaluable as they helped me maneuver the more complicated passages in Cleveland's fine-arts history.

Because my training is primarily as an art historian, my role in the creation of a volume that also incorporates music, literature, theater, and dance was that of a conductor. I had an orchestra of extremely talented people to call upon for help, including several authors who prepared essays for the original *Encyclopedia of Cleveland History*.

I was blessed with an advisory board made up of many of the pivotal figures in Cleveland's fine-arts history: Ruth Adomeit, Martha Joseph, Elizabeth Flory Kelly, Joseph McCullough, Klaus Roy, Viktor Schreckengost, Eugenia Thornton Silver, and Evan Turner. These generous artists and patrons of the arts made themselves available to me time and time again, and I am exceedingly grateful for the many interviews, phone conversations, and suggestions.

After the second draft of this manuscript was completed, Cleveland author John Vacha breathed life into it based on his extensive knowledge of the history of music and theater in Cleveland. I am indebted to Mr. Vacha for providing many anecdotes that would be unavailable to researchers from books and libraries.

My special thanks go to the staff of the *Encyclopedia* office, and particularly Sarah Snock, who worked unceasingly seeking illustrations, preparing captions, and spending untold hours on the phone coordinating details with a long-distance author. My husband, Curtis Witchey, was both editor and critic for the drafts of this manuscript. His constant support, and that of my family, was much appreciated.

Finally, I would like to acknowledge two people who aided and abetted my love for and interest in the fine arts: Andrew Chakalis and Dr. Edward J. Olszewski. I will always be indebted to these two gentlemen, who taught me to appreciate and enjoy the fine arts and, more important, how to share this appreciation with others.

FINE ARTS IN CLEVELAND

CHAPTER *1*

Settlement to City

The Development of Fine Arts in Antebellum Cleveland

Compared with such cultural meccas as ancient Athens, Rome, Florence, Paris, and even New York, Cleveland is not an old city. Less than two hundred years ago it was still merely an area indicated on a map in a venture proposed by the Connecticut Land Company. The city, laid out by Moses Cleaveland and his surveying team in 1796, was part of a proposition supported by wealthy, and for the most part educated, businessmen and gentlemen farmers on the East Coast, most of whom had no intention of ever seeing their holdings, much less settling in the wilderness. Their purpose was to buy, sell, and turn a profit.

The first Cleveland community was no more than a struggling group of individuals and families trying hard to survive. Gristmills, blacksmith shops, and even taverns were more important than libraries or theaters. Yet Moses Cleaveland and his survey team had the foresight to design a New England–style town with broad avenues and a town square. Although many small towns laid out in the Midwest and West started out with the same provisions for gracious growth, few avoided the encroachments of time and industry.

Statehood for Ohio came in 1803, and during the first years of the new century the Cleveland settlement slowly began to grow. By 1819 there was an advertisement in Cleveland's first newspaper, the *Cleaveland Gazette and Commercial Register*, of a performance of the Theater Royal at the Shake-

speare Gallery (located at 1 Superior Street) for the price of one dollar. (Another early newspaper, the *Cleveland Advertiser*, would simplify the spelling of the city's name in 1831.)

Cleveland's economy continued to expand, as citizens became involved in rapidly growing industries such as shipping and trading. The success of these endeavors in later years would become increasingly dependent on inexpensive immigrant labor. Each ethnic group that came to Cleveland brought its own architectural and artistic styles, as well as musical and cultural traditions, to its new home.

The most important change for the city would be the opening of the Erie and the Ohio canals. The canals made travel to and from northern Ohio easier and ensured visits of musical and theatrical groups, at least in the summer months. Such itinerant groups introduced Clevelanders to a variety of cultural experiences. Cleveland was particularly fortunate in being chosen as the northern terminus for the Ohio and Erie Canal. With the coming of the canals, Cleveland left its pioneer years behind and faced the struggle of transition from settlement to full-fledged city.

If Clevelanders seemed more interested in their businesses than in their cultural growth, that was only to be expected. However, from the 1820s on there were more frequent musical and theatrical activities and public entertainments. In 1820 Blanchard's visiting troupe of entertainers gave what was billed as the first theatrical performance in Cleveland. Patrons who attended the opening show on May 23 saw "The Purse Won the Benevolent Tar" and "The Mountaineers" for only fifty cents.

A book and stationery store opened the same year, and the first work by a Cleveland author was published. The novel, written anonymously "by a lady," was excitingly entitled *Catherine Brown: The Converted Cherokee*. It sold for 12 1/2 cents at a time when that sum could buy two pounds of cheese, three pounds of pork, or a half-gallon of whiskey. Clevelanders were much more concerned with producing French burr millstones, castor oil, gilt and mahogany frames for mirrors, and tin, sheet, and iron products than great literature.

The visual arts played little or no role in education or in the daily life of the city, though we can assume itinerant limners (painters) and woodcarvers visited Cleveland, providing for the needs of its citizens. Cleveland had at least one resident artist, Jarvis F. Hanks, who was described as a portrait painter but probably painted walls, wagons, and shop signs as well to stay in business.

After the City of Cleveland was incorporated in 1836, the Dean and McKinney Theater at Superior and Union Lane was granted the first official theater license. Following the prevalent taste of the day, one of the first plays presented was by the Bard; Shakespeare's *Hamlet* opened May 31, starring Billy

Forrest (who had achieved prominence as a comedian) and Julia Dean Hayne.

Many Clevelanders continued to embrace the Puritan beliefs of their New England ancestors. Theater, dance, music, and singing were still considered sinful by some of Cleveland's religious groups. Jarvis F. Hanks (see Fig. 1), a man of many talents, was criticized by the Methodist Church brethren in the late 1830s because he played his fiddle in their sanctuary, which they occasionally shared with the Presbyterians. Some of the parishioners considered this a desecration of the holy place, seeing the fiddle as a sinful instrument used to play profane music. Hanks silenced their objections by claiming that he and his fiddle had been converted together.

Nonetheless, music was in Cleveland to stay. In 1832 the first piano arrived, the property of the town brewer. Clevelanders, like other Americans in small towns in the nineteenth century, attended short-term singing schools, sang hymns in church, and on special holidays, such as the Fourth of July, listened happily to a brass band imported from another city for the occasion.

The late 1820s and early 1830s brought the first organized musical groups. In 1829 the Cleveland Harmonic Society, an instrumental group originally composed of seven amateur musicians, presented a concert of twenty-nine pieces featuring

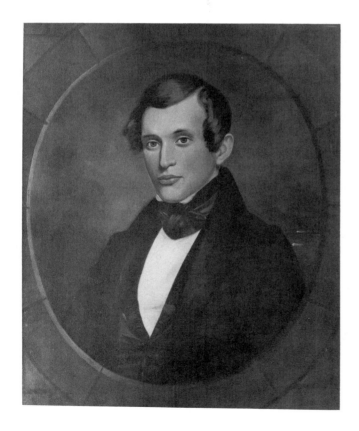

FIGURE 1. Jarvis F. Hanks, painter and musician. Courtesy of the Western Reserve Historical Society.

JARVIS FRARY HANKS (Sept. 24, 1799–June 27, 1853), early painter and musician (both a conductor and a fiddler), was born in Pittsfield, New York. He trained at the New York National School of Design and came to Cleveland in 1825. With the slow local development of the arts, Hanks supplemented his income with such endeavors as house, sign, and ornamental painting, clock face design, and emblem-making. By 1838 he could support himself in Cleveland as a portrait painter. His musical career in Cleveland culminated in his being made music director of the Cleveland Mendelssohn Society in 1850.

works by Haydn and Handel. Public performances were also given by the Sacred Music Society.

One of the most successful of the early choral groups was founded in April 1837, when Truman P. Handy was elected president of the Cleveland Mozart Society (see Fig. 2). The club was intended "for the promotion of musical science and the cultivation of a refined taste in its members, and in the community." If the Mozart Society catered to those of a refined musical taste, the brand new Cleveland City Band, also founded in 1837, with eighteen members, appealed to the popular taste. But again, as with Shakespeare, the cultural lines dividing symphonic or chamber music from band music were not as rigid as they were to become in the late nineteenth century.

A second band, the Cleveland Grays Band, was organized in 1840, and John Leland's band, called "the pride of Cleveland," was performing by 1844. In that same year the Cleveland Brass Band and Quartette Club were formed. Even with all these new ensembles, the majority of Cleveland's musical entertainment was still provided by traveling groups that visited for one or a few performances. These visitors included the Handel Society of Western Reserve College, Madame Cinti Damoreau of Paris's Opéra Comique, and the Swiss Bell Ringers.

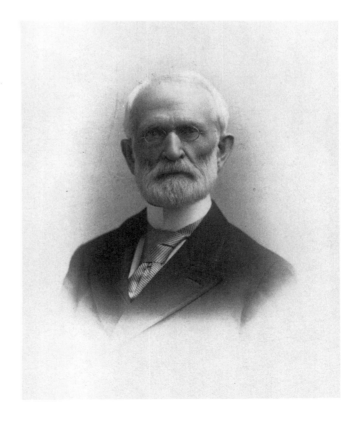

FIGURE 2. Truman P. Handy, Cleveland businessman and founder of the Cleveland Mozart Society. Courtesy of the Western Reserve Historical Society.

TRUMAN P. HANDY (Jan. 17, 1807–Mar. 25, 1898) was an early banker and financier active in establishing educational, philanthropic, and musical institutions in Cleveland. He came to the city at the request of business associates in 1832. He was a member of the first school board and helped to establish the first public schools in Cleveland. Interested in musical endeavors, Handy founded the Cleveland Mozart Society in 1838. In 1850 he became president of the Cleveland Mendelssohn Society.

Like any city during the mid-nineteenth century, Cleveland had its share of people opposed to both music and theater. In 1840 Jarvis Hanks offered to teach instrumental music in the public school, but the Board of School Managers rejected his offer. In 1848 the editor of a local paper suggested that all theatrical nuisances be driven from the city and the theater be turned into a house of worship.

The Young Men's Literary Association was started in 1837 and within a year had a circulating library of 800 volumes. In 1848 this institution reincorporated itself as the Cleveland Library Association; it provided citizens with an annual lecture series, a reading room, and a small museum in addition to the library. William Case and Charles Whittlesey were two of the leaders of this association.

At the mid-century mark, interested Clevelanders attended an "Operatic Soirée" in Cleveland. The Manvers Opera Company performed *La Sonnambula* and *The Daughter of the Regiment* in Watson's Hall. Again, Clevelanders were participating in what had become a national pastime and was not a rarefied cultural event, as operas sometimes are considered today. During the nineteenth century, operas were well known to large numbers of the public. Newspapers of the day relate that in some towns citizens were known to shout singers down or ask for their money back if they were displeased with the performance of a well-known opera.

As Cleveland entered the second half of the nineteenth century, participation in and practice of the fine arts often took place on two different levels, as they did throughout the city's history. On one hand, the monied shipping magnates and industrialists began to find time to appreciate music, art, literature, dance, and opera. These upper-class patrons were developing an aesthetic of taste focused primarily on the types of fine arts which had been found acceptable in the courts and social circles of Europe; patronizing local artists was not yet common practice.

The immigrant families, conversely, brought folk music, art, theater, and dance as well as literature in their native languages. These were static art forms. Families passed down traditions and art forms to their children and their children's children according to often rigid ceremony. The intent was to maintain the old ways rather than to create new traditions. Holidays, dances, music, theater, and art were designed as a link to the past, not a pathway to the future.

Thus neither of the two groups was particularly interested in the development of new and creative native art forms, a factor which has contributed to Cleveland's lack of any real influence in contemporary (then and now) fine-arts history. The last half of the nineteenth century would see Clevelanders educating themselves to appreciate the fine arts, but they would become collectors and connoisseurs, interpreters and educators rather than originators.

By 1850 Cleveland was a prosperous city with a population of 17,034 (thirty times its population in 1820). The city on the North Coast boasted three daily newspapers and two weeklies. Sixteen steamships ran between Buffalo and Chicago, making stops at Cleveland. Immigrants continued to flow into the city in ever-increasing numbers. They came from all over—the Germans, the Irish, the English, and a scattering of immigrants from Eastern Europe—to make their homes in Cleveland.

Canal traffic brought a wealth and diversity of businesses, products, and people to Cleveland. The traffic on the canals ushered in a period of prosperity, and the city's citizens were to become even more prosperous as the decade progressed, and the iron horse connected Cleveland with the great cities of the East.

While fortunes were made in shipping, trading, manufacturing, and the railroads, Cleveland still lagged behind East Coast cities in the fine arts, as did most midwestern cities, including fast-growing Chicago. Although theaters opened in Cleveland during the 1850s, and schools wholeheartedly embraced the teaching of music and drawing, Cleveland still depended upon the outside world for much of its fine arts. In a still-young community, the development of local talent had not been a primary concern. The production of fine-arts institutions (orchestras, theater, literature, painting, sculpture, and dance) was one of the later stages in the growth of a nineteenth-century midwestern community. Cleveland still needed an educated and financially responsible group of patrons who actively desired the hometown production/performance of one or more of the branches of the fine arts.

Although Cleveland could not boast an orchestra or a flourishing school of artists in the 1850s, the city did participate in another popular nineteenth-century pastime—the lecture series. Throughout the 1850s Clevelanders hosted Josiah Quincy, Henry Ward Beecher, Horace Greeley, Horace Mann, James G. Dana, and Bayard Taylor. Impressive nineteenth-century orators had the ability to sway crowds and affect the life of an individual or community in a manner comparable to the performance of a fine symphony, an opera, or a magnificent work of art.

Cleveland's impresarios also imported singers and musicians. Chief among these was Jenny Lind (see Fig. 3), who included Cleveland in her celebrated American tour on November 7, 1851. Kelley's Hall was packed with 1,125 spectators who paid from two to four dollars a head to hear the "Swedish Nightingale." Onlookers watching Lind through a skylight on the roof burst through the glass, momentarily exciting fears that the house might collapse into the drugstore below. Lind adeptly launched into her famous "Bird Song," calming the house and diverting a panic. "Thrice welcome thou!" gushed an amateur poet in the *Daily True Democrat*,

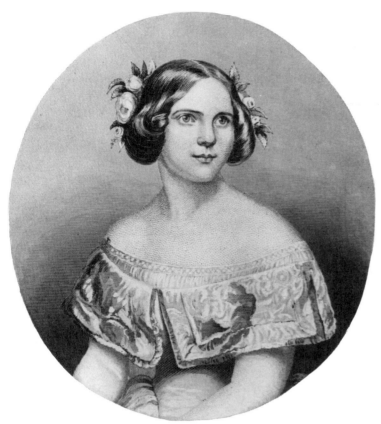

FIGURE 3. Jenny Lind, ca. mid-1800s. Courtesy of the Western Reserve Historical Society.

The **JENNY LIND** Tour visited Cleveland in 1851. Arriving with a troupe of 14 performers, the Swedish soprano performed before a crowd of 1,125 at Kelley's Hall. Her program included such songs as "John Anderson My Jo," "Gipsy Song," and her famous "Bird Song." While in Cleveland, Lind also made a trip to the Northern Ohio Lunatic Asylum in Newburgh to cheer the inmates.

Whose magic power can every heart enthrall
That listens to thy strains! 'Tis thine—to sweep
The diapason of Life's sweetest chords
Until the full soul vibrates with a bliss
It never knew before!

She sang half a dozen numbers, including "John Anderson My Jo," of which the reviewer from the *Cleveland Plain Dealer* remarked, "We thought we had known the resources of the song, but Jenny Lind turned up whole treasures of new wealth." Such reactions led one historian to refer to the event as "one of the most momentous in Cleveland's music history, for here public appreciation really began."

Appreciation was a pivotal first step in the cultural development of Cleveland. From the wellspring of appreciation, all things were possible. In December 1850, slightly less than a year before Jenny Lind's appearance, the Cleveland Mendelssohn Society had been organized. Within three years this society had attracted 112 members and performed to the accompaniment of a twenty-five-piece orchestra.

Schoolchildren benefited as well from this new spirit of appreciation. In 1853, Clevelanders donated a new piano, paintings and pictures, and 400 books to the Rockwell School

for a library. If older Clevelanders had not had the opportunity to appreciate music, art, and literature, they were making sure their children would have this chance.

Children and adults alike were educated and entertained during the 1850s by many fine visiting performers and speakers, including several opera companies, singer Adelina Patti, author and poet Ralph Waldo Emerson, and showman P. T. Barnum. Clevelanders had shown themselves to be a willing audience for theatrical productions, literature and literary speakers, drama, and music. Support for local artists, professional musicians, and artists, however, was still small.

Stage productions in Cleveland got a boost when John A. Ellsler, an actor and impresario, bought the failing Cleveland Theater at 1371 Bank St. (W. 6th) in 1853 (see Fig. 4). He turned the facility around by organizing Cleveland's first permanent stock company. The new organization

FIGURE 4. John A. Ellsler, pioneering force in Cleveland theater and owner of the Euclid Avenue Opera House. Courtesy of the Western Reserve Historical Society.

JOHN ADAM ELLSLER (Sept. 22, 1821–Aug. 21, 1903), a leading figure in Cleveland's theatrical history, enabled the city to share in what has been described as the "Golden Era of the American Stage." Ellsler and his wife, Euphemia Emma Myers, an actress from New York, came to Cleveland in the mid-1850s. He became manager of the Academy of Music and established a full-time theatrical company. Encouraged by the success of the Academy, Ellsler started construction of the Euclid Avenue Opera House in 1873. Although cost overruns forced him to sell the opera house to Marcus Hanna in 1879, Ellsler remained in Cleveland until 1886.

was one of the first dramatic schools in the nation. Many once-famous actors whose names have faded into obscurity got their start at the Cleveland Theater, including John McCullough and Lawrence Barrett.

Before the realization of his plans, Ellsler had to fend off one of the last gasps of the anti-stage faction, which took the form of a proposed theatrical license fee of $10 per night, or $1,000 per season. Councilman Stanley, who introduced the increase, could see no benefit whatever in the theater. "They come and get into debt with our hatters, shoemakers, tailors and mechanics, and then leave with these debts behind," he charged. Fortunately for local thespians, Councilman Sholl rose for the defense. "We suggest to Mr. Stanley that the Cleveland Theater supports more *honest, hard-working* people than all the *banks* in the city," retorted Sholl, "and we say to the members of the Council who voted for this injudicious ordinance, that none of the members of the Cleveland Theater corps are of disreputable character, and that many of them have fully enough talent to entitle them to a seat in the Cleveland Council (No flattery to the Company!)" Following the repeal of the prohibitory ordinance, Mrs. Ellsler read a special address to the opening-night audience with the following peroration:

> With taste to adorn and Art to guide
> *The Drama's School, and the City's pride,*
> Oh! may we not oft your patronage enjoy,
> And you our services long employ.

John Ellsler did more to organize theater in Cleveland during the last half of the nineteenth century than any other person. Ellsler's daughter, Effie, studied acting under her father and, billed as "Cleveland's Sweetheart," went on to act in the gaslight theaters of the 1880s and in some of the early motion pictures (see Fig. 5).

Cleveland achieved a measure of national fame in musical circles during the 1850s, owing to the tremendous success and popularity of the German singing society the Cleveland Gesangverein. German singing societies had sprung up all over the United States; wherever there was a German community, there was a singing club. The first such society in Cleveland, the Frohsinn Singing Society, had formed in 1848.

Continuing the traditions of their homeland, these groups traveled to visit German communities in other cities for exchange concerts. This tradition allowed Germans to indulge their native wanderlust, visit relatives, and have large parties all at the same time. The group exchanges became more formally organized in 1849, after a gathering of Gesangvereinen in Cincinnati, when it was decided to hold regular *saengerfests* in alternating cities. The groups from many neighboring states would descend upon a city and compete for the honor of best choir or group.

FIGURE 5. Effie Ellsler, daughter of John and Euphemia Ellsler, known as "Cleveland's Sweetheart" of the stage, ca. 1876. Courtesy of the Western Reserve Historical Society.

FIGURE 6. Saengerfest Hall, located at E. 55th and Scovill Ave., ca. 1896. Courtesy of the Cleveland Public Library.

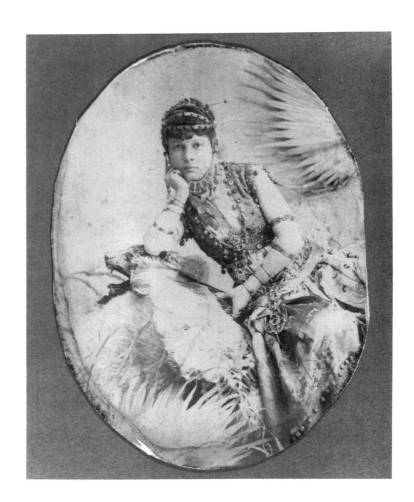

EFFIE ELLSLER (Apr. 4, 1854–Oct. 8, 1942) achieved stardom in the 1870s as one of America's finest actresses. She made her debut portraying Little Eva in Harriet Beecher Stowe's *Uncle Tom's Cabin.* When her father, John A. Ellsler, opened the Euclid Avenue Opera House in 1875, Effie was the leading lady in its first production, *Saratoga.* Her last appearance in Cleveland was on May 29, 1919, at the Shubert Colonial Theater in the play *Old Lady 31.*

SAENGERFESTS were national gatherings of German-American singing societies for the purpose of exchanging visits, staging singing competitions, and celebrating the German heritage. The first of a total of five Saengerfests held in Cleveland occurred in 1855; Saengerfest Hall was constructed to house the fourth, in 1893. The last, held in 1927, was the most spectacular, hosting 100 societies and 4,000 singers. Twelve thousand people jammed Public Hall to hear the final concert, which was dedicated to Beethoven upon the centenary of his death.

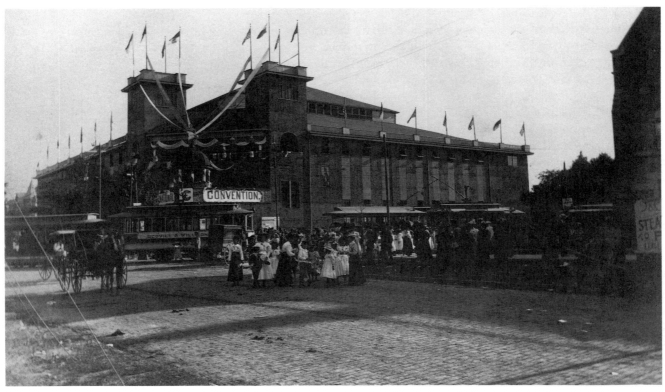

A typical festival lasted three or four days (sometimes as many as seven) and included (in addition to concerts) balls, torchlight processions, picnics, and dinners. Cleveland hosted five of these songfests in all, the first being the Seventh Annual Saengerfest in 1855, when 18 societies and 300 singers participated. By 1927, the last year Cleveland welcomed such a gathering, the participants numbered 4,000 singers in 100 societies. Not only did the festivals attract large numbers of singers and musicians, but they drew large audiences as well (see fig. 6). Noting on May 29, 1855, that 5,000 to 7,000 persons had attended a Saengerfest concert on Public Square, the *Cleveland Leader* pronounced it "the largest audience which has ever attended a concert in Cleveland." Four years later, a chorus of 400 gave Cleveland its first locally produced opera, when Flotow's *Alessandro Stradella* was performed at the Eleventh Annual Saengerfest.

The Cleveland Gesangverein was only one of a number of singing and instrumental societies, both large and small, that existed in Cleveland during the late nineteenth century. The singing society was the first introduction to music for many people, who often joined these clubs more for social reasons than out of a real love for vocal or instrumental music. Nevertheless, several of the societies, including the Cleveland Gesangverein, the Sacred Music Society, and the Cleveland Mendelssohn Society, expected high standards of musical performance from their members. Some Clevelanders had raised their standards for visiting artists as well. In 1856 a statement in a local newspaper expressed regret that the Norwegian violinist Ole Bull had played "Pop Goes the Weasel" at his Cleveland concert.

A Cleveland musical personality who is seldom discussed in histories of the city is the black musician and composer Justin Holland (1819–1887) (see Fig. 7). Holland came to Ohio in 1841 as a student at Oberlin College, but he never finished his degree; instead he traveled to Cleveland to pursue a musical career. He played the flute and piano but is best known for his skill with the guitar.

Holland was an amazing teacher who, in addition to his other accomplishments, spoke fluent Spanish, French, and German. He produced 35 original works for guitar, published his own arrangements for 300 more works, and developed a best-selling teaching guide entitled *Holland's Comprehensive Method for the Guitar*. Critics called it the best work of its kind in America in 1874.

The literary development of Cleveland during this period is hard to trace, primarily because historians tend to associate the quality and quantity of books available to a community with its literary history. Since the 1830s and 1840s, literary clubs and private libraries had been formed, disbanded, and re-formed. Although the population included a number of avid readers, Cleveland has had very few literary

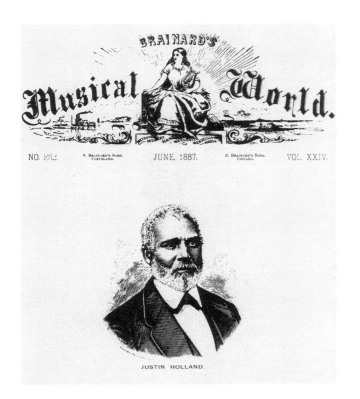

FIGURE 7. Memorial sketch of Justin Holland appearing in *Brainard's Musical World*, ca. 1887. Courtesy of the Western Reserve Historical Society.

FIGURE 8. Charles Farrar Browne, a.k.a. Artemus Ward, well-known humorist and satirist. Courtesy of the Cleveland Public Library.

JUSTIN HOLLAND (1819–Mar. 24, 1887) was a black musician and composer best known for his works on the guitar. He was born in Virginia and settled in Cleveland in 1845. Active in the antislavery movement, Holland was also a leader in black Masonic fraternal orders. Multilingual, he was able to establish links between black Masonic lodges in Peru, Portugal, Spain, France, and Germany. Holland was a performing artist who played the flute, piano, and guitar. He also organized the "Cleveland Guitar Club," which presented public recitals of guitar music.

CHARLES FARRAR BROWNE (Apr. 26, 1834–Mar. 6, 1867), who wrote under the pseudonym Artemus Ward, was a journalist and satirist whose work began appearing in the *Cleveland Plain Dealer* in 1857. Browne stayed with the *Plain Dealer* until 1860, when he moved to New York to become editor for *Vanity Fair*. In 1862, publication of *Artemus Ward: His Book* captured the attention of Abraham Lincoln, who was said to have entertained members of his cabinet with it.

lights in her history. One of the few was Charles Farrar Browne, sometimes referred to as "the Father of American Humor" (see Fig. 8).

Browne came to Cleveland from Toledo in 1857, when he still spelled his name without the final "e," to become associate editor and local reporter for the *Cleveland Plain Dealer*. Tall and gangly, with a scarecrowish head of hair, Browne soon showed a marked predilection for the latter word in the title of his daily column, "City Facts and Fancies." Deadpan announcements such as "Frogs were heard to bleonk in Kellogg's Pond the other night" began to fill holes on slow news days. In January 1858, Browne filled a rather large hole with a letter from a fictitious semiliterate itinerant showman named "Artemus Ward." It must have struck a responsive chord in what was still an overgrown town, and Browne kept the series going with letters from various Ohio and Pennsylvania towns, always promising Ward's imminent arrival in Cleveland with his snakes, "cangeroo," and wax works. "My snakes is under perfect subjecshun," Ward ostensibly wrote from Toledo for the *Plain Dealer* of March 9, 1858.

> Among my snakes is a Boy Constructor, the largist in the wurld. It wood make your blud freeze to see the mongster unkoil hisself. If yu put this letter in the papers i wish you wood be more particlar abowt the spellin and punctooation. i dont ploom myself on my learnin, but i want you to distinkly

understan that Artemus Ward has got sumthing in his hed besides lise.

For nearly three years Browne used Artemus Ward as an alter ego, letting him do interviews and other features. When Adelina Patti sang at Melodeon Hall in 1860, Ward reviewed the concert for "City Facts and Fancies." He probably represented the feelings of a majority of Clevelanders (then and later) when he observed, "But Miss Patty orter sing in the Inglish tung. As she kin do so as well as she kin in Italyun, why under the Son dont she do it? What cents is thare in singin wurds nobody dont understan when wurds we do understan is jest as handy?" Unfortunately, Browne's spreading fame soon led to his departure from Cleveland when *Plain Dealer* publisher Joseph Gray objected to sharing Artemus Ward with the readers of the New York magazine *Vanity Fair*. They parted amicably, however, and much of Browne's *Artemus Ward: His Book*, the work that brought him to Abraham Lincoln's appreciative notice, consisted of reworked pieces originally from the *Plain Dealer*.

A cultural movement which had little to do with the fine arts and much to do with the study of history and the natural sciences had begun in Cleveland in the 1840s with a small group of men who referred to themselves as the "Arkites." William and Leonard Case had begun a literary/social club which met in the Case home. These two brothers and their friends had a common interest in natural science, and the office where the group met became a repository for an odd assortment of mounted animals, stones, snakes, and bones—hence the name "Ark" (see Color Plate 1). The ideas and enthusiasm of these young men were the seeds which eventually grew into the Kirtland Society of Natural Science, Case Hall, the Cleveland Library Association, Case Library, Case School of Applied Science, and, ultimately, the Cleveland Museum of Natural History.

A letter from one of the Arkites, Elisha S. Sterling, to William Case shows the attraction and commitment to Cleveland these young men had formed. "I am glad to hear the city is going ahead, as it is the finest place in existence," wrote Sterling from Paris on September 8, 1849. "I have no desire to live in any other, and only ask to get back again within the scent of the old 'Ark'—the greatest place, you know, in these diggings—and be surrounded by the best of fellows."

The Case brothers and their friends were all young intellectuals fed on the literature and philosophies of the Enlightenment in England and France. As such, their interests turned for the most part toward the natural sciences, but they seemed to have a genuine concern for the improvement of Cleveland and its citizens as well. The Arkites were really the first organized group to see the opportunities for acculturation in Cleveland. Though the fine arts were not their specific focus, music,

theater, and art did indeed benefit from the impetus of the Arkite movement. These young men had a thirst for knowledge and any type of experience which might enrich their lives.

In 1859, William Case took a giant step forward when he decided that Cleveland needed a building designated solely as a cultural center. Toward that end he traveled to Boston to visit Faneuil Hall, which was considered one of the finest civic and architectural structures in the country. Case hired architect C. H. Heard to design Case Hall, an all-purpose facility which was to contain quarters for the Cleveland Academy of Natural Sciences and the Cleveland Library Association as well as a large auditorium. Case died in 1862, before he could see his grand plans completed, but not before he had envisioned a Cleveland whose cultural amenities could compare with the finest Boston had to offer.

A Young City Looks for Cultural Standards

Cleveland in the Era of the Civil War

The decade of the 1860s was a particularly disastrous one all over the United States as a result of the Civil War and the economic difficulties of the postwar Reconstruction period. For most workers, inflation outpaced salary and wage increases; some, though, got rich from businesses stimulated as a result of the war (particularly important for Cleveland was the oil-refining business, as well as the new industrial plants producing iron and cheap steel).

Cultural activities, though not halted, were significantly curtailed during the Civil War, but were taken up enthusiastically toward the end of the decade. The 1860s saw the flourishing of Euclid Avenue, described by author Bayard Taylor as "the most beautiful in the world." Artemus Ward (a.k.a. Charles Farrar Browne) humorously described the inhabitants of the famous homes:

> All the owners of Euclid Street homes employ hired girls and are patrons of the arts. A musical was held at one of these palatial homes the other day with singing. The soprano and the contralto were beautiful singers. The tenor has as fine a tenor voice as ever brought a bucket of water from a second-story window, and the basso sang so low that his voice at times sounded like the rumble in the tummy of a colicky whale!

Clevelanders learned early that fine-arts events could be a useful source of money for charity. To raise funds for the

war effort, Cleveland hosted the Northern Ohio Sanitary Fair in 1864, the year following Chicago's highly successful Northwestern Sanitary Fair. The funds from these events were earmarked for the United States Sanitary Commission (as well as the Soldiers Aid Society). A vast building created expressly for that purpose was erected on Public Square. Visitors to the fair wandered through floral exhibits, viewed fine-arts treasures, attended bazaars, heard lectures in a 3,000-seat auditorium (the opening address was given by Major General James A. Garfield), or listened to Leland's Band.

A few names of artists have survived, but their contributions to the field of American art history are comparatively minor. Cleveland did nurture one of the few successful female artists of the day, Caroline L. Ransom. Ransom achieved a small measure of fame as a portrait painter when, in 1867, she was granted $1,000 by the Congress of the United States to complete a portrait of Joshua R. Giddings. Less than ten years later, in 1875, Congress again authorized a grant for Ransom—this time for $15,000—to paint General George H. Thomas. Both paintings were created to hang in the Capitol in Washington, D.C., the city where Ransom produced most of her famous work. Considering both the physical and the societal constraints incumbent upon women at the time, Ransom's artistic success is no small achievement.

A local artist who achieved national fame was Archibald Willard, a decorative artist from Wellington, Ohio, whom fate brought together with James F. Ryder, a Cleveland photographer, in the mid-1860s (see Figs. 9–10). Willard's early formal training came via his apprenticeship to a wagonmaker and wheelwright who made and decorated wagons. Like the majority of regional American artists in the mid-nineteenth century, Willard made his living painting portraits and decorating furniture.

Willard's big break came when Ryder recognized the young artist's ability to paint poignant scenes that appealed to the emotions of nineteenth-century viewers. Ryder first photographed and copied some of Willard's Civil War sketches; later he did the same for the comic genre scenes Willard painted of his children and their pets. Clevelanders were the first to view what would later become a national icon, when Willard placed his *Yankee Doodle* in Ryder's Superior Street window before taking it to the Centennial Exposition in Philadelphia. "The canvas occupies almost the entire space of the large window, and is conspicuous even from the opposite side of the street," observed the *Cleveland Leader*. "It is a story which tells itself at a glance, and has been told as truthfully and poetically as art could tell it." Better known later as *Spirit of '76*, the painting marked Willard as the Norman Rockwell of his generation (see Color Plate 3).

Ryder's financial prosperity resulted from his sale of chromolithographs, a type of color print, and he was hard

FIGURE 9. Archibald Willard, painter of the famous *Spirit of '76* and founder of the Cleveland Art Club. Courtesy of the Cleveland Public Library.

ARCHIBALD WILLARD (Aug. 22, 1836–Oct. 11, 1918) was an American artist who is best remembered for the patriotic painting *Spirit of '76.* Living in Wellington, Ohio, in the early 1860s, he apprenticed himself to decorative artist E. S. Tripp and began painting vignettes on wagons and carriages. In 1863, Willard enlisted in the 86th Ohio Volunteer Infantry, painting and drawing scenes from the war. Then he met Cleveland photographer James F. Ryder, who photographed and printed several of Willard's sketches with much public success. In 1876 Willard came to Cleveland and set up a studio, where he completed the famous *Spirit of '76.* A founding member of the Art Club, also known as the Old Bohemians, Willard was a prominent force in the development of the arts in Cleveland.

pressed to supply enough chromolithographs of the famous Willard work to keep up with demand. Chromolithography was a process used to reproduce large numbers of inexpensive images of theater stars and statesmen, as well as old master paintings. For visual artists the importance of such a process was obvious. Suddenly, without traveling to Europe, local artists could have the great compositions of the world at their fingertips to study. Most chromolithographs produced in the nineteenth century were images of celebrities, however, or genre scenes such as those produced by Archibald Willard. As with many a nineteenth-century painter in America and abroad, Willard's popularity was due largely to his ability to evoke sentiment.

Photography and chromolithography were two of the visual-art forms most accessible to the average middle-class citizen in the nineteenth century. Photography had been a popular curiosity in Cleveland ever since Theodatus A. Garlick produced the first photograph in the Western Reserve in 1841, and since Louis Jacques Daguerre, inventor of the daguerreotype, exhibited French pictures in Cleveland in 1842.

Ryder was himself a pioneer in photography as well as

FIGURE 10. Advertisement for daguerreotypist James F. Ryder, ca. 1850. Courtesy of the Western Reserve Historical Society.

JAMES F. RYDER (1826–June 2, 1904) was a photographer responsible for introducing the technique of retouching negatives to American photography. Living in Ithaca, New York, Ryder trained as a daguerreotypist. In 1849 he met a Cleveland daguerreotypist, Charles Johnson, who invited him to visit his studio. Upon his arrival in Cleveland, Ryder managed Johnson's studio for a short time. Ryder introduced negative retouching to the U.S. in 1868, about the time that he set up shop on Superior Street. After retiring in 1894, Ryder produced his autobiography, *Voightlander and I*, one of the few biographical accounts written by a nineteenth-century photographer.

chromolithography. After studying the process of retouching negatives in Europe, he had introduced the process to the United States. In 1869 Ryder won top honors in a contest sponsored by the newly organized National Photographers Association in Boston for a collection of photographs made from retouched negatives, becoming the first American photographer to display such a collection in the United States. The Cleveland photographer's book *Voightlander and I* is one of the few autobiographical accounts of a nineteenth-century photographer.

Ryder's success ensured that he would have local com-

petition. Captain W. J. Morgan and his brother George began what was to become a booming lithography business in 1864, when they opened W. J. Morgan and Company (later Morgan Lithograph Corporation). The firm achieved international fame for its theatrical lithographs by winning the gold medal for artistic poster display at the Exposition Universelle in Paris with Morgan's reproduction of Rosa Bonheur's "Horse Fair," the world's first 24-sheet billboard poster. The company started out with one hand-press, and by the time George took over the company after his brother's death in 1904, the firm had a number of offices and warehouses in the United States and overseas.

The mid-1860s brought the completion of Case Hall. William Case's civic and cultural center for the city opened at long last on September 10, 1867, with a concert in the third-floor auditorium. Case Hall contributed more to Cleveland's continued dependence on outside art and artists in all fields, however, than to the promotion of local art and artists. The walls and ceiling had been painted to order by an Italian painter, Garibaldi, and the performers, musicians, and lecturers were primarily famous performers from places other than northern Ohio. The center was not as profitable as had been hoped, and eventually the building was converted into offices.

A more profitable institution was Brainard's Hall, although viewers were as likely to see a boxing exhibition or a billiard match as they were a musical or theatrical production at that venue. Brainard's Hall also occasionally served the section of the population interested in the visual arts; in 1865 the proprietors exhibited sixty-four paintings illustrating Milton's *Paradise Lost*.

Brainard was a name that had been associated with music in Cleveland since the 1830s. The Nathan Brainard family arrived from New Hampshire in 1834. While Nathan opened a grocery store, his son, Silas, had, by 1837, opened a music store in partnership with pianist J. Mould. Known as Brainard and Mould, the partners advertised themselves as "dealers in music and musical instruments." No records remain which would indicate the success of the early years of the business, but certainly the fact that the company prospered in Cleveland for close to sixty years is testimony to a native love and desire for music in the city.

The firm became S. Brainard, and later, in 1866, S. Brainard's Sons. Begun as an establishment selling music and musical instruments, by 1845 it was publishing music and making cabinet organs. Brainard's was indeed a full-service music emporium; concerts were held in Brainard's piano rooms, and musicians could schedule rehearsal time there as well.

In 1864 the firm began to publish a monthly journal discussing important musical events on local, national, and international levels. The original journal, *Western Musical World*,

became *Brainard's Musical World* in 1869. The emporium was such a success that branches were opened in Chicago, Louisville, and New York City. Eventually Brainard's became the second-largest music catalog house in the nation. Its success was due primarily to the tremendous market for popular sheet music, since singing to piano accompaniment became an important part of family recreation for the United States' growing urban middle class.

Although the firm moved its headquarters to Chicago in 1889, the success of S. Brainard's and *Brainard's Musical World* in Cleveland was evidence of how far the city had come in its receptivity to music since its founding. The type of sheet music purchased from Brainard's, however, was hardly indicative of the growing taste for symphonic or orchestral music in Cleveland. That there was such an interest among Clevelanders was demonstrated in the decades following the Civil War, as the city grew into its status as a major center of industry and wealth in the United States.

After the Civil War in cities across the United States, a small fraction of the population, primarily that with the time and financial ability, began to differentiate between what it considered fine art and those forms of art, dance, theater, and music which fell into a lower category. A brief perusal of Cleveland's cultural history in the 1870s indicates that a similar process was taking place on the shores of Lake Erie.

Many Clevelanders sought to elevate their cultural standards by joining newly created arts organizations that offered opportunities for education as well as appreciation. The net result was that, by the end of the decade, Cleveland could count a number of native amateur and professional artists, actors and actresses, and musicians at work in the city trying to improve the public response to the arts.

This trend, in Cleveland and across the nation, was partially the result of social and economic conditions in the United States following the Civil War. Since the 1850s Cleveland had consistently grown in terms of both geography and population. By the 1870s, the transition from village to metropolis was well underway, bringing with it the social problems of managing an economically and culturally diverse population. New York City and Boston, and to some extent Chicago, had experienced these same problems earlier in the century. To the civic leaders in each city fell the responsibility of solving these problems.

The majority of Cleveland's movers and shakers hailed originally from the eastern seaboard states. They were captains of industry and saw themselves as having little in common with the immigrants flooding in from all parts of the world. After the Civil War, throughout the United States, many patrons of the arts convinced themselves and their communities that cultural diversity and the ills of a growing urban community could be mediated, in part, by the elevation of the

spirit via the contemplation of fine art, music, literature, and theater. As the century continued toward its close, the virtues of a particular theatrical or musical performance, literary work, or art display were determined by those with money.

Laurence Levine, in his book *Highbrow, Lowbrow: The Emergence of Cultural Hierarchy in America* (1988), has called this process the sacralization of the fine arts, and has proved that in the late nineteenth century the leaders of industry and society began to make a distinction between what was considered fine art and what was popular with the general mass of people. The self-proclaimed arbiters of taste in Cleveland served their community better than those in many other cities, because they inevitably tried to bridge the widening gulf between the populace and the fine arts with progressively designed education programs. The movement to improve the quality of fine-arts performances and activities began in Cleveland during the decade of the 1870s and steadily increased in momentum, culminating in the early twentieth century in the establishment of Cleveland's major cultural institutions.

A pivotal event for Cleveland's music history was the 1870 performance of the Theodore Thomas Orchestra in the city. At a time when it was difficult for a musician to make a living from his art, Thomas kept his all-professional orchestra on the road almost constantly from its inception in 1864 to provide his musicians with the necessary work. Thomas's grand plan was to stop at "all the cities which he thought might become musical centers in time." Evidently this included Cleveland. *Brainard's Musical World* (January 1870) reported favorably on the concert, and Cleveland's impresarios began to schedule performances by outside orchestras whenever they were available.

Cleveland's music historians have pointed out the inherent problem of bringing professional orchestras into the city at a time when Cleveland's own struggling musicians were trying hard to organize. The native amateur musicians could not hope to compete with the better-trained professionals. Many of the cultural moguls preferred to spend their money on importing impressive guest orchestras rather than to stake their hopes (and funds) on the formation of a new orchestra.

Nonetheless, there were men with a vision for Cleveland and ambitions for themselves. In 1871 William Heydler opened the Cleveland Conservatory of Music. He was following in the footsteps of his father, Gottlieb Heydler, who had been involved in the organization of community choral societies earlier in the century. William had studied music in Europe and returned with a will to bring what he had learned to Cleveland's budding musicians. Accompanying Heydler in his new conservatory were John Hart, teaching violin and harmony, and John Underner, teaching voice. A series of talented instructors followed, including violinist John Nuss and Nuss's

student Charles Heydler, an accomplished cellist. The Cleveland Conservatory of Music was only one of many musical institutions and groups founded to try to keep Cleveland in step with the more successful music communities in Cincinnati, Chicago, and Pittsburgh.

That Cleveland had, at the very least, potential for a vital music community is demonstrated in Alfred F. Arthur's move to Cleveland from Boston in 1871 (see Fig. 11). Arthur had studied at the Boston Music School and abroad. A multitalented musician, he sang tenor and played the cornet in addition to his skills as an educator, conductor, and composer. Soon after his arrival in Cleveland, he and William B. Colson, Jr., opened a studio together in the Cushing Block. The following year Arthur had gathered together a group of musicians who gave their first symphony concert in Cleveland, featuring soloist Mrs. Nellie Glaser, on March 7, 1872.

Arthur was avid and active at a time, during the 1870s, when community interest in music seemed to be dramatically on the rise. He served as conductor of the Sacred Music Society at Pilgrim Church, the Cleveland Oratorio Society, and the

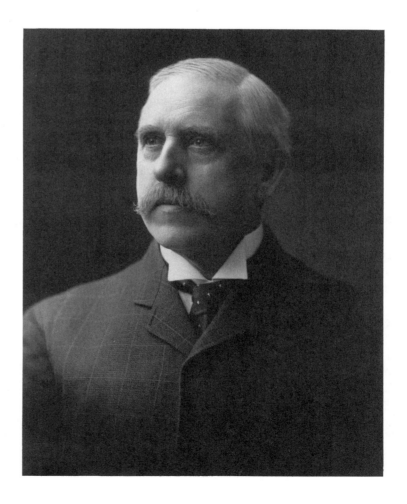

FIGURE 11. Alfred Arthur, founder of the Cleveland Vocal Society, ca. 1910. Courtesy of the Western Reserve Historical Society.

ALFRED ARTHUR (Oct. 8, 1844–Nov. 20, 1918), noted conductor, educator, composer, and musician, was born in Pittsburgh and came to Cleveland in 1871. He founded the Cleveland Vocal Society in 1873 and conducted it through 29 seasons. In 1875 he founded the Cleveland School of Music, which continued under the management of his son until 1938. A composer, Arthur wrote a number of songs and three operas, none of which were published. He was an important contributor to nineteenth-century music in Cleveland, able to organize large numbers of performers for landmark presentations.

East End Choral Society. His most important contribution to the Cleveland musical scene, however, was his reign for twenty-nine seasons as conductor of the Cleveland Vocal Society, beginning in 1873.

The Cleveland Vocal Society was more than just a group of Clevelanders interested in singing. Among its members were some of the city's leading citizens, including the Reverend Dr. John Wesley Brown of Trinity Church, Truman P. Handy, and Charles F. Olney. Brown's congregation included most of Cleveland's wealthy industrialists. Handy's musical activities have been mentioned earlier, in connection with the Cleveland Mozart Society. Charles F. Olney was a moving force in the visual arts and in Cleveland's city-planning efforts in the late nineteenth century.

The Cleveland Vocal Society's first concerts featured works sung both a capella and to piano accompaniment. Arthur and the officers of the Vocal Society had greater ambitions for the group, and by 1875 they were performing works with an orchestra. By 1880, the Cleveland Vocal Society numbered seventy singers with a thirty-piece orchestra. Cleveland could now honestly claim both an audience for fine music and an increasing number of trained musicians, vocal and instrumental.

The Vocal Society jumped on the festival bandwagon with visits to cities such as Boston and Chicago, following the lead of the Gesangverein and the general American exuberance for large music festivals which began after the Civil War with the Boston peace jubilees of 1869 and 1872. Another inspiration for Cleveland were the Cincinnati May festivals, which began in 1873 under the skillful baton of Theodore Thomas. Cleveland's musicians were not about to be left behind if they could help it.

By the time Cleveland played host, for the third time, to the singers and musicians at the Nineteenth Saengerfest in 1874, the annual event was becoming increasingly grand. A large temporary structure was built at Euclid and Case (E. 40th St.) avenues to house the festival at a cost of $30,000. Sixteen hundred singers from the fifty-six leading societies of the West competed for honors in an auditorium that seated 9,100 and allowed 500 participants on stage. Cleveland's schools closed for a day when the schoolchildren performed at the festival under the music director, N. Coe Stewart. Also attending the event was Carl Bergmann, conducting the Philharmonic Orchestra of New York. Clevelanders immersed themselves in music for the seven days of the festival.

Theater was gaining respectability in Cleveland as well. John Ellsler managed the Academy of Music at the height of its popularity in the early 1870s (see Fig. 12). James O'Neill, a well-known tragedian and father of the dramatist Eugene O'Neill, trod the boards there, as did the noted Shakespearean actor Edwin Forrest. Edward A. Sothern starred in the Tom

FIGURE 12. The Academy of Music, considered one of the best theater schools in the nation. Courtesy of the Western Reserve Historical Society.

The ACADEMY OF MUSIC was one of Cleveland's most famous theaters. Located at W. 6th near St. Clair Avenue, it was built in 1852 and leased to John A. Ellsler. At the time, the Academy was one of the nation's best drama schools, training large numbers of actors. Famous actors who played there included John Wilkes Booth, Charlotte Cushman, and James O'Neill (father of Eugene O'Neill). In 1892 the theater was destroyed by fire.

Taylor play *Our American Cousin* at the Academy of Music in 1871. The play, which was sophomoric even for the nineteenth century, drew crowds because of Sothern's fame (he had played the part of Lord Dundeary more than 3,500 times), and because it was the play Abraham Lincoln had been watching when he was assassinated.

There was an audience for theater in Cleveland, but that audience, like the city's music lovers, still preferred to hear and see the famous in leading roles, rather than its own sons and daughters. The need for additional cast members to perform a play, however, allowed Cleveland's aspiring actors to watch and learn from some of the most respected actors and actresses of the period.

The Academy of Music was drawing crowds large enough to encourage John Ellsler to build his dream project, the Euclid Avenue Opera House (see Fig. 13). The incorporators of the Opera House, Jeptha H. Wade, Horace P. Weddell, Earl Bill, A. W. Fairbanks, and Ellsler himself, erected one of the finest playhouses in the country at a cost of $200,000. On a gala evening in September 1875, society leaders attended the

opening night performance of *Saratoga*, with Ellsler, his wife Euphemia Emma Myers, and his daughter Effie all in leading roles (see Fig. 14). The actor Edward Sothern called it "the most perfect theater in America or England," and it is likely that audiences were as impressed with the marble and velvet interior and crystal gas chandeliers as with the performances they saw. Unfortunately, Ellsler was a better actor and dreamer than a financier, and although big-name opera stars and actors played the Euclid Avenue Opera House on numerous occasions throughout the 1870s, the theater was losing money within three years of its grand opening. Ellsler sold it to Marcus A. Hanna in a sheriff's sale in 1879.

Theater, then as now, was an umbrella term which meant many things in Cleveland. The majority of Clevelanders probably cared little for the distinctions between legitimate theater and performances such as *Buffalo Bill, King of the Border Men*, starring "Buffalo Bill" Cody (a reputedly terrible show that played seven nights to capacity crowds). They attended performances of the Great Royal Japanese Troupe from the Imperial Theater of Yeddo, or the local West Side Dickens Club's presentation of *Mr. Pickwick and His Friends* (starring Marcus Alonzo Hanna as Mr. Pickwick), with equal

FIGURE 13. Construction of the Euclid Avenue Opera House, ca. 1870s. Courtesy of the Western Reserve Historical Society.

FIGURE 14. Handbill from *Saratoga*, the first production of the Euclid Avenue Opera House, ca. 1875. Courtesy of the Press Collection, Cleveland State University.

The **EUCLID AVENUE OPERA HOUSE**, built in 1875, was known as one of the finest theaters in the U.S. Located on the west corner of Euclid Avenue and Sheriff (E. 4th) Street, the theater cost $200,000 to build and was funded primarily with the life savings of John A. Ellsler. Elaborate and luxurious, its interior was 70 feet deep by 65 feet wide and seated 1,638. Financial difficulties forced Ellsler to sell the opera house to Marcus A. Hanna in 1892. The building was demolished in 1922, and the Hanna Theater became its successor.

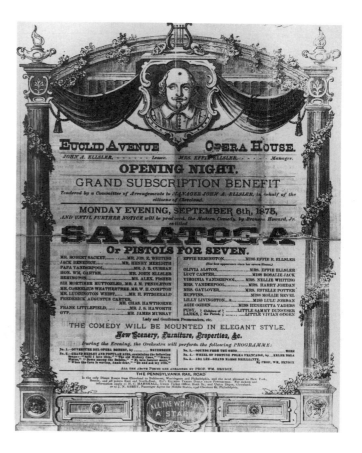

A YOUNG CITY LOOKS FOR CULTURAL STANDARDS ■ 25

enthusiasm. Famous lecturers were still the preferred recreation of many Clevelanders, who in the 1870s had an opportunity to hear Henry M. Stanley give his famous account of "How I Found Dr. Livingstone" and listen to Bret Harte tell stories of his life in western mining camps during the California Gold Rush.

The visual arts got a boost in Cleveland during the 1870s as well. Not only were there a growing number of artists, but the presence of a famous artist, Archibald Willard, proved to be the catalyst for organized activity. Willard had opened a studio in Cleveland after his unparalleled success with Ryder at the Centennial Exposition in 1876, and a number of young artists in his studio formed the first Cleveland Art Club. The group was known by a variety of nicknames, including "the Old Bohemians," because most of the artists were of German extraction, and "the City Hall Colony," because Willard's studio was on the top floor of the City Hall building after 1876. The group later changed its name to the more staid Cleveland Society of Artists (see Fig. 15).

Members of the Art Club met to discuss art and draw from live models. They specifically defined their purpose as

FIGURE 15. The "Old Bohemians" of the Cleveland Art Club, ca. 1890-1900. The Club provided the city with its first organization of notable area artists, including Archibald Willard, Frederick Gottwald, and John Herkomer. Courtesy of the Cleveland Institute of Art.

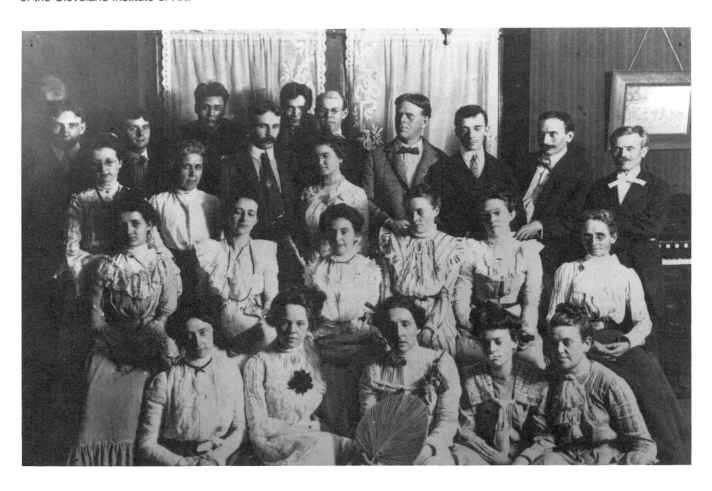

"to furnish instruction in drawing and painting of the same standard provided in foreign schools; to present exhibitions and lectures; and to assist art students." The artists, though nurtured in Cleveland, went elsewhere if possible—to New York or Europe—for more formal training or to seek their fortunes. Their styles were traditional; watercolors, portraits, landscapes, and genre scenes predominated. The Art Club boasted a number of minor success stories. George Grossman founded a New York City artists' colony. Louis Loeb became an illustrator for *Harper's Magazine*. Daniel and Emil Wehrschmidt taught and painted in Bushey, England, and the daring Arthur Schneider became court painter to the Sultan of Morocco.

This tendency to look elsewhere for inspiration and training in the visual arts was not unusual in the nineteenth century, nor is it unusual today. Many of the country's finest artists and architects, musicians and actors spent time in

FIGURE 16. Herkomer Staircase originally built for the Euclid Avenue home of John Hay and later moved to the Hay Wade Park home, now the museum of the Western Reserve Historical Society. Courtesy of the Western Reserve Historical Society.

JOHN HERKOMER (1821–1913) was a Bavarian-born woodcarver. In 1851 he and his brother, Lorenz Herkomer, settled in Cleveland. They opened a woodcarving shop on Prospect Street, moving in 1857 to a location on Euclid Avenue. Working in Cleveland from 1851 to 1883, Herkomer became best known for the staircases and interior decorations he carved for the homes of prominent Clevelanders. After 30 years in Cleveland, he left for England. Some Cleveland residences decorated by Herkomer included the homes of John Hay, Samuel Andrews, and Amasa Stone, Jr. Herkomer was one of the original members of the Art Club.

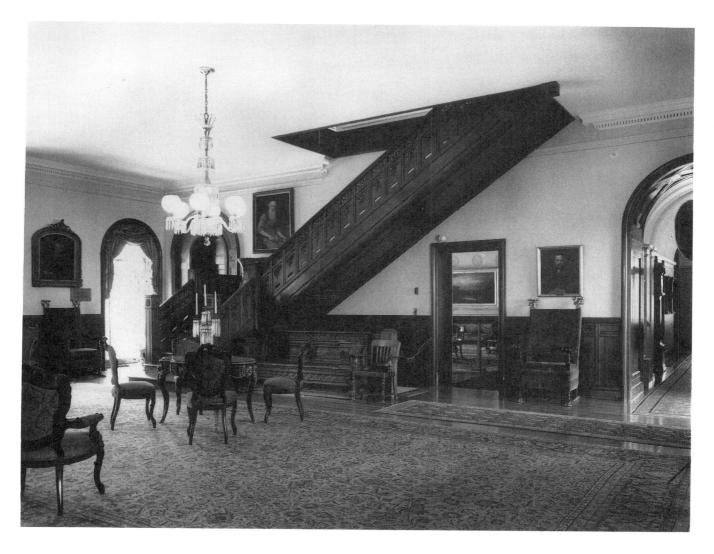

Europe learning their crafts. Cleveland artists, like those in every American city, were well aware that the history of the visual arts in the western world began in Europe rather than the Americas.

Only John Herkomer and Frederick Carl Gottwald continued to make significant contributions to the arts in Cleveland. Herkomer, a Bavarian woodcarver, practiced in Cleveland from 1851 to 1883. He was best known for his carved staircases and interiors of wealthy homes; most of his work vanished as the grand homes along Euclid Avenue were systematically torn down (see Fig. 16). Gottwald, one of the original founders of the Art Club, studied in New York City and Europe before returning to Cleveland in the late 1880s. He took a teaching position with the newly formed School of Art and for the next forty years shaped the lives of Cleveland artists (see Fig. 17).

There was not a great deal of interest in patronage or collecting as yet among Cleveland's elite, but there were a few objets d'art in homes around town. These items were put on display in 1878 to raise money for charity. The "loan exposition" was the forerunner of the museum in many Midwestern

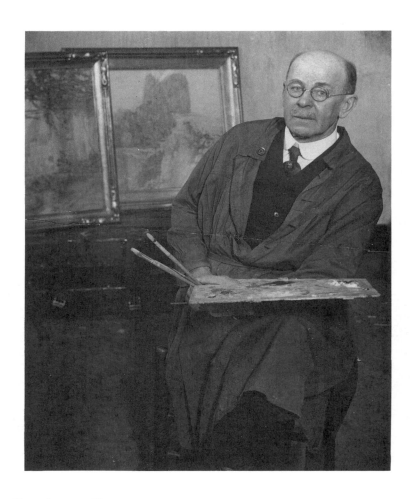

Frederick C. Gottwald, Cleveland painter and founding member of the Cleveland Art Club. Courtesy of the Cleveland Institute of Art.

FREDERICK C. GOTTWALD (Aug. 15, 1860– June 23, 1941) was a painter and instructor at the Cleveland School of Art. Born in Austria and brought to Cleveland before his first birthday, he received artistic training under Archibald Willard and helped to establish the Art Club in 1876. After studying in New York City, Munich, and Paris, Gottwald returned to Cleveland in the late 1880s and taught at the School of Art (later known as the Cleveland Institute of Art). In 1919 he received the Penton Medal at the May Show for his work entitled *The Thinker*. He retired to California in 1932.

cities. Prominent families loaned paintings, sculptures, tapestries, and other objects, while visitors paid to see the items. The money raised was turned over to a charity of choice.

The Loan Exposition of 1878 benefited the Huron Road and City hospitals. The Mathers, Nortons, Severances, Hurlbuts, Wades, Hayes, Haydens, and Eellses all helped sponsor the Exposition, which raised more than $12,800—quite an accomplishment considering that the admission price was twenty-five cents. The Old Central High School building was renovated for the purpose, and a special police guard and a safe were provided to protect the assembled valuables. Excursion trains brought visitors from as far as Detroit and Erie to see the Exposition.

"Coming in from the slush and mud and dreariness of the streets to the warmth and light and color of the Exhibition is like an escape from the gloom of winter to an atmosphere of radiant summer," rhapsodized the *Cleveland Leader*. Most overwhelming was the Department of Painting, in which 152 works of all sizes and schools jostled for attention in a single room. Local artists had their own department, featuring the landscape *Cleveland from Lake View* by Archibald Willard and three portraits, including the one of General Thomas, by Caroline Ransom. "They have found rare and beautiful things in unexpected places," said the *Leader* of the organizers, "and have been gratified with the generous readiness of every one to strip their homes and leave blank places on their walls and in their libraries for the benefit of the Exhibition."

Home-grown and -nurtured musicians, actors and actresses, and artists were the standard rather than the exception by the end of the 1870s. At the same time, Cleveland was achieving a national and international reputation as one of the booming centers of industry. A number of Cleveland's first families, those whose houses fronted Euclid Avenue, had begun to travel regularly to the East as well as making the "Grand Tour" of Europe. As Cleveland entered the "Gilded Age," a new sense of civic stature led to patronage of the fine arts on a grandiose scale.

Society, Philanthropy, and the Fine Arts

The Development of Art Patronage during Cleveland's Gilded Age

Doan, Hanna, Hurlbut, Case, Mather, Brush, Rockefeller, Wade, Huntington, Holden—the names of Cleveland's industrial leaders who made fortunes during the 1880s and 1890s are familiar to present-day Clevelanders from the many charitable and educational institutions, monuments, and parks that they endowed. Fortunes were made in industries as important for the development of the United States as oil, coal, steel, electric lighting, and pig iron, and as mundane as sewing machines and chewing gum.

Cleveland's industrialists and businessmen responded as their counterparts did across the country in New York, Boston, Philadelphia, Detroit, and Chicago. With money and power came civic responsibility, and the first families of Cleveland were not blind to the needs of the city. New undertakings all over Cleveland and the Cuyahoga River valley were dedicated to the public good.

Cleveland had its own special brand of noblesse oblige, which can best be understood by a comparison of the city to its counterpart on Lake Michigan, Chicago, which experienced a similar rapid rise in population growth, cultural diversity, and economic disparity in the nineteenth century. Historian Kathleen McCarthy has done an extensive study of patrons and patronage in Chicago and has identified three different types of civic responsibility among that city's leaders during the nineteenth and early twentieth centuries.

Prior to the Civil War, both social and cultural philanthropy were considered an individual's duty and privilege. Religious and social pressures encouraged men and women to perform personal acts of charity. After the Civil War, and after the reapportionment of the population due to the great conflagration of 1871, wealthy Chicagoans increasingly removed themselves from actual contact with both the needy and the new immigrant classes. This movement occurred at the same time that fine-arts proponents were beginning to emphasize the need for the elevation of standards for art, theater, music, and dance. Thus, philanthropists involved with the fine arts were moved to encourage organizations and institutions, which also reflected this "sacralization process." Fine-arts institutions were comfortable and offered patrons a neutral forum for philanthropic activities. McCarthy describes the process as a transition from "collective doers" to "collective donors."

Finally, McCarthy describes the late nineteenth and early twentieth centuries as an era when donors increasingly turned to professionals—musicians, artists, actors and actresses, museum curators, and critics—for interpretation or education of art, theater, and music. At this juncture the word "amateur" took on a new, derogatory meaning from which, even to the present day, it has not recovered.

Cleveland, too, passed through similar phases in its philanthropic history; however, in Cleveland the phases do not fall into discrete chronological periods as in Chicago, perhaps because of Cleveland's conservatism. The success of Cleveland's fine-arts institutions and organizations is due to the complex presence of all three types of philanthropy on a continuing basis. Another factor was the overwhelming emphasis given to education, of both adults and children, in music and art. This interest in education complemented the conservative character of Cleveland's cultural community, as education frequently emphasized traditional art forms and rejected modern innovations in the arts.

Thus Cleveland entered a new age in the 1880s and 1890s; the gulf between the wealthy and the worker continued to widen. The city's poor huddled in crowded neighborhoods, surrounding the mills in which they worked. The elite families still built grand mansions on Euclid Avenue, but with the coming of the new century they would begin to move west to the Franklin Circle area, and east to what would one day be known as University Circle, as the city became more congested and business districts threatened to overrun the high-priced residential areas.

John Hay's *The Bread-Winners*, perhaps the best-known of that small group of novels with Cleveland settings, aptly illustrates the city's growing social rift during the Gilded Age. Hay was already the author of *Pike County Ballads* and *Castilian Days* when he settled in Cleveland after marrying the

daughter of Amasa Stone in 1875. While he stuck mostly to business during his decade in the city, labor disturbances such as the Cleveland Rolling Mills Strike in 1882 prompted him to publish *The Bread-Winners* anonymously in 1883. It is set in an ostensibly neutral city called Buffland, but with a mansion-lined thoroughfare named Algonquin (read Euclid) Avenue and a forthrightly named Public Square, there can be no doubt of the real location.

There is also no mistaking the author's social predilections. The hero, Arthur Farnham, is a retired Army officer and Algonquin Avenue scion. Andrew Jackson Offitt (named after "the most injurious personality in American history"), a "reformer," is the villain. Any doubt on that score may be dispelled by his mustache, "long and drooping, dyed black and profusely oiled, the dye and the grease forming an inharmonious compound." The Bread-Winners is Offitt's socialistic organization of "the laziest and most incapable workmen in the town," who are sent by their boss during the chaos of a general strike to attack and loot the Algonquin Avenue mansions. They are foiled by Farnham, naturally, who collects a company of Civil War veterans to fight them off and save the girl next door. After this splendid little fracas, Farnham settles in his library for a well-earned drink with a fellow millionaire, but not before taking care of his volunteer vigilantes outside:

> "Budsey," said Farnham, "give all the men a glass of this wine."
> "Not this, sir?" said Budsey, aghast.
> "I said this," replied Farnham. "Perhaps they won't enjoy it, but I shall enjoy giving it to them." (p. 235)

Lines such as that may explain why *The Bread-Winners* was published anonymously. One would hope that it didn't express the motivation behind the noblesse oblige of too many from the author's Cleveland social stratum.

The 1880s and 1890s were the golden years of ostentatious wealth. Cleveland had finally grown into its wealth and power, and those with money, influence, and education formed the elite group of movers and shakers. The first *Social Directory* for families, afterwards known as *The Blue Book of Cleveland Society*, appeared in 1885. These families had a vested interest in Cleveland and were determined to turn the city, which was already an industrial center, into a cultural center as well. Who were these men and women, and what characteristics did they share with others in power in the United States? To begin with they were wealthy, and in order to maintain (and increase) their wealth and that of the city, they were active in local, state, and national politics.

Cleveland's leading citizens were primarily Republicans. These kings and princes of industry ran campaigns and held offices in addition to all their other activities. Men such as John Huntington, Marcus Alonzo Hanna, John Hay, Myron T.

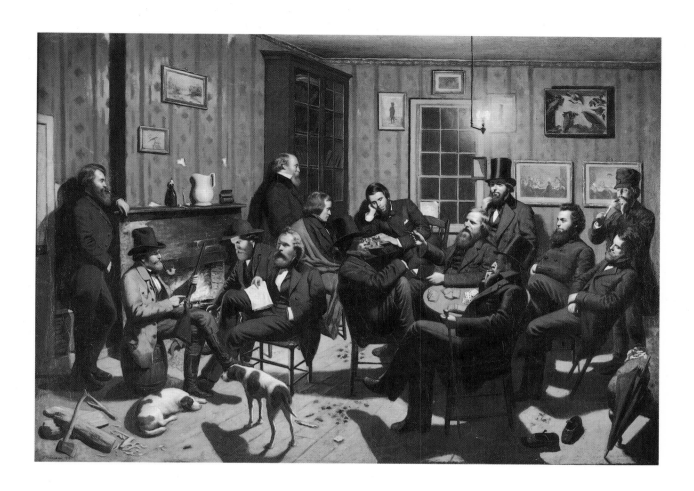

Plate 1. *A Meeting at the Ark,* by Julius Gollman. Courtesy of the Western Reserve Historical Society.

Plate 2. Painting of the 1860 Northern Ohio
Sanitary Fair. Courtesy of the Western Reserve
Historical Society.

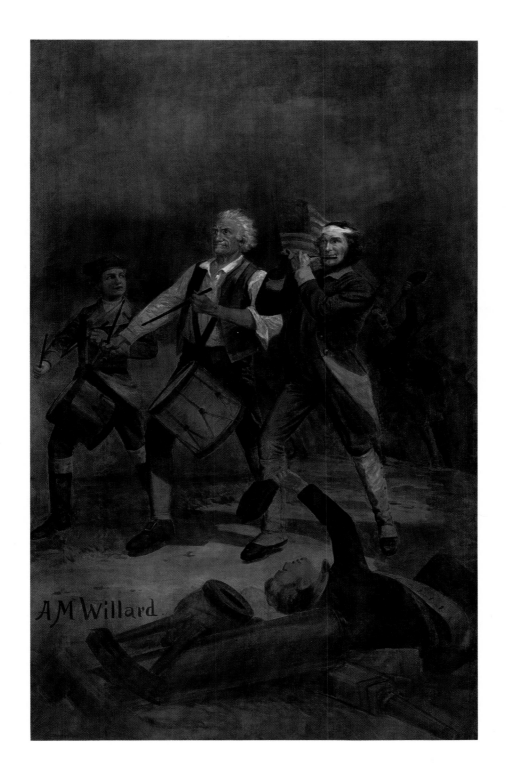

Plate 3. *Spirit of '76,* by Archibald Willard.
Courtesy of the Western Reserve Historical
Society.

Plate 4. Exterior view of the Cleveland Museum of Art and Wade Lagoon during the "Insight/On Sight" exhibition celebrating the museum's 75th anniversary in 1991. Photo by Howard T. Agriesti with Gary Kirchener and Emily S. Rosen; courtesy of the Cleveland Museum of Art.

Plate 5. The Cleveland Play House Theater facility, ca. 1991. Photo by Barney Taxel, courtesy of the Cleveland Play House.

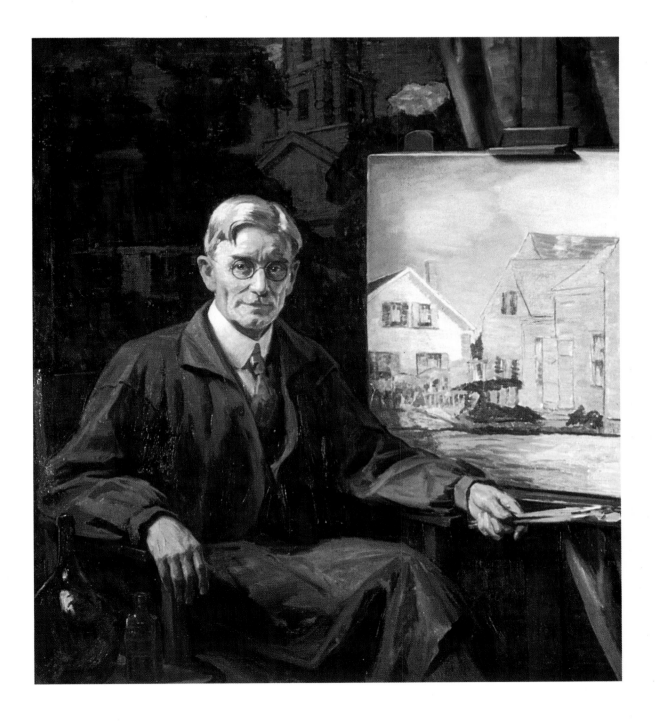

Plate 6. *Portrait of Ora Coltman,* by William Edmondson (1868–1966). Courtesy of the Cleveland Artists Foundation, Gift of the Cleveland Society of Artists.

Plate 8. Cowan pottery vase, signed by Arthur Baggs, 1928. Courtesy of the Western Reserve Historical Society.

Plate 7. The Tatterman Marionettes from the early years of the Cleveland Play House. Photo by Richard Termine, courtesy of the Collection of Elizabeth Flory Kelly.

Plate 9. Poster of the Surrealist Festival held in Cleveland, ca. 1979. Courtesy of the Department of History, Case Western Reserve University.

Plate 10. *The Umbrian Valley, Italy,* by Frederick
Gottwald (1860–1941). Courtesy of the Cleveland
Museum of Art, Gift of Mrs. John Huntington.

Plate 11. *God's Garden,* by Thelma Frazier Winter (b. 1905). Courtesy of the Cleveland Museum of Art, Silver Jubilee Treasure Fund.

Plate 12. *Plaque-Mexico,* by Edward Winter
(b. 1908). Courtesy of the Cleveland Museum of
Art, Gift of the Cleveland Arts Association.

Plate 13. *Painted Mask: Pagliacci,* by Edris
Eckhardt (b. 1907). Courtesy of the Cleveland
Museum of Art, the George J. Huth Purchase
Prize.

Plate 14. *The Pool*, by William Sommer (1867–1949). Courtesy of the Cleveland Museum of Art, Silver Jubilee Treasure Fund.

Plate 15. *Lavandieres au Goyen,* by Abel G.
Warshawsky (1883–1962). Courtesy of the
Cleveland Museum of Art, Gift of the Cleveland
Art Association.

Plate 16. *Fisherman's Bride,* by Alexander
Warshawsky (1887–1945). Courtesy of the
Cleveland Museum of Art, Gift presented to CMA
by Friends of the Artist.

Plate 17. *Down to the Harbor,* by George G. Adomeit (1879–1967). Courtesy of the Cleveland Museum of Art, Gift of the Cleveland Art Association.

Herrick, and Sylvester Everett all had a hand not only in the government of the city, but in the government of the nation as well. They were churchgoers who not only attended church but kept the institutions solvent. They also supported Sunday schools, wayfarers' homes, and orphan asylums. Many top industrialists belonged to Cleveland's Trinity Cathedral, including Samuel and William G. Mather, Andrew Squire, Ralph King, Charles Brush, and David Z. Norton. Just as many public-spirited citizens belonged to Old Stone Church (First Presbyterian) on Public Square.

These men and women were culturally aware and well-traveled. Jeptha Wade, Jr., who would later be a great friend to the Cleveland Museum of Art, traveled through Europe and Greece, first as a child with his parents and later on his own. His grandfather, Jeptha Wade, Sr., had begun his professional life as an itinerant portrait painter and never lost his love for fine art. Jeptha Wade, Jr., who was named for his grandfather, inherited that love and donated land for the art museum as a Christmas gift to the city. John Huntington, Horace Kelley, and Hinman Barret Hurlbut, the three men whose separate legacies were finally enjoined to allow the creation of the Cleveland Museum of Art, all traveled extensively and collected art.

Perhaps most important for the city, and particularly for the fine arts, these men and women were philanthropists. Ministers preached sermons on civic responsibility, and Cleveland's wealthy citizens responded. The Gilded Age was the era of philanthropy and private patronage in Cleveland. Many of its wealthier citizens had strong memories of hardships survived during the city's early years and were determined to see it become a better place for future generations. They gave money and land and established institutions that would ensure a better life for Cleveland's citizens.

Jeptha Wade had generously given the city Wade Park. John D. Rockefeller similarly donated the large section near Wade Park known today as Rockefeller Park, aided in his endeavor by the further generosity of the Wade and Gordon families, who gave adjacent portions of their own property to create a continuous chain of forested roadway from the Shaker Lakes to Lake Erie.

Money and lands were left for hospitals, research institutions, libraries, settlement houses, and schools. The fine arts were not forgotten by these prominent citizens, who had used their vast wealth to travel and see the great cities and arts institutions of the world. They were well-rounded men and women who had been raised in a period when the Judeo-Christian ethic seemed designed to allow men to expiate their sins by providing for institutions of learning and culture.

Great wealth was created for a small segment of the population by the exploitation of the workers. While perhaps harsh by today's standards, working conditions were compa-

rable to those in other cities during the new industrial age. If the industrialists felt any guilt over creating such conditions, they assuaged their feelings in social, religious, and cultural philanthropy.

These comments are not meant as criticism of the members of Cleveland's high society; they did far more for the people of Cleveland than did many of their counterparts in other cities. Political and social events in Cleveland were generally run by a small segment of white Anglo-Saxon Protestant males of New England extraction. These men, in a most honorable fashion, let themselves be persuaded by their own belief in Cleveland, by the sermons of their local clergymen, and by the nationwide progressive movement into providing money and lands for what are today many of Cleveland's finest institutions. Like Andrew Carnegie, many Clevelanders seemed to feel that the rich "hold and use wealth in trust for the good of society."

An exemplary philanthropist, even for the nineteenth century, was John P. Huntington (1832–1893). The son of an English mathematics professor, Huntington immigrated to the United States in 1854, traveling to Cleveland at the age of twenty-two. In 1863 he joined Clark, Payne and Company, an oil company in need of his knowledge of mechanics. Clark, Payne and Company merged with Standard Oil in 1870, and as the industry soared, so did Huntington's fortune. He bought ships and became vice-president of the Cleveland Stone Company. As an interested citizen and businessman, he was elected to the City Council in 1862, serving for thirteen years. During his time in office, Huntington was instrumental in the construction of the Superior Viaduct, the first high-level bridge to join the east and west sides of the city.

Outside of his work and civic pursuits, Huntington found time to be interested in charitable activities. Like many immigrants he never forgot his early years in the United States; each Christmas and Thanksgiving he sent food to 100 families in remembrance of those years. His generosity was celebrated during the 1872 mayoralty campaign by the following parody of a Robert Burns poem, signed "A Workingman," which appeared in the *Cleveland Leader*, April 2, 1873:

> John Huntington, my Joe John,
> When first we were acquaint,
> Ye were a toiling laborer
> Which now all know ye ain't.
>
> No one e'er found your purse or hand
> Closed to another's woe;
> Ye always by the poor did stand,
> John Huntington, my Joe.

Concerned with the plight of the working man in Cleveland, Huntington became fascinated with the London poly-

technical school system, which emphasized the teaching of industrial arts and applied sciences. His death in 1893 occurred during a visit to London's Regent Street and Battersea schools to determine how the polytechnical system might best be adapted in Cleveland to provide free educational opportunities for needy Clevelanders.

Huntington had developed an interest in the visual arts late in life after a second marriage and a grand tour of the major art centers of Europe. Prior to his European tour, Huntington had been a philatelist; afterwards he turned his attention to art objects. He was concerned that Cleveland, unlike the great cities of Europe, could not offer its citizens a permanent art collection.

On his fifty-seventh birthday, in 1889, Huntington invited several of his closest colleagues to his home and announced that he was placing $200,000 in their hands to establish the John Huntington Benevolent Trust for the benefit of charitable institutions in the city of Cleveland. His friends, who would monitor the trust and its programs, shared Huntington's faith in Cleveland and its potential. They included Edwin R. Perkins, John V. Painter, Samuel E. Williamson, Charles W. Bingham, John H. Lowman, Henry C. Ranney, and James D. Cleveland. The trust was designed to support nineteen charitable institutions of an astonishing variety. Not only were his charities affiliated with several different religions— Catholic, Protestant, and Jewish—but they did everything from providing homes for the aged to purchasing better scientific equipment for Western Reserve University.

When Huntington died in 1893, his will made provisions for the creation of the John Huntington Art and Polytechnic Trust, combining the two major interests of his final years, to provide a "gallery and museum of art" and a "free evening polytechnic school." The will stipulated that both institutions were to be open and free to all citizens. The two major recipients of his endowment, the Cleveland Museum of Art and the John Huntington Polytechnic Institute, did not open until 1916 and 1918 respectively, because of legal problems with the allocation of funds.

Huntington's will is important because during the 1880s and 1890s, three major legacies were entrusted to the city government for the provision of an art gallery or museum. Until the 1880s and 1890s, Clevelanders had not shown any particular interest in the visual arts, except for the occasional viewing of a single work of art or a small collection at one of the local churches or at a private home. The *Cleveland Herald* had announced in 1840 that a painting of Adam and Eve being exhibited at the Court House was appropriate for viewers of both sexes. The Baptist Church frequently had special showings of single paintings, including a display of Benjamin West's *Death on a Pale Horse* in 1845.

The largest event to date, however, had been the success-

ful Art Loan Exposition of 1878, which had proved to Clevelanders that there was an audience for art in northern Ohio. The significance of this particular exposition cannot be overlooked, for it seemed to be an attempt to raise Cleveland's standards to the level of those of other cities in the United States. After all, Boston's Museum of Fine Arts had opened in 1870, followed by the Corcoran Gallery in Washington, D.C., in 1874 and the Philadelphia Museum of Fine Arts in 1876. The local exposition, though well attended, had not been an impressive collection of art, much of it probably falling under the heading of colorful bric-a-brac. There were exceptions, however, such as the European oil paintings from the collection of Hinman B. Hurlbut.

Hurlbut was a colorful figure who is all but forgotten in the twentieth century. He arrived in the Western Reserve in 1837 at the age of eighteen to live with a brother and study law. He practiced law for a time in Massillon, Ohio, until he decided that banking was a more profitable field of endeavor. Moving his family to Cleveland in 1852, he opened the Hurlbut and Company Banking House in association with Amasa Stone and Stillman Witt. By the time of the Civil War, Hurlbut managed to acquire three more banks, thus assuring his financial and social position in Cleveland. In 1865, he made the first of two trips to Europe, which piqued his interest in art; presumably during this trip he began his collection of paintings, which numbered fifty-eight at his death.

When Hurlbut died in 1884, he left instructions in his will that after his wife's death, remaining funds should be used to build an art museum for the city, and that his personal collection would be the property of that museum. Trustees were named for the Hurlbut estate, but the legacy was in legal limbo until such time as his widow would pass away.

Meanwhile there was a third prominent Clevelander with an interest in art museums. Horace Kelley was a member of the large family that once owned Kelley's Island off Sandusky. Born in Cleveland in 1819 and orphaned at the age of four, Horace was raised in the families of his four uncles. His uncle Thomas was the proprietor of Kelley's Hall, where Jenny Lind had performed in 1851. The Kelley families invested heavily and successfully in real estate. Horace was responsible for building several business blocks in Cleveland, and at one time owned most of Kelley's Island, as well as Rattlesnake Island and North Bass Island.

Kelley and his wife, Fanny Miles of Elyria, made their first trip to Europe in 1868, when Kelley was forty-nine. He made five trips in all to Europe and, probably through his wife, became interested not only in art but in the training of artists as well. He and his wife seem to have led a fairly private and modest life in Cleveland, and when Kelley died in 1890, he left more than a half-million dollars for the creation of an art museum.

Kelley's will was a masterpiece of practicality. He left the balance of his estate in the hands of three trustees who were instructed to purchase land and erect a fireproof art gallery, a part of which would be devoted to "a school or college for designing, drawing, painting, and the other fine arts." Kelley was making provisions for living artists as well as a safe haven for the work of artists long since dead. As John Huntington's will would stipulate three years later, Kelley's will provided for free public access to his gallery. The trustees named were Henry C. Ranney, his cousin Alfred S. Kelley, and Judge J. M. Jones.

Kelley, who was right to be concerned with fire in a day when entire sections of the city regularly were destroyed in conflagrations, had started a small political fire of his own with one of the provisions of his will. He had given the city of Cleveland a three-month right of refusal on a parcel of land he owned downtown which was needed to create a connecting street between the Union Depot and Seneca Street (W. 3rd). His will stipulated that if the city refused the land, the funds from the sale should be added to the museum fund.

Businessmen in the area immediately began petitioning the city to accept the land, so that they could avoid assessments that would be levied on them for the opening of the street. The newspapers took up the defense of the museum, with the *Plain Dealer* proclaiming on December 13, 1890, "There is no city in the United States which is so poor in facilities for painting and art as Cleveland." A month later the *Cleveland Leader and Herald* noted wryly, "The point at issue lies between the business of possibly one hundred persons and the education, enlightenment, and elevation of unnumbered thousands, now and hereafter." City Council let the three-month grace period lapse without a decision, and an extra $100,000 was added to the Kelley fund.

Thus by the mid-1890s, Cleveland's City Council members found themselves with an unusual situation on their hands. Three separate benefactors had left money for the creation of an art gallery: Hurlbut, Kelley, and then Huntington. Added to these three legacies was the generous Christmas gift to the city from Jeptha Wade, Jr., of a portion of land in Wade Park set aside for the art museum. The political and practical problem of the art museum would take another twenty years and all the legal ingenuity of Henry C. Ranney and William Sanders to resolve.

The other areas of the fine arts were not without their benefactors, patrons, and patronesses during this period; however, these three men who were closely involved with the foundation of the art museum serve as representative examples of the type of benefactors associated with the fine arts in Cleveland.

Dudley Peter Allen (see Fig. 18), Francis Fleury Prentiss, David Z. Norton, Elisabeth Severance Allen Prentiss, Adella

FIGURE 18. Dudley P. Allen, one of the first trustees of the Cleveland Museum of Art. Courtesy of the Cleveland Public Library.

DUDLEY P. ALLEN (Mar. 25, 1852–Jan. 6, 1915), founder of the Cleveland Medical Library Association, was an eminent physician, surgeon, and professor who settled in Cleveland in 1883. Also considered to be a connoisseur of fine arts and an expert in Chinese porcelain, Allen was one of the first to be appointed a trustee of the Cleveland Museum of Art. In 1910 he retired from all professional positions and settled in New York City.

Prentiss Hughes—the list of generous patrons and patronesses in Cleveland could go on and on. As Cleveland entered the twentieth century, the time was ripe, the money was available, and Cleveland had, at long last, an educated segment of society committed to the city and its fine arts institutions.

Setting Artistic Standards for a New Century

The Maturation of the Fine Arts in Late-Nineteenth-Century Cleveland

Many of the new institutions which were formed in the 1880s and 1890s were oriented toward both the fine arts and education. The YMCA, for example, remodeled its facilities in the early 1880s to provide a gymnasium, bowling room, chapel, library, and two classrooms for its members. Joseph B. Meriam, president of the association, also introduced night classes for those who couldn't attend school during the day. Volunteer teachers taught drawing alongside practical classes in bookkeeping and commercial law, and scholarly courses in German and Latin.

The lasting influence of the Arkite Movement was ensured when Leonard Case passed away on January 6, 1880, leaving lands and endowment monies to establish a school of applied sciences. The Case School became the first endowed and independent college of applied sciences west of the Alleghenies. Leonard Case, in one stroke, assured a steady stream of scientists and engineers for the community. This was important as Cleveland climbed to rank fifteenth in manufacturing in the United States.

After the Civil War, many single women began to join the work force, and in 1882 Sarah M. Kimball, Mrs. Mary P. (Henry B.) Payne, and Mrs. Delia E. (Liberty E.) Holden organized the Western Reserve School of Design for Women. The school was founded to provide women with a practical opportunity to make a living for themselves in the areas of

industrial and home design. The first class at the new Cleveland institution had one student and one teacher, the principal, Harriet J. Kester.

The idea of an art school to train women to design for industry was not welcomed by everyone. Nancy Coe Wixom, in her history *Cleveland Institute of Art: The First Hundred Years, 1882–1982*, relates a visit Harriet Kester paid to a local businessman looking for financial help for the fledgling school. "What's the good of teaching anyone to paint pretty pictures?" the businessman replied to her request. "It's a waste of time. If you wanted money for a ladies' cooking institute, I might be interested."

Luckily, not all of Cleveland's businessmen echoed his sentiments. The president of the school was Henry C. Ranney, a prominent local attorney who would be a moving force in the realization of the Cleveland Museum of Art. Other important benefactors were Judge E. Stevenson and his wife. The latter served as treasurer of the school for twenty-seven years.

The inspiration for the institution had been provided by the decorative-arts movement which occurred after the Civil War, associated in England with the art critic John Ruskin, and in America with William Morris. The purpose of the new school of design was defined as teaching women "the principles of Art and Design as practically applied to artistic and industrial pursuits." Principal Kester amplified this simple statement in the prospectus for the 1883 school year, writing, "While we may be glad to foster and develope [*sic*] the fine arts, our first care is for the art industries. . . . America should soon be able to compete with Europe in its industries—such as glass painting, china decorating, pottery and the like—all of which tends greatly to increase the wealth and importance of a country." The original class met at the Kimball residence, but when that proved too small for the growing number of students, the school rented rooms on the top floor of City Hall. Sarah Kimball approached Mrs. Holden and Mrs. Payne, who gave $3,000 to refurnish and properly equip the new art school. Another benefit of the new classroom location was that it placed the students in direct proximity to the Art Club founded in the previous decade. One of the most oft-told stories of the City Hall years concerns Harriet Kester's machinations to get around the women-only rule. She allowed young artists such as Andrew Scobie, Robert Hayden Jones, and Henry G. Keller to attend classes by referring to them in print as employees—the three men held the titles of janitor, first assistant janitor, and second assistant janitor.

It is interesting to note that the major feminine response to the arts and crafts movement in Chicago was somewhat different in character. In 1877, the Chicago Society for Decorative Arts was founded. The focus of this group was collection and appreciation of the decorative arts rather than the social benefits to be realized from training women in their production.

In 1888 the Cleveland school merged briefly with Western Reserve University to become a department of the women's college. Just a few years later, in 1892, the administrators of the school sought their independence from the university. The reason for the return to independence is interesting. When the school had been founded, its purpose was clear—to train women for careers in the decorative arts. At this juncture in history, the goals of the arts and crafts movement of the nineteenth century dovetailed with the growing needs of industry. Designers were needed, and the Cleveland School of Art had been founded to train women to meet those needs.

Unfortunately for industry, during the few years the school had been under the auspices of the women's college of Western Reserve University, practical training had given way to the academic approach to art. The art school separated from the university and returned to teaching its students the basics of practical design. In just a few short years the Cleveland School of Art had gone from a few individuals meeting in a private home to an independent institution of art education that continues to serve the Cleveland community today as the Cleveland Institute of Art.

The presence of Western Reserve University itself was important for Cleveland's cultural growth in the 1880s and the 1890s. Western Reserve College had been founded in 1826 in Hudson, Ohio, but by the 1880s it was struggling with financial difficulties. Hiram C. Haydn, trustee of the college, pastor of Cleveland's Old Stone Church, and later president of Western Reserve University, knew that many prominent Clevelanders were interested in establishing a university in Cleveland. Haydn suggested that the struggling college move to Cleveland and reincorporate as a university—an ironic suggestion, since the founders of Western Reserve College had chosen Hudson in order that the students would be far away from the sins and temptations of Cleveland.

Amasa Stone, a wealthy businessman and parishioner of Haydn, was persuaded to give $500,000 to effect the move. However, Stone had certain conditions that he wanted met, requiring that the city and citizens of Cleveland provide the land for the new university, that he be able to appoint a number of the trustees, thus ensuring his control, and that the name of the institution be changed to the Adelbert College of Western Reserve University (after his only son, who had drowned during a geology field trip while a student at Yale). Adelbert College was dedicated on October 26, 1882.

Adelbert College stood on a corner of Liberty Holden's property near Doan Brook, right across the street from seventy-five acres of farmland belonging to Jeptha H. Wade. Wade had made a fortune constructing telegraph lines and was the first president of Western Union. He had moved to Cleveland in 1856 and was soon a civic and business leader of the city,

FIGURE 19. Hruby Brothers William (1899-1965) and Alois (1886-1968) are pictured along with Alfred Kaufer, another member of the Cleveland Orchestra. Courtesy of the Musical Arts Association.

Frank Hruby (IV), father of "America's foremost musical family," first came to Cleveland in 1884 from Czechoslovakia. The **HRUBY FAMILY** consisted of eight children: Frank (V), Alois, John, Celia, Ferdinand, Charles, Mayme, and William, each of whom played several instruments. All but Celia and Ferdinand played for the Cleveland Orchestra at one time or another. The family toured Europe as an orchestra, performing in Holland, Czechoslovakia, and Germany. In 1916, Frank (V) and Ferdinand founded the Hruby Conservatory of Music, located at Broadway and E. 55th. The five oldest brothers formed a quintet known as the "Five Hruby Brothers" and gained a national reputation.

increasing his fortune in banking and railroad ventures. Wade had purchased land along Doan Brook and had spent some ten years landscaping the seventy-five acres. In 1881, he offered the land as a gift to the Cleveland City Council.

There was disagreement among council members about accepting the land, as it was far from the center of town, and many felt that only the wealthy with their horses and carriages would ever benefit from the park. In addition, there was still forested land around Cleveland, and some council members thought spending money on parks was senseless. In 1882, the City Council finally accepted Wade's generous gift and promised to spend $75,000 on improvements.

A section of the seventy-five acre park was retained by Wade for his family's personal use. Wade's grandson and namesake, Jeptha Wade, Jr., handed over the reserved section to the city in 1892 as a site for the proposed art museum. Wade Park would eventually become the center of University Circle and the home of Cleveland's major fine-arts institutions in the early twentieth century.

Music also benefited from the period's general emphasis on education. In 1884 Alfred F. Arthur, Cleveland's premier vocal teacher, opened the Cleveland School of Music in the Benedict Building. The purpose of the school was to give pupils a well-rounded musical education, and the list of faculty could double as a roster of Cleveland's finest and most energetic musicians. Piano and organ teachers included William B. Colson, Jr., organist for Old Stone Church, and James H. Rogers, composer and critic. Other faculty included George Brainard and Miss M. S. Wright. Julius Deiss and Margarete Wuertz taught violin. Rocco Rottino was the flute instructor, Mrs. Anna P. Tucker had charge of elocution and expression, and Frank Hruby taught clarinet.

The Hruby name was synonymous with music in Cleveland for many years, beginning with Frank Hruby, who settled in Cleveland in 1884. Born in Czechoslovakia in 1856, Frank Hruby had his first musical job at nine playing for a circus. He stayed with the circus directing bands for twelve years, before moving on to play first clarinet with a band at Brighton Beach, England's premier summer resort. Hruby left England and came to Cleveland looking for new experiences. After learning of the need for experienced musicians, he was put in contact with Joseph Zamecnik, a local Czech bandleader. Through Zamecnik, Hruby met the director of the Euclid Avenue Opera House orchestra, John Faust. He subsequently played in that orchestra for twenty-two years.

Three generations of the Hruby family would influence Cleveland's music scene; Frank had eight children, each of whom played more than one instrument. Two of his sons founded the Hruby Conservatory on Broadway and E. 55th, which was later restored as a branch of the Cleveland Music School Settlement. When the present Cleveland Orchestra was

founded in 1918, there were three Hrubys on the roster (see Fig. 19). When the *Cleveland Press* closed nearly a century after the patriarch's arrival, its last music critic was his grandson and namesake, Frank Hruby.

A new group that became popular in the 1880s was the Cleveland Amateur Philharmonic Society. The small orchestra of thirty-six players was first conducted by Ferdinand Puehringer, who was followed by Mueller Heuhoff and then Franz X. Arens. Despite the frequent turnover of conductors, the editors of *Brainard's Musical World* saw the potential for this type of group in the community. As they wrote in November 1881,

> A new orchestra of very interesting proportions has recently been organized in this city which promises to be a useful, instructive and attractive element to our local musical interests. The successful introduction of orchestral numbers in the Cleveland Vocal Society programmes suggested an organization whose purpose should be ostensibly orchestral and The Cleveland Amateur Philharmonic Society is the result. Its object will be the cultivation, practice and public presentation of the best class of orchestral compositions and its future usefulness is at once apparent.

Arens was succeeded as conductor by Emil Ring, a Czech musician trained as a teacher, conductor, and composer as well as an oboist and pianist (see Fig. 20). Prior to his appointment as conductor of the Cleveland Amateur Philharmonic, Ring played in orchestras all over Europe (including Leipzig, Berlin, Vienna, Holland, and England). Upon his arrival in the United States in 1887, he became a member of the Boston Symphony Orchestra. A chance meeting with the Cleveland soprano Rita Elandi at a command performance for Queen Victoria led to Ring's eventual move to Cleveland.

A smaller ensemble, the Philharmonic String Quartet, was founded in 1886. The members of the quartet proposed to bring the classics to life in Cleveland and thus contribute to the cultural development of the city. Original members of this small but influential group included George Lehman, A. Reinhardt, Julius Hermann, and Charles Heydler.

The Cleveland Amateur Philharmonic gave summer concerts at a popular nineteenth-century watering hole, Haltnorth's Gardens. Located at the corner of Woodland and Wilson (now E. 55th Street), Haltnorth's was originally a German beer garden where Clevelanders could come to picnic, drink beer, and hear an evening of instrumental music or opera. The establishment had been in existence at least as early as the 1860s on Kinsman Avenue, where it had been targeted by the temperance movement as a den of iniquity. By the 1880s, however, it had become a fashionable meeting place associated with the local Gesangverein and other musical groups.

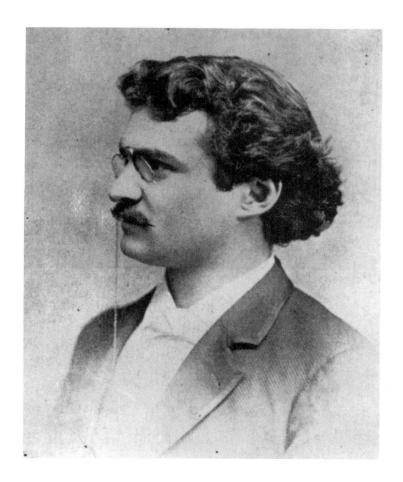

FIGURE 20. Emil Ring, Czech musician and composer, ca. 1890. Courtesy of the Cleveland Public Library.

EMIL RING (Nov. 21, 1863–Feb. 1, 1922) was a Czech oboe player, pianist, teacher, and composer prominent in Cleveland's musical development. He trained at the Prague Conservatory of Music. His first exposure to Cleveland came after meeting Cleveland operatic soprano Rita Elandi. The two formed a friendship that eventually brought Ring to Cleveland in 1888, when he became the conductor of the Philharmonic Orchestra. Piano instructor at the Cleveland Conservatory of Music from 1888 to 1895, Ring also served as director of the Gesangverein and festival conductor at the 1893 Cleveland Saengerfest.

The Gardens was also a center for operatic productions in Cleveland, home to Charles L. LaMarche's stock company and other companies, including the Holman Opera Company, the Wilbur Opera Company, and the Murray-Lane Opera Company. From June through September the Gardens featured light opera in a covered theater that seated between 600 and 800 patrons.

The last decades of the nineteenth century were the Gilbert and Sullivan years in the United States as well as Great Britain. *H.M.S. Pinafore* was introduced to the United States in Boston in 1878, and by 1879 an amateur group led by J. T. Wamelink was performing it at the Euclid Avenue Opera House.

Better education was making Clevelanders more well-read, and in 1884 the influential William Howard Brett was named the third librarian of the Cleveland Public Library (see Fig. 21). While he cannot be counted as a great literary figure himself, Brett eased the way for scholars to accomplish their work. Under his tenure the library became a more organized and efficient facility. He improved the lighting conditions, generally poor in nineteenth-century buildings, and intro-

FIGURE 21. William Howard Brett (*2nd row, 5th from left*), Linda Eastman (*2nd row, 7th from left*), and other librarians, ca. 1900. Courtesy of the Cleveland Public Library.

WILLIAM HOWARD BRETT (July 1, 1846–Aug. 24, 1918) developed the open-shelf library as head of the Cleveland Public Library from 1884 to 1918. Elected president of the American Library Association in 1896, he was active in promoting libraries designed especially for children. This led to the establishment of an alcove for juvenile books at the Cleveland Public Library. Under his leadership and with the financial backing of Andrew Carnegie, the first branch libraries were opened in Cleveland. Brett developed a plan in the following years for a library school at Western Reserve University, which opened in 1904 with him as dean.

LINDA EASTMAN (July 17, 1867–Apr. 5, 1963) was the fourth head librarian of the Cleveland Public Library and one of the first women in the world to head a major urban library. Eastman became an assistant at CPL in 1892 and was promoted to vice-librarian under William Howard Brett in 1895. She was named librarian in 1918

duced a systematic classification and cataloging of books. Eventually he opened the stacks to the public and organized a children's section.

Brett also had time for activities outside the Cleveland Public Library. He founded and was first president of the Ohio Library Association, and in 1897 he was elected president of the American Library Association. In 1903 he organized the Western Reserve Library School, of which he was dean from 1903 until his death in 1918, training new generations of librarians to follow in his laudable footsteps.

The popularity of books in Cleveland was one thing; the popularity of authors in the nineteenth century, however, was quite a different matter. Clevelanders were not particularly inspired by a visit to Cleveland by Oscar Wilde in February 1882. An auditorium filled with 600 of Cleveland's elite turned out to hear Wilde speak on "The English Renaissance." The content of the speech, though, seemed secondary, as the audience's interest turned more to the "naughty" Wilde's clothes and adventures than to his literary acumen.

Cleveland's authors were, for the most part, history writers. Dr. Burke A. Hinsdale, who had been president of Hiram College and served as superintendent of Cleveland

Public Schools beginning in 1882, edited two volumes of his old friend James A. Garfield's work. Hinsdale himself wrote *President Garfield and Education; The Old Northwest; How to Study and Teach History;* and *The American Government.* Another prominent historian, James Ford Rhodes—best known for his monumental seven-volume history of the Civil War era, *History of the United States from the Compromise of 1850*—was born, lived, and worked in Cleveland. His writing, however, was accomplished primarily after his move to Cambridge, Massachusetts, in 1891.

A single exception to the general dearth of creative literary talent in late nineteenth-century Cleveland was an important fringe figure of the American literary mainstream. Born in Cleveland in 1858, Charles Waddell Chesnutt (see Fig. 22) was raised by his former slave parents and educated in Reconstruction North Carolina, eventually returning to Cleveland to practice the professions of law and court stenography. Though light enough in color to pass for white, Chesnutt never denied his black heritage, declining a well-intentioned offer by Samuel E. Williamson which would have enabled him to evade the effects of prejudice by practicing law in Europe. His real ambition was to become an American writer, seeking, in his words, "not so much the elevation of the colored people as the elevation of the white—for I consider the unjust spirit of caste . . . a barrier to the moral progress of the American people; and I would be one of the first to head a determined, organized crusade against it."

Chesnutt began writing stories in the 1880s, placing one in the *Atlantic Monthly* as early as 1887. Although his publishers initially downplayed his racial identity, Chesnutt's dialect pieces gained the approbation of such literary figures as Walter Hines Page. Two story collections, *The Conjure Woman* and *The Wife of His Youth,* appeared in 1899, followed in the next six years by three novels. *The House behind the Cedars* (1900), an artificially plotted tale of the consequences of miscegenation, was his most popular work. His masterpiece may have been *The Marrow of Tradition* (1901), which took a pessimistic view of the future of race relations. Despite his identification with Cleveland, Chesnutt set his stories exclusively in the South of his youth. While his characterization and insights often display a fine sense of irony, his style never strays far from the genteel tradition of the late nineteenth century. By endowing his characters with dignity despite their faults, however, he provided a counterpoise to the stereotypical treatment of black characters in white fiction.

Failing health and the inadequate returns from his books largely curtailed Chesnutt's literary career after publication of *The Colonel's Dream* in 1905. He lived on until 1932, maintaining his court-reporting business and basking in his reputation as a pioneer in black letters, for which he was awarded the NAACP's Spingarn Medal in 1928. His downtown office was

and held that position until her retirement in 1938. During her term, Eastman developed several specialized operations: a travel section, a business information bureau, and services for the blind and handicapped. She served as president of both the Ohio Library Association and the Library School of Western Reserve University. Eastman retired from the library at the age of 71.

FIGURE 22. Charles Waddell Chesnutt, Cleveland novelist and lawyer, pictured here with his daughter. Courtesy of the Western Reserve Historical Society.

CHARLES WADDELL CHESNUTT (June 20, 1858–Nov. 15, 1932) was a black novelist, short-story writer, and lawyer. He was one of the first black writers to deal with the "race question" from a black perspective. Born in Cleveland and educated in North Carolina, Chesnutt moved back to Cleveland in 1883, began studying law, and was admitted to the Ohio bar in 1887. His first published story appeared in the *Atlantic Monthly* in 1887, and his first collection of short stories, entitled *The Conjure Woman,* came out in 1899. After 1900 Chesnutt's popularity began to decrease, although he continued to write articles and lecture. He was a member of the Cleveland Rowfant Club.

notable for the tradition of serving tea promptly at four o'clock every afternoon.

While Chesnutt's first stories were being published, a new chronicle of literature and fine arts appeared in Cleveland. A weekly review called *Cleveland Town Topics* made its debut in December 1887. Colonel Felix Rosenberg was editor and T. J. Rose the business manager for the magazine, which covered social and cultural events in Cleveland for over forty

years. The original editions were billed as "A Weekly Review of Society, Art, and Literature."

Meanwhile, theater in Cleveland had been energized when Augustus "Gus" Hartz arrived in 1880. Hartz was born in Liverpool, England, trained as a magician from the age of eight, and came to the United States in 1863 at the age of twenty. After nearly twenty years of traveling and performing, he settled in Cleveland, where he became manager of the newly constructed Park Theater, part of the three-story Wick Block on the northwest corner of Public Square. The first production at the Park was Richard Sheridan's classic *The School for Scandal*, a favorite with Cleveland audiences; the Cleveland Theater had opened with Sheridan's convoluted comedy in 1851.

The Park Theater was destroyed by fire less than a year later. By the time it reopened in 1886, Hartz had already joined the staff of the Euclid Avenue Opera House (see Fig. 23). The rebuilt Park Theater hired "Uncle John" Ellsler to try his hand at management. During the 1886/87 season, the finest opera companies in the country and personalities such

FIGURE 23. Augustus Hartz, manager of the Euclid Avenue Opera House. Courtesy of the Western Reserve Historical Society.

AUGUSTUS "GUS" HARTZ (Sept. 8, 1843–May 22, 1929) was one of Cleveland's best-known theatrical figures. Arriving in the U.S. from Liverpool, England, Hartz settled in Cleveland in 1880. He managed the Park Theater from 1883 until it was destroyed by fire the following year. He then joined the Euclid Avenue Opera House, serving as both manager and lessee from 1884 to 1920. Under Hartz's management, the Opera House flourished as Cleveland's favorite playhouse.

as Lilian Olcot, Francesca Janauschek, and Robert Mantell appeared on the Park's stage. Regrettably, however, Ellsler proved to be no better a manager for the Park than he had for the Euclid Avenue Opera House. After a disastrous season under Ellsler, the Park Theater closed again. It reopened in 1889 as the Lyceum Theater, where Clevelanders thrilled to the likes of the Kendalls, the mighty Sarah Bernhardt, Lillian Russell, and Mrs. John Drew.

Hartz was more skilled at management than Ellsler and had more success with making the Euclid Avenue Opera House a paying concern. Under his administration from 1884 until 1920, the Opera House became the most popular playhouse in Cleveland, its dominance fading only when larger, more up-to-date theaters were built in the 1920s. Ultimately the Hanna Theater would replace the Opera House as the home for what would come to be known as legitimate theater (as opposed to vaudeville and nickelodeons).

The Euclid Avenue Opera House booked a surefire money-maker in the combined appearance of Edwin Booth and Madame Modjeska, the leading Shakespearean performers of the decade, for seven days in late September 1889. Cleveland and Pittsburgh were the only two venues for the pair outside of New York. With audiences who appreciated great talent, Cleveland could command the finest performers in the nation, and indeed the world. Actors and actresses of the stature of Ethel Barrymore, John Drew, Sarah Bernhardt, and Richard Mansfield drew record crowds at the Opera House.

Ellsler had already proved that the city could support a stock company, and small opera companies were well received. Clevelanders were conservative in their tastes for legitimate theater, however, preferring their plays and players well tested. Ibsen was not seen by a local audience until 1895, when Minnie Maddern Fiske appeared at the Lyceum in *A Doll's House*—sixteen years after Nora's exit first shocked the complacent bourgeoisie of Europe. "There is no poetry in the characters represented in 'A Doll's House'; they are every-day folks who move about in every-day clothes and discuss every-day happenings just like people we all know," reported the *Cleveland World*. Not until the following century would local acting companies challenge audiences with more progressive works.

In 1890 Cleveland's population was 261,353, ranking tenth in the United States; Cincinnati was eighth. The number had grown more than 600 percent since 1860. Moses Cleaveland and the early settlers would hardly have recognized their tiny settlement in the large industrial metropolis. Cleveland led the way in shipbuilding for cities on the Great Lakes and was one of the most powerful in the nation in terms of manufacturing.

One of the most influential events of the 1890s for Cleve-

land and many cities in the Midwest was the World's Columbian Exposition in Chicago in 1893. The Exposition was the largest and most elaborate of the world's fairs held during the nineteenth century, and Clevelanders flocked to behold the wonders exhibited there, as well as to hear the Cleveland Vocal Society perform and win first prize in the World Choral Competition.

Visitors to the World's Columbian Exposition marveled at the white neoclassical buildings flanking the great central basin and canals. The entire design was coherent, harmonious, at once both beautiful and magnificent. Members of Cleveland's City Council and Chamber of Commerce, as well as architects and painters and simple citizens, made the trip to Chicago and were impressed with the result of Daniel Burnham's grand plan, impermanent though it was. They returned to Cleveland inspired.

By the 1890s, Cleveland was in need of a new court house, city hall, and federal building, not to mention a railroad station capable of handling the influx of new residents and visitors. The city was growing; it needed a larger library, more auditorium space, a Board of Education building, and perhaps a music hall. Prominent Clevelanders dreamed of creating a permanent array of majestic public buildings on Cleveland's lakeshore, based on what they had seen in Chicago. The seed for Cleveland's great Group Plan of 1903 was planted in 1893, but it needed time, money, a friendly administration, and powerful friends to grow to fruition.

The nineties were a busy decade. New supportive arts organizations, societies, and clubs seemed to spring up overnight. In 1890 a group of men formed the YMCA Choir, which later evolved into the popular Singers Club. The two founders, Homer B. Hatch and Carroll B. Ellinwood, wanted a club devoted to singers and songs "better than those of the barbershop and corner-saloon variety" (see Fig. 24).

The Cleveland Sorosis Society was founded in 1891. The philosophy of this women's association stated that females could change and improve their place in society if they all worked together. Their mandate was to "bring together women engaged in literary, artistic, scientific, and philanthropic pursuits." The Sorosis was actually more a group of societies bound under one name. Each of the various committees and subcommittees would pursue its own interests—scientific, philanthropic, artistic—and then report to the combined members. The name of the society is a clever bit of wordplay which reflected the association's administrative setup. Sorosis, in botanical terms, refers to a fruit which develops from a collection of flowers, like a pineapple or a mulberry. The common bond for the society was the improvement and general welfare of women.

Men were not without their own clubs. The Rowfant Club, founded in 1892, brought together businessmen and

FIGURE 24. The Singers Club of Cleveland, an
all-male chorus founded in 1891, ca. 1964.
Courtesy of the Cleveland Public Library.

The **SINGERS CLUB**, an all-male chorus, was
begun in 1891 by Homer B. Hatch and Carroll B.
Ellinwood. The club rehearsed at Central YMCA,
where it offered informal Sunday afternoon
programs to the public in exchange for the use of
the space. In 1893 the organization became
known as the Singers Club of Cleveland, making
its formal debut in 1894 at the chapel of the First
Baptist Church, conducted by Ellinwood. Over the
years the group has had many well-known
conductors, including Beryl Rubinstein, Boris
Goldovsky, Frank Hruby (V), and Thomas J.
Shellhammer.

professionals whose common interests lay primarily in the
collecting of rare books, prints, and examples of the book-
maker's art. The Rowfant Club had rather less effect on Cleve-
land than might be expected because of its exclusiveness—its
male members were chosen by invitation only; it was (and is)
similar in type and purpose to the Grolier Club in New York.
Its existence demonstrated a growing interest in art and col-
lecting among a small group of intellectuals and businessmen.

Of more recognizable and lasting influence on the com-
munity was the formal incorporation of the Western Reserve
Historical Society in 1892 (organized in 1867). The incorpora-
tors consisted of a number of leading citizens: Henry C. Ran-
ney, Amos Townsend, D. W. Manchester, William Bingham,
Charles C. Baldwin, David C. Baldwin, Percy W. Rice,
James D. Cleveland, and A. T. Brewer. The resolve to form a

historical society in any given community usually does not occur until there is a general recognition among its citizens that something has been accomplished that needs to be remembered. Cleveland had arrived at the decade of its centennial, and members of society began to reflect on where the city had been and where it was going. The celebration of the centennial may well have been a major catalyst for the changes that occurred in the city in the coming decades.

Cleveland's artists and performers seemed to have unconsciously chosen this decade to promote their worth. The Cleveland Art Club held a reception at the Hollenden Hotel on July 3, 1893, to honor Cleveland's own prima donna, Mademoiselle Rita Elandi (see Fig. 25). Elandi, who had been born and raised in Cleveland with the less romantic name of Amelia Groll, had changed her name when she decided on an operatic career. The name Elandi was rumored to be an italianate form of "Cleveland."

Cleveland's first lady of the opera was home for a performance at the Twenty-seventh Saengerfest, being held the second week in July in a temporary concert hall built for the

FIGURE 25. Operatic soprano Rita Elandi, ca. 1898. Elandi, born Amelia Groll, was an internationally known operatic soprano who came from Cleveland. She appeared before Queen Victoria in England and Emperor Wilhelm in Berlin. Courtesy of the Western Reserve Historical Society.

occasion. It provided an opportunity for Elandi to be reunited with her old acquaintance Emil Ring, conductor of Cleveland's Philharmonic Orchestra. An appearance of John Philip Sousa's band also attracted large crowds, and N. Coe Stewart, Cleveland's popular music educator, brought forward an astonishing group of 4,000 schoolchildren who sang a section of *The Creation* for the occasion.

Though the United States was suffering a nationwide depression in 1893, it proved to be a banner year for the fine arts. In addition to the Saengerfest, the Cleveland Vocal Society's success at the World's Columbian Exposition, and the triumphant return of Rita Elandi, Cleveland hosted the first of two extremely successful Art Loan Exhibitions for Cleveland's needy.

Like their forerunner in 1878, the exhibitions had the twofold purpose of raising money for the poor and stimulating interest and raising standards in the visual arts. A Loan Association, formed and headed by Charles F. Olney, appealed for artworks to collectors all over the country. The result was an exhibition in Cleveland's Garfield Building of 200 works from across the United States, and from Cleveland collectors as well. Schoolchildren were taken through and asked to write compositions about works of art, thus adding an extra educational component to the exposition.

A second and larger display was held the following year, 1894, again at the Garfield Building. The list of donors for this exhibition included the names of many of Cleveland's most prominent families: Brush, White, Holden, Huntington, Hanna, Wade, and Chisholm. Publicity for the second show announced that viewers would see works by Claude Lorrain, Paolo Veronese, Albrecht Dürer, Tintoretto, and even Leonardo da Vinci. Along with these great works of art there were displays of textiles, fans, relics, and curios—all to be seen for a single quarter (or five dollars for a season ticket). The growing popularity of local artists was demonstrated by the display of works by Archibald Willard, Max Bohm, and Frederick Gottwald.

In response to the popularity of the first Art Loan Exhibition, Charles Olney and his wife opened the Olney Art Gallery in 1893 (see Fig. 26). At the preview prior to the opening, Cleveland's art enthusiasts viewed more than 200 oil paintings, watercolors, sculptures, ceramics, and miscellaneous objets d'art. The Olney Art Gallery was Cleveland's premier gallery until Charles Olney's death in 1907, meeting a need in Cleveland not to be satisfied again until the Cleveland Museum of Art opened in 1916.

Olney was much more than just an early supporter of the visual arts in Cleveland. He was also a proponent for the grand ideas for city planning that resulted from the popularity of the World's Columbian Exposition. In 1895, two years after the Exposition, Olney served as a judge for a competition

FIGURE 26. The Olney Gallery, Cleveland's first art gallery, was located on W. 14th Street. Courtesy of the Western Reserve Historical Society.

sponsored by the Cleveland Architectural Club (which had been founded only the year before) to prepare plans for the "grouping of Cleveland's Public Buildings."

Olney became so interested in the "group plan" project that in 1898 he served as a judge for a second competition. The efforts of Olney and his compatriots met with success on January 17, 1899, when the Chamber of Commerce officially adopted a resolution appointing a Grouping Plan Committee and a consultative body to study the practicalities of such a plan. The resolution had been introduced by Charles Olney. For Olney, the visual appearance of the city was as important and crucial to the development of Cleveland as were the cultural tastes of its citizens.

It was also in 1893 that artists from the City Hall Colony founded the Brush and Palette Club and elected as their first president the grand old man of Cleveland painting, Archibald

The **OLNEY ART GALLERY** was a private art gallery located on Jennings Avenue (W. 14th Street), established in 1893 by Charles Fayette Olney and his wife, Edna. Encouraged by the success of the Art Loan Exhibitions earlier that year, the Olneys saw that Cleveland needed an art gallery. Operating out of a long, narrow brick-and-stone building, their gallery housed over 200 objects, including oil and watercolor paintings, porcelains, and statuary. After the Olney Gallery closed in 1907, the bulk of the collection was donated to Oberlin College.

FIGURE 27. The Cleveland Camera Club (est. 1887), ca. late 1880s. The club's members were advocates of the leisure aspect of photography. Incorporated in 1920 as the Cleveland Photographic Society, it continued to offer classes in photographic technique into the 1990s. Courtesy of the Western Reserve Historical Society.

Willard. They held annual shows beginning in 1894 to display the works of Cleveland artists. At about the same time the Camera Club (see Fig. 27) and the Cleveland Water Color Society were founded, each focusing rather more specifically on particular branches of the visual arts, but adding to the general sense of growth and vitality which had previously been lacking in the visual-arts community.

Cleveland's music aficionados were not far behind in their support groups. Dedicated to "further[ing] the interests of music in Cleveland," the Fortnightly Musical Club held its first meeting at the home of its founder, Mrs. Curtis Webster, in 1894. The club's executive board set a membership quota of 500 enthusiasts, which was quickly filled, and a long waiting list formed. Functioning as a concert agency for its first quarter-century, the Fortnightly Musical Club was responsible for bringing to Cleveland most of the ensembles and performers that played to the city's receptive musical audiences.

One of the charter members of the group was Adella Prentiss (after her marriage in 1904 she became Adella Prentiss Hughes). Prentiss had been born in Cleveland, and she returned in 1891, after graduating from Vassar College with a music degree and making a tour of Europe's music capitals. She became a professional accompanist and soon was enthusi-

astically cheerleading musical endeavors in Cleveland. She took charge of the Fortnightly's public concerts after the third season, and under her care the club became famous for its well-managed concert seasons. By the end of the decade she had embraced the role of Cleveland's premier music impresario, bringing orchestras and performers of high quality to Cleveland. Hughes was responsible for bringing groups such as the Diaghilev Ballets Russes and the Metropolitan Opera to Cleveland audiences, in addition to orchestras conducted by Arturo Toscanini, Gustav Mahler, Walter Damrosch, Frederick Stock, Richard Strauss, Karl Muck, and many others.

There was an attempt in 1895 to found an orchestra, and the group even adopted the name of the Cleveland Orchestra. It premiered in Cleveland on June 14 with Max Droge as director and Charles Sonntam as concertmaster. Grays Armory was the home to the new institution for its Sunday afternoon concerts in the wintertime. The members of the new orchestra hoped to be able to provide Cleveland with continuous quality musical performances in the same way Pittsburgh's and Cincinnati's orchestras were doing for their communities.

Cleveland's centennial was fast approaching, and in anticipation of the event, a competition to design a symbol for the city had been announced on Founder's Day, July 22, 1895, with Archibald Willard named as committee chairman. Julian Ralph of *Harper's Monthly* suggested a municipal flag be created, and centennial fever got underway. Three months later Susie Hepburn, an eighteen-year-old graduate of the Cleveland School of Art, received the first prize of fifty dollars awarded by the *Plain Dealer*. In addition to providing the winning design (a shield containing symbols representative of the city's manufacturing and marine interests), Hepburn could claim as ancestors Seth Pease of the original survey party and her great-grandfather Morris Hepburn, a member of Cleveland's first city council.

A final musical endeavor of the 1890s which deserves mention is the Rubinstein Club, a local women's chorus which was organized in 1899 and led by Mrs. Royce Day Fry. Like Adella Prentiss Hughes, Mrs. Fry had been trained in music in the East, having studied conducting and voice performance with Carl Zerrahn in Boston. The first presentation of the sixteen-member Rubinstein Club was a musical evening held at Plymouth Church in May 1899. The role of conductor was taken over in 1905 by James H. Rogers (see Fig. 28), who had served as organizer and choirmaster of the group, and more classical arrangements were added to the group's repertoire.

The decade of the 1890s had been one of organization and celebration. Cleveland's artists and arts organizations were ready to enter the twentieth century with a determina-

FIGURE 28. James H. Rogers, noted Cleveland composer. Courtesy of the Western Reserve Historical Society.

JAMES HOTCHKISS ROGERS (Feb. 7, 1857–Nov. 28, 1940) was a composer, music critic, organist, and teacher born in Fair Haven, Connecticut. After extended study in Europe, he moved to Cleveland in 1883. Organist at the Euclid Avenue Temple until he retired in 1932, Rogers also worked as music critic for the *Plain Dealer* from 1915 to 1932. He wrote more than 50 compositions for the organ, 5 cantatas, more than 130 songs, and instruction books for both piano and organ.

tion to make the city more responsive to all the fine arts, and, more important, to make Cleveland a cultural center of the United States.

Institutions for a New Century

The Founding of Cleveland's Great Cultural Organizations

Any discussion of Cleveland at the beginning of the twentieth century usually points to the city's new status as the seventh-largest city in the nation and the fact that Cleveland had, at long last, surpassed the Queen City, Cincinnati, in terms of population. Clevelanders were jubilant and determined to keep right on climbing.

In shipping and manufacturing, Clevelanders certainly had a right to cheer, but in the fine arts the city had been slow off the mark. As the twentieth century began, Cleveland stood sheepishly by the sidelines with no art museum, and no symphony orchestra of professional caliber. Clevelanders watched cities such as Detroit, Cincinnati, Chicago, and Pittsburgh surpass them in establishing fine-arts institutions.

Cleveland was not a literary center, nor an art center, nor a city known for its fine local theater. Cleveland was known, however, for its library and well-read citizens, and for the money it had to bring in the finest professional performers. It gave back to these performers a rare commodity in the nineteenth century, a cultivated, educated, and responsive audience.

Cleveland had a growing reputation during the first decade of the twentieth century as a place where things happened. Clevelanders had elected the often controversial Tom L. Johnson as mayor in 1901. From his election until his death in 1911, Johnson was one of the key figures of the

American Progressive Era. He had started out as a good old-fashioned capitalist, but, after reading Henry George's *Progress and Poverty*, he joined the reform movement. Lincoln Steffens, the noted muckraker and author of *The Shame of the Cities*, called Johnson "the best mayor of the best governed city in America."

An important feature of the Johnson mayoralty was the city's formal adoption of the Group Plan for public buildings. The Chamber of Commerce had passed a resolution in 1899 to support such a plan and had even submitted a plan financed by that body. However, Mayor Johnson and his advisors decided that if Cleveland was going to pursue such a goal, they needed the finest planners in the country. In 1902 the governor of Ohio, George K. Nash, formally appointed Daniel H. Burnham, John M. Carrere, and Arnold R. Brunner as the Group Plan Committee for the City of Cleveland.

On August 17, 1903, the three men presented to the mayor and the Chamber of Commerce a grand plan for Cleveland which eliminated the unsightly jumble of buildings northeast of Public Square and created a beautifully landscaped greensward reaching to the lakeshore, surrounded by neoclassical public buildings. The Cleveland Mall was intended as a civic center for the people of Cleveland, where they could transact their business or simply content themselves with a walk through a wooded park in the center of the city. The landscaped section was to be twice the width of Paris's famous Champs Élysées.

Burnham, Brunner, and Carrere brought a new vision of the city to Clevelanders, and for the next thirty years their plan brought the most promising architects, artists, and designers to the city. By re-creating the downtown area in a manner only dreamt of by most city governments, Cleveland rapidly became the model for city planning for the United States.

The positive attitude toward change which can be directly attributed to the Group Plan is illustrated by a painting found today in Cleveland's Federal Building, a twentieth-century romantic allegory by artist William H. Low entitled *The City of Cleveland, Supported by Federal Power, Welcomes the Arts Bearing the Plan for the New Civic Center*. Three striking women personify the different agencies at work in the city. A magnificent, statuesque brunette seated on a heavy granite throne by Lake Erie is the personification of the City of Cleveland. Her throne is decorated with the seals of Cleveland and Ohio. Resting beside her is another beauty, this one representing Federal Power. She holds a sheathed sword (symbolizing the latent strength of the federal government) and an oak branch (symbolizing wisdom). The seated pair welcome a third woman, personifying the Arts, who has just arrived at the

pier in a gondola decorated with the Great Seal of the United States. In her left hand, just slightly unfurled, the Arts bears a replica of the presentation drawing of Cleveland's Group Plan.

Low painted the work for the new Federal Building in 1910, seven years after the Group Plan had first been introduced, yet before any other building in the plan had been completed. Clevelanders had the patience to work steadily to see their visions realized, not only with the Group Plan but in the organization of their fine-arts institutions as well. Patience and determination are the representative characteristics of the men and women who worked throughout the first two decades of the twentieth century to see institutions such as the Cleveland Museum of Art and the Cleveland Orchestra become a vital part of the community. Like the Group Plan, Cleveland's fine-arts institutions did not appear overnight.

Between 1900 and 1920, all the areas of the fine arts in Cleveland were to undergo radical changes. In that short time the musical, theatrical, and art institutions for which Cleveland is best known were founded: the Music School Settlement (1912), the Cleveland Museum of Art (inc. 1913, opened to the public in 1916), the Playhouse Settlement (1915; known today as Karamu House), the Cleveland Play House (1915), the Cleveland Orchestra (1918), and the Cleveland School of Music (1920; later the Cleveland Institute of Music). The Cleveland School of Art deserves addition to this list as well; though founded in 1882, it benefited from the cultural growth of the early twentieth century as much as the newer institutions.

Thus, the story of Cleveland's cultural life from 1900 to 1920 is actually an anthology—a rich tapestry composed of the individual stories of each of these institutions. A common thread of each story is the importance given to educational purposes. The trustees of these institutions, many of whom served on more than one board, understood that unless coming generations, as well as the general public, were educated to understand the importance of music, art, and theater in civilization, the new institutions being formed in the city were simply self-serving entities.

In retrospect, the development of cultural life in Cleveland can be seen as a sign of the increasing urban maturity of the city. Institutions incorporated during the Progressive Era in Cleveland, such as the museum and the orchestra, were redeemed from being viewed as mere playgrounds for the wealthy. Facilities such as Karamu House and the Music School Settlement were products of an enlightened attitude toward the poor and less fortunate that epitomized the social reforms sweeping the nation's major cities in the late nineteenth and early twentieth centuries.

The Cleveland Music School Settlement

The Cleveland Music School Settlement was ultimately inspired by the settlement movement begun in London in the 1880s. By 1912, when the Music School Settlement was founded, there were already a number of settlement houses in the city. Three of the most prominent were Hiram House (1896) on Orange Avenue, Goodrich House (1897) on Bond St. (E. 6th) at St. Clair, and Alta House (1900) in Cleveland's Little Italy district. Each had been opened to respond to the specific needs of the neighboring communities—Italian immigrants in Little Italy, Germans and Irish in the area served by Goodrich House, and an Eastern European community near the Orange Avenue settlement home.

The Cleveland Music School Settlement was the brainchild of a remarkable teacher named Almeda Adams (see Fig. 29). Blind from the age of six months, Adams studied music at the State School for the Blind in Columbus, Ohio, and later she earned a two-year scholarship to the New England

FIGURE 29. Almeda Adams, founder of the Cleveland Music School Settlement, ca. 1949. Courtesy of the *Cleveland Plain Dealer*.

The **CLEVELAND MUSIC SCHOOL SETTLEMENT**, designed to provide inexpensive (or free) musical training to interested students, opened in 1912 with 50 pupils. It was founded by Almeda Adams, a music teacher blind since birth, with the help of Adella Prentiss Hughes and initial funding of $1,000 procured from the Fortnightly Musical Club. The school was funded by private donations until 1919, when it became a charter member of the Welfare Federation. The Music School Settlement has had many expansions. The main operation, originally located in the Goodrich Settlement House, moved to its present site, the former mansion of Edmund S. Burke located on Magnolia Drive, in 1938. In 1958 a branch was opened in the West Side Community House; in 1969 a south-side branch on Harvard Road was opened. In 1970 the settlement merged with the Koch School of Music in Rocky River, and in 1980 a branch opened at the former home of the Hruby Conservatory of Music on Broadway Avenue.

Conservatory of Music, through a determined campaign selling magazine subscriptions to *The Ladies' Home Journal*. Adams left the conservatory to teach music in Nebraska, where she remained for five years, at Lincoln Normal University and at the Nebraska School for the Blind in Nebraska City.

Adams quit teaching and left Nebraska in 1900 to study voice in New York City. A year later she returned to Ohio to help care for her family after her mother in Cleveland was injured in an accident. In Cleveland, Adams became acquainted with the work being done at local settlement houses and added her skills to the cause, directing choral classes and teaching voice to individual students at the Central Friendly Inn, Alta House, and Hiram House.

Sometime between 1901 and 1911, Almeda Adams's father read her a long article about a settlement house in New York City devoted entirely to teaching music. Aware of his daughter's unlimited energies, he encouraged her to devote her talents to creating a similar settlement for Cleveland. Adams traveled to New York City and visited the school discussed in the article. When she returned to Cleveland, she approached Adella Prentiss Hughes, Cleveland's foremost music promoter, with her idea.

Hughes brought Adams's proposition to the attention of fellow members of the Fortnightly Musical Club. The response was favorable, and Adams was invited to speak to the group about the project at a special meeting on February 7, 1912. Mayor Newton D. Baker presided over the meeting, held at the home of Mariette Huntington. Almeda Adams spoke of her desire to teach music to children and adults who would not be able to afford lessons under normal circumstances, and a resolution was passed to help her in the formation of the settlement house. Just two short months later, on April 25, the Cleveland Music School Settlement was officially incorporated.

The first board of trustees included Newton D. Baker, Mrs. Dudley S. Blossom, Mrs. L. Dean Holden, Mrs. John Huntington, Frank B. Meade, Francis F. Prentiss, Mrs. Ralph Silver, and Mrs. Andrew Squire, giving Adams the support of some of the most powerful and socially active citizens in town. The school was financially supported by a membership of subscribers, and additional funding was earned by giving benefit concerts and through a special Christmas caroling program. Categories of membership were established, with the founder's level set at a donation of $1,000. The Fortnightly Musical Club became the settlement's first founder.

Rooms were engaged for the new venture in Goodrich House, and the founding faculty was hired, with Almeda Adams, of course, as head of the vocal music department. Walter Logan was named head of the violin department, and Mrs. Gertrude Kemmerling led the piano department.

On October 1, the school opened with 50 applicants. This number had increased to 130 by the end of the month; 111

FIGURE 30. Children's music class at the
Cleveland Music School Settlement, ca. 1930.
Courtesy of the Cleveland Music School
Settlement.

students were finally accepted. Six months later school
records indicated the faculty had offered 780 lessons in voice,
violin, cello, cornet, and piano. In addition to practical classes,
the settlement offered its students courses in music history,
sight reading, and harmony. With the help of some of Cleve-
land's first citizens, Almeda Adams had succeeded in her
dream to bring music and music education to the underprivi-
leged of Cleveland (see Fig. 30).

The Cleveland Museum of Art

Considering the legal hurdles that had to be sur-
mounted, it is remarkable that the Cleveland Museum of Art
ever opened its doors to the public. As it was, they opened

relatively late compared to the rest of the nation. Of the famous early institutions still in existence today, the Metropolitan Museum of Art was founded in the late 1860s, the Boston Museum of Fine Arts was incorporated in 1870, and the Art Institute of Chicago was founded in 1879. Closer to Cleveland, Cincinnati had a small public collection as early as 1818, and the Detroit Institute of Art was founded as a result of a loan exhibition held there in the 1880s.

Many of these earlier museums, however, began their existences as repositories for all manner of objects, including—in most cases—collections of plaster replicas of famous works and reproductions of paintings. The 1880s and 1890s saw institutions such as the Boston Museum of Fine Arts and the Art Institute of Chicago making the difficult transition from serving as repositories of copies for the educational edification of the community to becoming collectors of original works of art. By the time the Cleveland Museum of Art opened to the public in 1916, audiences expected to see original art. The stature of the Cleveland Museum today in the art world is due, in part, to its late arrival on the scene, as well as to extraordinary benefactors, a professional and qualified staff of museum workers rather than dilettantes, and the decision to acquire only first-class artworks.

The city, the lawyers, and the boards of trustees for the Huntington, Hurlbut, and Kelley bequests spent more than twenty years resolving the complex tangle of legal issues involved in combining terms specified under three different wills into one institution. That there is a museum at all today is due primarily to William B. Sanders and Henry C. Ranney. Sanders was a founding partner with the prominent legal firm of Squire, Sanders, and Dempsey, as well as a trustee for the Huntington and Kelley estates. Ranney, also a powerful attorney, was a trustee for all three trusts.

The partisans for a museum schemed and cajoled, maneuvered and manipulated the parties concerned until, in 1913, the museum was officially incorporated. Though it had proved impossible to legally unite, or rather consolidate, the Huntington and Kelley trusts, both boards agreed to work "as a unit" for the good of the institution. The Hurlbut trust had ceased to be an issue when it was determined that there were not enough funds remaining after the passage of years to fulfill his wishes. What funds remained were earmarked for acquisitions.

Another difficulty in actually building the museum was the problem of location. Horace Kelley's will had left funds which were to be used for the purchase of a site; however, in 1892, Jeptha Wade, Jr., had donated land in Wade Park for an art museum. Certainly the donated land seemed the logical and economical place to put the new gallery, but there were strong objections to the Wade Park site. Reform-minded members of Mayor Tom L. Johnson's staff were opposed to locating

the gallery so far from the center of town. Particularly with the enthusiasm raging in the city over the Group Plan, a downtown site for the city's gallery seemed more democratic and in keeping with the grand new design. Many feared that access to the museum would be limited for most citizens by locating it in the elite Wade Park neighborhood. Thus, though a building committee was established as early as 1905, no actual work would get underway on the physical structure of the museum until after Johnson left office in 1909.

The board of trustees in 1913, at the time of incorporation, was an impressive list of Cleveland's most powerful businessmen and philanthropists: Dudley P. Allen, Charles W. Bingham, Mariette Huntington (John Huntington's widow), Hermon A. Kelley, John H. Lowman, Samuel Mather, Charles L. Murfey, David Z. Norton, Edwin R. Perkins, William B. Sanders, Jeptha H. Wade, and George H. Worthington.

Members of the various trusts, the board of trustees, and the Building Committee had also seen to it that the museum would start off equipped with the finest possible facilities. Toward that end they hired Edmund M. Wheelwright as a consultant. Wheelwright had been a planner for the Boston Museum of Fine Arts, and he prepared a report for Cleveland on the particular problems facing museums in terms of heating, lighting (always important for an art museum), and ventilation systems.

Once the building was underway, the board turned its attention to hiring the director for the new institution—an important decision, as the first director would establish the philosophy of the collection. The board offered the job to Henry Watson Kent, a Bostonian on the staff of the Metropolitan Museum of Art, whose interests in education and administration seemed to echo the interests of the board members. Kent declined the job, preferring to stay in New York City, and suggested instead that Cleveland hire Frederic Allen Whiting (see Fig. 31).

Whiting was neither an artist nor an art historian. He held no academic degrees apart from an honorary Master of Arts degree he would receive from Kenyon College in 1920. Whiting was a social worker and reformer. Before coming to Cleveland he had held many jobs. He had worked with the impoverished textile employees in Lowell, Massachusetts. His interests led him to work not only with adults but also with the children of the community. Because of his work in Lowell, Whiting developed a strong sense of the role the skilled craftsman would play in an increasingly industrialized society.

Whiting moved on to Boston, where he became an advocate for the Society of Arts and Crafts, organized the National League of Handicraft Societies, and published a journal called *Handicraft*. In 1904 he was in charge of the handicrafts exhibit at the Louisiana Purchase Exposition in St. Louis. Whiting was perfect for Cleveland. Familiar and comfortable with han-

FIGURE 31. Frederic Allen Whiting, first director of the Cleveland Museum of Art, ca. 1920. Courtesy of the Archives of the Cleveland Museum of Art.

dling artworks, he knew how they ought to be displayed to best advantage; most important, he saw a museum as a service institution for a community.

When he came to Cleveland, there was no museum—just an office on Euclid Avenue. As soon as he arrived, however, he began promoting the museum. One of the first *Museum Bulletins*, dating from before there was a collection to speak of, includes the following notice:

> Public interest in the possibilities and scope of the Museum must be aroused throughout the city. . . . The plans and needs of the Museum should become a constant theme of discussion among the art-loving people of Cleveland and vicinity in order that the whole community may be prepared to welcome the day in the near future when the doors of the Museum will be thrown open to the public. The Director is prepared to talk before clubs and other organizations on the need of an Art Museum in the Community, either with or without stereopticon slides.

Whiting was first and foremost an educator who came to Cleveland believing that the museum could act as a social

force in the city. Cleveland was an industrial town; therefore, the museum could be used, via the permanent collection, to educate workers and manufacturers on the principles of aesthetics and good design. The museum was not a static vault for treasures; rather, the objects therein were meant to teach and improve the viewer. Whiting announced plans as early as 1914 to develop an exceptional collection of textiles, prints, metalwork, and furniture to aid the craftsmen of the city.

Whiting was aided in his endeavors by the enlightened attitudes of the museum's board of trustees, particularly Dudley P. Allen, who gave both moral and financial support to Whiting's emphasis on the educational component of the museum. Whiting wanted the Cleveland museum to offer lectures and classes for both adults and children. He believed it was absolutely necessary for the institution to establish working relationships with the schools, colleges, and universities in the vicinity of Cleveland so they could benefit from the collection. Before the museum ever opened its doors, its Extensions Division was at work providing small displays for libraries and schools, as well as lectures by request, under the guidance of Mrs. Emily Gibson.

After the museum opened, the Cleveland schools helped to support it by appointing a teacher whose work schedule was divided between visiting schools to talk about art and the museum (often using lantern slides and small exhibits), and actually touring students through the collection. The museum even provided a classroom, equipment (presumably drawing and sculpting materials), and services for the use of schools (see Fig. 32).

Among Whiting's many innovative plans for the museum were suggestions for the support of Ohio artists and craftsmen through an annual juried exhibition of their work and the purchase of exceptional examples for the museum. This would become a reality in 1919, when the museum sponsored the first Annual Exhibition of Cleveland Artists and Craftsmen, thus inaugurating the famous May Show. Whiting also wanted to see musical programs and music education classes as a part of the museum's permanent program. Cleveland's art museum was to be dedicated to all forms of art, not just the visual arts.

Two extremely important decisions were made with regard to the collection in the first years after incorporation. The first was to devote as much room as possible to showing the permanent collection. Objects in storage represented lost opportunities for learning; acquisitions were meant to be seen, not hidden away for protection. The second mandate was that only first-class objects be acquired. Whiting understood the ultimate benefit of quality over quantity in the creation of a permanent collection.

The Cleveland Museum of Art opened to the public in 1916. A Cleveland architectural firm, Hubbell and Benes, had

FIGURE 32. Frederic Allen Whiting with a group of University School students in the Armor and Tapestry Court on the Museum's opening day, June 7, 1916. Courtesy of the Cleveland Press Collection, Cleveland State University.

FIGURE 33. Students from the Murray Hill School attend a class at the Cleveland Museum of Art, ca. 1929. Courtesy of the Cleveland Museum of Art.

The **CLEVELAND MUSEUM OF ART** has been known for its vigorous support of the education of children in regard to the arts. Besides presenting educational programs and classes in the museum itself, the CMA, through the use of extension exhibitions, has traveled to local schools and libraries in an effort to bring aesthetic awareness to the population as a whole.

designed and constructed a magnificent 300 × 120-foot building faced with white Georgian marble. Like many museums built in the United States during the first part of this century, it was a neoclassical structure. The central facade of the new museum was modeled after the entrance to a Greek temple, thus ideologically identifying the museum as a "temple" for the arts. The exterior was impressive, but not nearly as impressive as the events going on within the institution during the first five years of its existence.

In 1917 a "Children's Museum" opened within the museum, where children could come and draw, or hear lectures or see exhibitions specially prepared for them. They had access to a collection of photographs and reproductions of works of art which they could look at and draw. Whiting fought continuously during his entire career in Cleveland for the construction of an actual children's museum, separate from the Cleveland Museum of Art. At one point he even convinced Jeptha Wade to donate the land for this pet project, but he could never find a benefactor willing to finance the necessary endowment. Whiting's dream was realized in the 1980s, when the Cleveland Children's Museum opened on a site not far from where Whiting had envisioned his children's museum.

In 1918, the museum offered its first course in art appreciation to students from local colleges. Any doubts about interest in the new museum and the visual arts were soon dispelled when 506 students and 97 auditors enrolled in the course, which was taught by Henry Turner Bailey, dean of the Cleveland Art School.

One year later new departments were created at the museum, including the Oriental, Colonial, Print, and Decorative Arts departments. The latter department was under the direction of a young curator named William M. Milliken, who had been assistant curator of decorative arts at the Metropolitan Museum in New York. Milliken would succeed Whiting as director of the museum in 1930.

Whiting surrounded himself with qualified, interested, and creative staff. Louise Dunn joined the Cleveland Museum of Art in 1919, and from that year until her retirement in 1944, she was a central figure in children's art education in Cleveland. It was Dunn who began the remarkable art classes at the museum which became so popular with the children of the city. Cleveland became the first museum in the country to allow children to sketch in the main galleries, as well as in the children's room (see Fig. 33).

The first year a class was offered, it was limited to eight children recommended by their principals. In the second year word had gotten around about the classes, and there were more students available than places for them. Dunn tried to limit the number by having each student draw two pictures— one of some object in the museum, and one free drawing of

the child's choice. Those exhibiting the most talent would naturally be chosen for the classes. The solution seemed a good one until a student asked Mrs. Dunn, "What happens to the losers?" In response to the student's query, Dunn began organizing free classes for all interested students in 1922. Dunn never refused a student who showed interest, and it was she who issued the first invitation to black printmaking students from Karamu House to participate in her classes.

The sensitivity of Whiting and his staff extended to Cleveland's large immigrant population as well. A well-attended exhibition in 1919 was the "Homelands Exhibition" for foreign-born residents of the city, at which were displayed the arts and crafts of many of the native countries whose citizens had found their way to Cleveland.

Within four years of opening its doors, the Cleveland Museum of Art was establishing a reputation for quality acquisitions and quality education. Jeptha Wade (see Fig. 34) took a step toward ensuring the quality of acquisitions in 1920 by establishing a trust fund of $600,000 for purchases, which he augmented the following year with an additional $360,000. Whiting, his staff, and the board of trustees had, after a long period of waiting, begun the long process of creating a first-rate museum for the city of Cleveland.

The Playhouse Settlement

The Playhouse Settlement, or Karamu House as it is known today, did not attract as much attention in its early years as did the other institutions discussed in this chapter. Perhaps this is because many Clevelanders were slower to see the value of this type of settlement house project, which was begun with little more than the strength and determination of two white social workers, Russell and Rowena Jelliffe (see Fig. 35), and some funding from the Second Presbyterian Church.

Like the other settlement houses in Cleveland, the Playhouse Settlement was designed to aid a neighborhood community, in this case a predominantly black neighborhood in and around E. 38th Street, by providing a wide range of motivational activities to the underprivileged. The Jelliffes encouraged participation in fine-arts areas, particularly theater, as a way in which the boundaries between people of different races could be eliminated.

Russell and Rowena Jelliffe met and began dating during their freshman year at Oberlin College. As graduation approached, they went to a favorite economics professor and sought his advice on possible careers. As Rowena Jelliffe puts it, he told them to "get out the Constitution [of the United States] and read it, read it as you have never read it before."

FIGURE 34. Jeptha Homer Wade II, major contributor to the Cleveland Museum of Art. Courtesy of the Archives of the Cleveland Museum of Art.

JEPTHA HOMER WADE II (Oct. 15, 1857–Mar. 6, 1926), a financier and philanthropist, was born in Cleveland. The only son of Randall P. Wade and the grandson of Jeptha Homer Wade, Jeptha II was skilled in business and civic affairs. He served as an executive for 45 companies and trustee to many institutions, including the Cleveland Art School, the Western Reserve Historical Society, and Western Reserve University. Wade was also a leading supporter of the Cleveland Museum of Art. One of its incorporators in 1913 and then president in 1920, he made many contributions to the museum, including collections of rare lace, textiles, jewels, enamels, and paintings. Wade established a purchasing fund for the CMA which grew to over $1 million.

FIGURE 35. Russell and Rowena Jelliffe, founders of the Playhouse Settlement, later known as Karamu House. Courtesy of the Cleveland Press Collection, Cleveland State University.

RUSSELL (Nov. 19, 1891–June 7, 1980) and **ROWENA** (Mar. 23, 1892–April 5, 1992) **JELLIFFE** came to Cleveland in 1915 to establish an interracial settlement house which evolved into Karamu House. Russell was born in Mansfield, Ohio, and Rowena was born in Albion, Illinois. Both were students at Oberlin College who then entered graduate school at the University of Chicago and spent time at Chicago settlement houses. They were married in 1915 and came to Cleveland that same year, making their home on E. 38th Street alongside a playground with the intention of starting a community settlement. In 1920 theater and the arts were introduced in hopes of developing the potential of community members and creating a biracial community center. The Jelliffes received many awards for their community work, including the 1941 Charles Eisenman Civic Award and the 1944 Human Relations Award of the National Conference of Christians and Jews. They retired as directors of Karamu House in 1963.

They not only read, but they also began to research the events surrounding the drafting of the Constitution.

In the course of their research, they discovered a letter from Abigail Adams in which she encouraged her husband John to embrace an "open gate" policy with regard to American citizenship but reminded him that this policy also brought great danger. Democracy was safe only if those who entered its gates, though they be of many different ethnic or religious groups, were interested in a common cause. Democracy, to Abigail Adams, and to the Jelliffes, meant the combining and mixing of all the different cultures in society, and not a country where each culture exists in isolation from other communities.

It was the turning point in the lives of the Jelliffes, who had discovered a shared ideology. Off the pair went to the University of Chicago to get their M.A.'s and to do fieldwork with many of the social-reform agencies in that city, including Chicago Commons and Hull House. At Chicago Commons they met and were influenced by Graham Taylor, the minister and social reformer. Taylor married the two the day after they qualified for their master's degrees in 1915.

The Jelliffes had spent considerable time during the previous year doing research on American communities, hoping to find one where they might realize their dream—to create a center where people of all races could come together and share cultures and experiences in the practice of the fine arts. Cleveland seemed perfect for their plans—a large, diverse community with progressive attitudes toward government and culture. As they later stated their philosophy, as quoted in John Selby's history of Karamu, *Beyond Civil Rights*, "Now, when people work and play together with their motivation drawn from the creative areas, they inevitably respect each other, assist each other in a thousand ways, and arrive at an attitude toward their associates that far transcends the bare bones of racial equality."

Meanwhile, members of Cleveland's Second Presbyterian Church had begun to worry about the changes taking place in their neighborhood. What had been a white neighborhood in the late nineteenth century was slowly becoming the home of black families from the southern states who came to find jobs in the industries around Cleveland. As the black families moved in, the white families moved out. Saloons, pool halls, gaming houses, and cheap movie houses opened in the neighborhood to exacerbate the conditions of poverty. Particularly concerned was a member of the Men's Club of the church, Dudley P. Allen, who had also attended Oberlin College. Allen donated $5,000 to fund a study of the neighborhood. He also approached his old college, looking for an appropriate person or persons to undertake his study. He was advised to see Russell and Rowena Jelliffe, who arrived in Cleveland in June 1915.

In their report to the Men's Club, the Jelliffes identified

the major problem in the predominantly black neighborhood. The children of these working-class families were almost constantly left at loose ends. The neglect of the children resulted, of course, from other societal ills, including the parents' lack of education and the day-to-day struggle for most families just to survive. The Jelliffes decided that they had found their lives' work.

With the support of the church, they bought two houses next to the Grant Park playground and began their outreach program through contacts with the children in the neighborhood. Hoping to reach the adults through the children, Russell would sit outside and play the guitar. Music was always an icebreaker, and he would encourage the children to sing with him. Rowena had unusual gifts as a storyteller. On the third day after their arrival, they had 115 "visitors" to their home, which quickly earned the well-deserved nickname "the playground house."

This nickname was later shortened to simply the Playhouse. By the end of the first year, the Jelliffes' little community center had 425 members, only 55 of them over the age of twenty. The Jelliffes encouraged the children and teenagers to be interested in music, drawing, cooking—anything, as long as it challenged them and kept them away from the many gaming houses and saloons that were continuously springing up in the poorer neighborhoods.

The Jelliffes had chosen a difficult task for their lives' work. The couple were mistrusted by many of the black families, who considered them do-gooders and regarded them with more than a little suspicion. Many of the more prominent white families in town refused to associate with the Jelliffes because of the stand they had taken on racial harmony.

Nonetheless, the Playhouse Settlement continued to prosper. The same factors which contributed to the development of the Cleveland Play House (not to be confused with the Playhouse Settlement) influenced some of the young black people living in the E. 38th Street neighborhood. The Little Theater Movement had taken Great Britain and Europe by storm toward the end of the nineteenth century, and by the 1910s it had caught on in Cleveland. No longer was theater solely the realm of professional touring groups. Clevelanders, white and black alike, realized that they could develop their own talents in acting, directing, playwriting, costume making, and set design. Theater was a creative outlet with tremendous potential for the community.

It was in 1917 that the Playhouse first became associated with theater. In February of that year, the settlement house presented an integrated production of *Cinderella*. Cinderella, her stepmother, and one of the stepsisters were played by black children; two white girls portrayed the other stepsister and Prince Charming. The adult groups associated with the Playhouse wouldn't start performing serious theatrical pro-

ductions until almost three years later; the children in 1917 showed them that integrated theater could work.

In 1920, the Dumas Dramatic Club was started by six young black men meeting in the living room of the Jelliffe house; later the group would become the Gilpin Players, in honor of Charles Gilpin, the black actor who created the title role in Eugene O'Neill's *The Emperor Jones*. What happened in that living room was the beginning of what would become a tradition of innovative theater—innovative not only in terms of the works presented by the players, but in the very existence of the theater group. Despite the occasional setbacks caused by racial tensions, Karamu House remains a landmark fine-arts institution in the city of Cleveland, as well as in the nation. Rowena and Russell Jelliffe broke new ground and managed to cross racial barriers, not without problems, to enable children and adults alike to share in the rich variety of cultural experiences available in Cleveland in the twentieth century.

The Cleveland Play House

The idea for a resident acting company and a play house developed from a weekly discussion group held at the home of Charles S. Brooks, who had recently quit business to pursue writing, and who later became the Play House's first president (see Fig. 36). The formal Play House Company was incorporated in 1916 for the purpose of establishing an "art theater" of the type found on the European continent in such cosmopolitan centers as Paris, Berlin, and Moscow. Art theaters produced avant-garde plays of European modernist playwrights such as Anton Chekhov, George Bernard Shaw, and Luigi Pirandello.

In some ways, therefore, the Cleveland Play House was at the cutting edge of fine-arts institutions founded during these decades. Producing socially relevant and often disturbing theatrical presentations was a far cry from the more traditional ideas of a settlement house, art museum, or orchestra.

Walter Flory, one of the founders of the Cleveland Play House and president of the board of trustees, once wrote about the "mission" of the Play House. In words which might well have been those of Russell and Rowena Jelliffe, Frederic Allen Whiting, Almeda Adams, or Adella Prentiss Hughes, Flory wrote,

> Let us first recognize that The Play House does not belong
> to you or me, or even to all of us as a group. IT BELONGS TO
> THE COMMUNITY. It was dedicated at birth to this great,
> striving, thriving, struggling, multifarious, cosmopolitan city.
> We are merely its trustees and guardians—not its owners. We
> must go into every nook and cranny, into the churches and the

FIGURE 36. Charles S. Brooks, founding member of the Cleveland Play House Company. Courtesy of the Cleveland Play House.

CHARLES S. BROOKS (June 25, 1878–June 29, 1934) was a founding member of the Cleveland Play House. Informal gatherings held at his house in 1916 laid the foundation for the Cleveland Play House Company. Brooks was the first president, with Raymond O'Neil as the first art director. Brooks left Cleveland in 1917 to pursue a literary career in New York. Upon his return in 1921, he was made vice-president of the Play House. He continued to serve on the Play House board of directors for the remainder of his life.

schools, the workshops and the market places, and seek those who have in them the seeds of those higher artistic aspirations which are seeking a means of expression. We must ignore creed and race and station and language and nationality. (Flory, *The Cleveland Play House*, p. 44)

The first real home for the Play House Company was the former Cedar Avenue Church on E. 73rd Street, purchased in 1917 and transformed into a relatively small, 200-seat auditorium. The theater company moved into larger quarters in 1927, when the Drury family donated land between Carnegie and Euclid Avenue near E. 86th Street for the new Play House. The new facilities included the 522-seat Drury Theater and the 160-seat Brooks Theater.

One of the interesting influences on the theater of the early decades of the twentieth century was the use of marionettes. Raymond O'Neil, drama critic for the *Cleveland Leader* and the first art director of the Play House, had studied theaters in Europe and became fascinated with the innovations in lighting, movement, and stage design he saw in little theaters there. Marionettes were used to test stage designs and lighting in miniature scale, and also as "actors" in plays. O'Neil's

mother was an invalid, and he began using marionettes to entertain her, later using them to reproduce the techniques he had seen in Great Britain. There is still in existence today a complete set of marionettes used at the Play House for Shakespeare's *A Midsummer Night's Dream*, carved from wood by Mrs. Walter (Julia) Flory, a local artist, and a number of her artist friends (see Fig. 37 and Color Plate 4).

Live actors were not ignored, of course, and early Play House productions included *Everyman* and *Sakuntala* from the medieval and Asian theaters, Molière's *The Miser* and Beaumarchais's *Barber of Seville* from the classics, and Synge's *Deirdre of the Sorrows* and Maeterlinck's *Pelleas and Melisande* from the moderns.

After a period of relative inactivity, the Play House imported a triumvirate of brilliant professionals from Pittsburgh: Frederic McConnell, K. Elmo Lowe, and Max Eisenstat. In 1921, McConnell began to assemble a professional company (see Figs. 38–39). During the 1920s the Play House, like all innovative institutions, gradually drifted into the mainstream of theater production. Mainstream works were featured in the larger Drury Theater, while experimental works

FIGURE 37. Puppet play rehearsal at the Cleveland Play House with Julia Flory (*left*), Helen Haiman Joseph (*right*), and assistants. Courtesy of the Cleveland Play House.

The **CLEVELAND PLAY HOUSE** is the oldest continuously running theater company in Cleveland. The idea for the Play House developed from weekly discussions held at the home of Charles and Minerva Brooks. Members of the group formed the Play House Company in 1916 with the purpose of establishing an art theater based on the bohemian spirit of art theaters in Paris and Moscow. In the early years, the theater staged the works of many modernist playwrights. During the 1920s, avant-garde theater began to fade, and the Play House moved into more mainstream productions. In 1917 the Play House acquired the Cedar Avenue Church (E. 73rd Street) and converted it into a theater. A new Play House was built in 1926 on land donated between Carnegie and Euclid near E. 86th Street. A church at the corner of E. 77th was secured and converted into a theater in 1949. In 1983 the Play House opened its $14 million complex housing three theaters under one roof, which is considered to be one of the largest in America.

FIGURE 38. Nationally known directors K. Elmo Lowe (*left*) and Frederic McConnell (*right*) at the Cedar Avenue Theater of the Cleveland Play House. Courtesy of the Cleveland Play House.

were produced in the smaller Brooks. The Cleveland Play House is the nation's oldest continuously running regional theater company.

The Cleveland Orchestra

By 1917 Cleveland could boast a fine museum and active theatrical groups. As yet, however, the city trailed behind others in the United States in the establishment of a professional orchestra, although the foundations had long been in place. In 1918 the right people met in the right place at the right time, and the Cleveland Orchestra was born.

Adella Prentiss Hughes had been working toward the establishment of a professional orchestra for Cleveland ever since her return to the city in the 1890s. For more than fifteen

FIGURE 39. Cleveland-born actress Margaret Hamilton in the 1929 Cleveland Play House production of *Fashion.* Courtesy of the Cleveland Play House.

One of the brightest stars in the galaxy of Cleveland Play House alumni was **MARGARET HAMILTON** (1902–May 15, 1985). A Cleveland native, she learned her craft during three seasons at the Play House in the late 1920s, before going on to win fame as the Wicked Witch of the West in Hollywood's *The Wizard of Oz* and as "Cora" in a series of Maxwell House television commercials. Hamilton returned for several guest appearances at the Play House, the last being for *The Night Must Fall* in 1979. Other notable alumni of the Cleveland Play House include Russell Collins, Howard DaSilva, Joan Diener, and Joel Grey.

years she had managed the successful Symphony Orchestra Concert series in conjunction with the Fortnightly Musical Club (see Fig. 40). Her desire to create a profit-making organization for the support of music in Cleveland resulted in the formation of the Musical Arts Association in 1915. The word "Arts" in the title was purposefully plural to represent dance, opera, chamber music, and music education in the community. The incorporators for the new association were David Z. Norton, Paul Feiss, Otto Miller, Howard P. Eells, and Andrew Squire—almost all of whom had also been associated with the formation of the Music School Settlement just three years previously. Norton served as the group's first president.

The Musical Arts Association's first sponsored event was bringing to Cleveland the Diaghilev Ballets Russes for three performances in 1916. This was followed by a performance of Wagner's *Siegfried* by members of the Metropolitan Opera at League Park, which had been fitted with an entirely new lighting system for the occasion.

The greatest responsibility of the Musical Arts Association was yet to come, however, as Hughes and a number of

FIGURE 40. Handbill of the "People's Symphony Orchestra" with conductors Johann Beck and Emil Ring, ca. 1910. Courtesy of the Musical Arts Association.

The **FORTNIGHTLY MUSICAL CLUB**, one of the oldest musical clubs in Ohio, was organized in 1894 by Mrs. Curtis Webster. During its first 25 years, Fortnightly served as a concert agency for Cleveland, bringing in visiting orchestras and artists. After Adella Prentiss Hughes took charge of Fortnightly's public concerts in 1897, she and the club went into partnership to present "Symphony Orchestra Concerts." Public interest developed through these concerts made possible the organization of the Cleveland Orchestra. Fortnightly was one of the first supporters of the Cleveland Music School Settlement. Since its inception, the club has organized workshops and music appreciation groups.

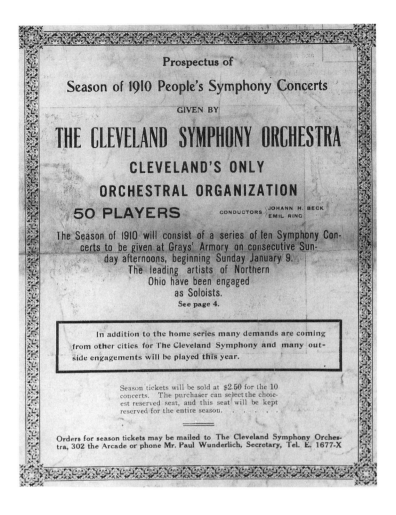

music lovers in town began to bemoan Cleveland's lack of a permanent symphonic orchestra. In the summer of 1918 Hughes attended the Ohio Music Teachers Association Meeting in Cincinnati. She was so impressed by the performance there of a thirteen-year-old oboist trained in the Cincinnati schools that she began to think of the lost opportunities for Cleveland's young people, who had no such program to speak of.

During the same conference she heard a young conductor named Nikolai Sokoloff speak on "The American Conductor." Sokoloff spoke of the many difficulties a young conductor faced in trying to learn his craft, since there were not many chances to practice with orchestras and ensembles. The resultant vicious circle of "no experience, no job; no job, no experience," he felt, was particularly detrimental to the country's young conductors.

After hearing Sokoloff conduct a children's concert at the Cincinnati Zoo, the Cleveland impresario returned to her native town firmly convinced that she had found the man to lead Cleveland's orchestra. Furthermore, she imagined an

orchestra that would both serve the needs of the adult community and, at the same time, provide formal music programs for its schoolchildren. Upon her return, Hughes approached the superintendent of the Cleveland Public Schools, Frank E. Spaulding, with the suggestion that the children in Cleveland be given the opportunity to learn to play musical instruments. She offered the assistance of the Musical Arts Association to finance the project and apparently also discussed hiring the talented young conductor she had seen in Cincinnati, Nikolai Sokoloff, to run the program.

Spaulding was enthusiastic about the plan, and Hughes was given the go-ahead to approach Sokoloff with an offer to come and work in Cleveland. Sokoloff wanted the position but had his own condition as well—that he be allowed to organize and conduct his own orchestra in the city. Thus, Cleveland got its orchestra and its children's training program in one man. John L. Severance, who was one of the Cleveland Orchestra's most generous benefactors, agreed to pay Sokoloff a $6,000 salary (see Fig. 41).

A benefit concert performed at Grays Armory for St. Ann's Parish in Cleveland Heights on December 11, 1918, marked the debut of the orchestra. Following the "Star-Spangled Banner" (it was only a month after the Armistice), Sokoloff led fifty-four musicians in Victor Herbert's *American Fantasy*, Liszt's *Les Préludes*, Bizet's *Carmen Suite*, and two movements of Tchaikovsky's *Fourth Symphony*. Reviewing the concert for the *Cleveland News*, Louise Graham approvingly noted six women among the players. "Will Cleveland rise to this splendid opportunity to make ours one of the big musical organizations?" she asked rhetorically. "The musicians are co-operating, some making sacrifices for rehearsal." Indeed, the musicians were paid in the beginning per rehearsal and concert rather than by salary. In June 1919, at the end of the first season for what was originally called Cleveland's Symphony Orchestra, the new ensemble had played twenty-seven concerts, including seven out-of-town engagements.

The new orchestra had a successful first season, but Adella Prentiss Hughes and the other members of the Musical Arts Association hoped to build ever-larger audiences. In order to attract new listeners and increase community interest, the orchestra played concerts in local high-school auditoriums in and around Cleveland. Popular vocal soloists were added to the program, and the orchestra even included pieces by local composers, including Johann Beck's *Fireworks*, in its concert repertoire. One early concert featured the "Duo-Art Reproducing Piano" playing the Saint-Saëns G minor concerto to the orchestra's live accompaniment, which attracted the attention of Cleveland's premier inventor, Charles F. Brush of electric arc light fame. "Ultimately we may get a machine orchestra and save most of that $200,000 annual budget," Brush mused in a letter to his son, "then, perhaps, we

FIGURE 41. *From left to right:* First conductor of the Cleveland Orchestra, Nikolai Sokoloff, Mrs. Sergei Rachmaninoff, Sergei Rachmaninoff, Adella Prentiss Hughes, and Mrs. Nikolai Sokoloff. Courtesy of the Musical Arts Association.

ADELLA PRENTISS HUGHES (Nov. 29, 1869–Aug. 23, 1950), best known as the "founder of the Cleveland Orchestra," was born in Cleveland. She studied at Miss Fisher's School for Girls and Vassar College (1890). After touring Europe upon graduation, she returned to Cleveland intent upon broadening the city's musical horizons. As Cleveland's leading impresario, she supplied the city with a series of musical attractions, including orchestras, opera, ballet, and chamber music. Hughes created the Musical Arts Association in 1915, which provided financial support for her projects. It was through her that Nikolai Sokoloff came to Cleveland. She and Sokoloff, along with the Musical Arts Association, created the Cleveland Orchestra in 1918.

can find some way of automatically staying at home and hearing the orchestra while we smoke our pipes before automatically going to bed for an automatic night's rest etc."

Happily, Brush's machine orchestra didn't materialize, and by 1920 Sokoloff and his orchestra had already attained a measure of recognition outside Cleveland. The same year saw the inauguration of the popular children's concerts performed by the orchestra. A year later music memory contests would begin, in which children would study certain compositions all through the year and try to identify them from fragments played at the year's conclusion. The first contest included twenty-six different compositions, from Bach to Sibelius.

The Cleveland Orchestra may well have been the most desired and sought-after fine-arts institution in the city. Instrumental instruction had been incorporated into the schools, the Cleveland Music School Settlement was giving talented, underprivileged students an opportunity to learn

and prove themselves; all that was lacking in Cleveland was a professional school or conservatory to train musicians and vocalists. The city didn't have long to wait.

The Cleveland Institute of Music

This section will only touch on the origins of the Cleveland Institute of Music, as the last of the great fine-arts institutions founded during the period from 1900 to 1920. The institute was founded in 1920, just two years after the organization of the Cleveland Orchestra, by a concerned group of music enthusiasts led by Mrs. Franklyn B. Sanders and Mrs. Joseph T. Smith. Mrs. Sanders was named executive director (see Fig. 42).

The administrators of the Cleveland Institute of Music recognized from the beginning the importance of employing faculty who were distinguished musicians as well as teachers. As director for the new school the board hired Ernest Bloch

NIKOLAI SOKOLOFF (May 28, 1886–Sept. 25, 1965) was born in Kiev, Russia, and came to America with his family in 1899. In 1918 he met Adella Prentiss Hughes, who persuaded him to accept a position with the Musical Arts Association to survey Cleveland's public schools and outline an instrumental music program for them. He accepted this offer with the stipulation that he also be allowed to organize and conduct his own orchestra. In 1918, Sokoloff, along with Hughes and the Musical Arts Association, created the Cleveland Orchestra, for which he served as conductor for 14 years. During the Depression, Sokoloff was appointed director of the WPA's Federal Music Project by the Roosevelt administration. Sokoloff died in La Jolla, California.

FIGURE 42. Mrs. Franklyn B. Sanders, ca. 1938. Founding member of the Cleveland Institute of Music in 1920, she held the position of executive director, with Ernest Bloch serving as artistic director. Courtesy of the Cleveland Press Collection, Cleveland State University.

FIGURE 43. Ernest Bloch, first artistic director of the Cleveland Institute of Music. Courtesy of the Cleveland Institute of Music.

ERNEST BLOCH (July 24, 1880–July 15, 1959) was an internationally known composer, conductor, teacher, and lecturer who served as director of the Cleveland Institute of Music from 1920 to 1925. During his years in Cleveland, he completed 21 works of music. Bloch assumed the directorship of the San Francisco Conservatory in 1925.

(see Fig. 43), the renowned Swiss-born composer who had been teaching at the David Mannes School in New York City. Bloch instituted a policy of instruction using Dalcroze Eurythmics, which interpreted musical composition via rhythmical movement. Emphasizing teaching skills, he insisted that all students be trained in composition and theory. Bloch continued to compose during his five years as director, completing twenty-one pieces including the *Concerto Grosso*, which was written specifically for the student orchestra at the school.

Bloch seems to have worked in close conjunction with Frederic Allen Whiting, the director of the Cleveland Museum of Art, as he organized a chorus to perform at the museum. Bloch thus helped to realize Whiting's ultimate goal of uniting all the different art forms—music, theater, literature, and the visual arts—in a museum setting. After a disagreement with the administrative policymakers at the Institute of Music, however, he left Cleveland in 1925 to take a similar position at the San Francisco Conservatory. He was not officially replaced until 1932, when staff member Beryl Rubinstein became director of the Institute.

During the early years of its existence, the school had a number of homes, many of which were former private residences. The first classes were taught at the Hotel Statler and then at the Hall residence, followed by the Chisholm home (1923), the Samuel Mather home (1932), and the Cox home (1941). When classes were transferred to the Cox home, a 400-seat auditorium was added to the facility. The school remained in residence there until permanent quarters were constructed in the early 1960s. The Cleveland Institute of

Music then joined the many fine-arts institutions in the University Circle area (see Fig. 44).

The founding of the Cleveland Institute of Music capped a tremendously productive period in the history of the fine arts in Cleveland. The city had reached a point where its businesses and citizens were prosperous, and they used both their money and their influence to found and endow institutions which are still contributing to Cleveland's cultural growth today. The patience and generosity of the patrons during this period must be regarded, in part, as due to the educationally oriented foundations of each and every one of the organizations. The motivation for the success of these projects was not selfish but was meant to improve the city and its citizens by increasing cultural awareness and the quality of life in Cleveland.

The Group Plan, the Music School Settlement, the Cleveland Museum of Art, Karamu House, the Cleveland Play House, the Cleveland Orchestra, and the Cleveland Institute of Music—all of these institutions were the cultural prerequisites to the process of building a great urban center.

The **CLEVELAND INSTITUTE OF MUSIC** is a nationally recognized conservatory which was founded in 1920 by Mrs. Franklyn B. Sanders and Mrs. Joseph T. Smith. Classes were first held in the Hotel Statler; and after a series of moves, a new building was constructed in University Circle in 1961. The Institute has a reputation for distinguished faculty. Swiss composer Ernest Bloch was its first director; his successors have included Beryl Rubinstein, Ward Davenny, Victor Babin, Grant Johannesen, and David Cerone. CIM has combined efforts with other institutions, including the Cleveland Orchestra, which has provided many faculty members, and Case Western Reserve University, which in 1968 began a cooperative music program with the Institute.

Styles for a New Century

The Cleveland School of Artists
and the Quest for a
Regional Style

The Cleveland School of Artists

The term "Cleveland School" has many meanings in the 1990s. In the most narrowly defined sense, it can be used to describe the Cleveland painters who, in the first half of this century, forsook traditional academic painting to embrace many of the modernist ideas coming out of Paris and New York. This group would include such artists as Abel and Alexander Warshawsky, Charles Burchfield, William Sommer, and Clarence Carter.

In the larger and perhaps more accurate sense, the term "Cleveland School" has been used since the 1970s and 1980s in reference to those artists who formed part of a tightly knit artists' community in Cleveland during the first half of the century. The Cleveland School refers to artists who worked and lived in Cleveland; theirs is a geographical relationship, not stylistic (see Color Plates 5–14). No cohesive style links these artists to one another. The group includes sculptors and painters, enamelists, ceramic artists, furniture designers, and jewelers. Most of these artists attended the Cleveland Institute of Art, and many of them returned to teach at their alma mater at some point in their careers. Henry Keller, Frank Wil-

cox, Carl Gaertner, Elsa Vick Shaw, and Paul Travis all took their turns first as students, and later as faculty of the school. Works by the most prominent artists in Cleveland during this period—George Adomeit, August F. Biehle, William Eastman, Frederick Gottwald, Max Kalish, Henry Keller, Herman Matzen, Paul Travis, William Sommer, and Frank Wilcox—are found in collections across the nation, even though their name recognition is far from the national or international status accorded a Jackson Pollock or a Thomas Hart Benton.

Some of these artists went on to greater fame after leaving Cleveland for further training. They felt a need to experience the larger world and traveled to the cultural centers in Europe and, more often after World War II, New York City. Abel "Buck" Warshawsky, the artist son of Jewish immigrants from Poland, left Cleveland for Paris in 1908, claiming that if he stayed in Cleveland, he would "sink down to the level of the local artist and possibly be forced to take a job in Commercial art." His younger brother, Alexander "Xander" Warshawsky, followed his brother's example in 1916, when he too moved to Paris to occupy the former studio of Gustav Courbet (see Figs. 45–46).

Charles Burchfield's stay in Cleveland was essentially limited to the years between 1912 and 1916, when he attended the Cleveland School (now Institute) of Art to study under Keller, Wilcox, and Eastman. By 1922 he had left the Cleveland area, but the painfully shy Burchfield acknowledged how crucial his Ohio years were to his development as an artist. Cleveland School professors encouraged students to draw and paint the world around them, and Cleveland and the Western Reserve provided unlimited inspiration for the moody and nature-loving Burchfield. And it was in Cleveland that Burchfield had his first introduction to Asian art, finding an affinity between his developing style and the decorative qualities of Japanese prints and Chinese scroll paintings.

Artists and patrons alike recognized that, as an industrial center, Cleveland had a commitment to training young artists to become decorators, enamelists, printmakers, ceramic artists, metalworkers, and textile artists. In Cleveland the role of the artist extended far beyond the traditional media of painting and sculpture. Many of the artists nurtured in Cleveland who chose to remain in the city did so because of this enlightened attitude toward what some considered crafts. Louis Rorimer, Herman Matzen, William McVey, Viktor Schreckengost, Edris Eckhardt, Guy Cowan, Thelma and Edward Winter, and Kenneth Bates are just a few who worked in Cleveland and received both national and international recognition for their works (see Figs. 47–49).

Louis Rorimer experienced the cultural centers but ultimately returned to Cleveland to pursue an extremely successful career in interior, architectural, and furniture design. The son of a tobacco dealer, Rorimer was born in Cleveland and

FIGURE 45. Abel Warshawsky, internationally known painter, in his studio. Courtesy of the Cleveland Institute of Art.

FIGURE 46. Alex Warshawsky, also an internationally recognized painter. Both brothers studied in Cleveland. Courtesy of the Cleveland Institute of Art.

ABEL (Dec. 28, 1883–May 30, 1962) and **ALEX** (Mar. 29, 1887–May 28, 1945) **WARSHAWSKY** were internationally known painters who got their start in Cleveland. As children they attended the Cleveland School of Art and the National Academy of Design in New York. Abel left for France in 1908. Alex is credited with organizing a 1914 exhibition of Post-Impressionism in Cleveland, which included some work by local artists but mainly that of New York artists. Alex left for France in 1916, and the brothers served together in World War I, utilizing their craft by decorating soldiers' huts with murals. At the onset of World War II, the brothers left France and settled in California.

studied under sculptor Herman Matzen. In 1888, at the age of sixteen, he left to study in Europe, attending both the Munich Kunstgewer and the Académie Julien in Paris. Rorimer returned to Cleveland in 1893 and set up an interior and architectural design studio in the Arcade. He later merged with Brooks Household Arts Company, a consultant firm in interior design, and the company became nationally known as Rorimer Brooks Company.

Believing that art was an essential part of life and that clean, more utilitarian designs were the order of the day, Rorimer advocated a move away from Victorian styles. In the

FIGURE 47. William McVey and arts patron, ca. 1964. Courtesy of the Cleveland Institute of Art.

WILLIAM H. MCVEY (July 12, 1905–), a prominent Cleveland sculptor whose works have been nationally exhibited, was born in Boston and moved to Cleveland when he was a teenager. He attended East Cleveland's Shaw High School and then went on to study at the Cleveland Institute of Art, graduating in 1928. After graduation, McVey studied abroad from 1929 to 1931. Returning to Cleveland, he began teaching at the Institute of Art in 1935. McVey is nationally known for his statues and relief work. Some of his Cleveland work includes a bear in Wade Park, a relief of Paul Bunyan in Lakeview Terrace, a terra cotta figure of Christ in Fairmount Presbyterian Church, and a bronze statue of Jesse Owens in Huntington Park. In 1963, McVey became internationally known for his statue of Winston Churchill, commissioned by the British government for its Washington, D.C., embassy.

1890s Cleveland was rising to become one of the premier cities of the United States, and Rorimer recognized the promise this growth offered for artists and craftsmen. From 1918 to 1936 he taught architectural design at one of the most positive forces for artistic growth in Cleveland, the Cleveland School of Art, now the Cleveland Institute of Art.

The Cleveland School of Art and Artists' Societies in Cleveland

The Cleveland School of Art was a source of continual support and development for Cleveland's visual-arts community. The school provided classes for its regular students, as well as Saturday morning classes for young people and summer classes for teachers, whose jobs prevented them from attending the institute during the school year. The school also hosted annual exhibitions of student work, thus providing a

FIGURE 48. Viktor Schreckengost and students at the Cleveland School of Art. Courtesy of the Cleveland Institute of Art.

VIKTOR SCHRECKENGOST (June 26, 1906–), ceramicist, painter, and sculptor, was born in Sebring, Ohio, and attended the Cleveland School of Art from 1926 to 1929. Upon graduation he studied in Austria, returning to Cleveland in 1930 and becoming head of industrial design at the Cleveland School of Art later that same year. Schreckengost has received many local and national awards for his work. In 1955 he won the Special and First Prize from the Cleveland Museum of Art; in 1958 the Gold Medal Fine Arts Award from the American Institute of Architecture; and in 1973 the Women's City Club Award. Schreckengost's work can be seen at the Cleveland Zoo and Cleveland Hopkins Airport; his work has been exhibited internationally at the Paris Expo and nationally at the Cleveland Museum of Art, the Metropolitan Museum of Art, and the Whitney Museum of American Art in New York.

venue for artists whose works might not have been seen by the public otherwise.

Begun as the Western Reserve School of Design for Women, the school had merged for a few years with the Women's College of Western Reserve University before reasserting its independence in 1891 as the Cleveland School of Art and turning coeducational. The principal of the new school was Georgie Leighton Norton (see Figs. 50 and 51), who was hand-picked for the position after Judge and Mrs. E. Stevenson Burke, the school's most avid patrons, traveled to Boston to search for a qualified candidate. While in the Boston area they visited the Massachusetts Normal Art School, which the Cleveland school had taken for its model. At the suggestion of that school's principal, they agreed to hire Norton, who was then drawing supervisor for the Medford public schools.

When Norton arrived in Cleveland in 1891, the most immediate concern was new quarters for the school, as its rooms in City Hall were hopelessly inadequate. Fate came to

FIGURE 49. Kenneth Bates at kiln, ca. 1947. Internationally recognized for his enamel crafting, Bates has long been considered the dean of American enameling. His work has appeared in every May Show since 1927. Courtesy of the Cleveland Press Collection, Cleveland State University.

her aid in the guise of the legacy Horace Kelley had left in 1890. The terms of his will had specified that the estate's three trustees were to buy land and erect a fireproof gallery, part of which would be devoted to "a school or college for designing, drawing, painting, and the other fine arts."

While the trustees and the city worried about whether or not the art museum could be built, Norton petitioned the estate for use of the Kelley mansion on Willson Avenue (now E. 55th) at Carnegie as home for the Cleveland School of Art. Her petition was granted, and the school moved into its elegant, if not exactly ideal, new facility.

Norton made a few enemies in her successful battle for the mansion. The Cleveland Art Club, the art school's next-door neighbor in City Hall, had also lobbied for the property and lost. Until the end of the decade, when the Art Club disbanded, there was a strong and often venomous rivalry between the two groups. Art Club members were not allowed to exhibit in School of Art exhibitions, a situation which elicited cries of elitism with regard to the new school.

Though students looked back fondly in later years on the time the Cleveland School of Art was in residence at the Kelley mansion, it was not the perfect place for classes. Faculty and students were all aware that permanent quarters designed for art studies, with studios and workshops, were needed to make the school competitive. In 1904, Jeptha Wade took the first step toward making a new facility possible by donating an acre and a half of his own property on Magnolia Drive near Western Reserve College as the site for a new structure. With the decline of Euclid Avenue in the early twentieth century, many of Cleveland's society moved farther

out from the city, both east and west. Wade had developed a residential section between E. 105th and E. 115th, referred to as the Wade allotment, that soon replaced Euclid Avenue as a fashionable place to live.

Wade Park and the University Circle area would later become home to the Cleveland Museum of Art and the Cleveland Orchestra. In 1904, however, the Cleveland School of Art was the first fine-arts institution to become a part of the university area. Once land had been acquired, the Burkes promised $50,000 for a new building, and the endowment for the school was on its way. Probably at the instigation of Wade, the Cleveland architectural firm of Hubbell and Benes was hired to design the new school.

The first classes were held in the new building in 1905. The pride and joy of students and faculty alike was the exhibition hall, complete with a double-skylight ceiling and lighting facilities. No longer were Cleveland's art shows to be confined to small private galleries; the city now had a public place for formal exhibitions. And though there were still financial struggles from time to time, no one could dispute that Cleveland did indeed have a professional school to train artists.

Cleveland's art community also had the support of several clubs established during the early twentieth century. One such supporter was the Women's Art Club of Cleveland, founded in 1912. The original club included twenty-five members whose goal was the mutual improvement of women artists through exhibitions, sketching trips, life classes, and monthly forums. Springing as it did from the students in the Cleveland School of Art, the club had a wide variety of interests, ranging from a traditional interest in watercolor and oil painting to design, illustration, and commercial art.

Two very active clubs were the Kokoon Arts Club and the Cleveland Society of Artists. The Kokoon Arts Club was founded in 1911 by Carl Moellman and William Sommer (see Fig. 52) who had decided that Cleveland needed an organization for avant-garde artists like those found in New York City. These young artists were tired of the academic traditions of painting and sculpture and sought new means of expression. Kokoon Club artists spent much of their meeting time in painting or drawing sessions during which works could be compared and critiqued. The club hosted lectures on timely subjects and sponsored exhibitions in its rooms, originally a one-room structure on E. 36th, and later larger quarters at 2121 E. 21st St. Club members offered art classes to the public and twice a year presented exhibits of their own often-controversial works.

The original thirteen artists who founded the group were a lively bunch who tried to create a bohemian atmosphere in Cleveland that would rival, or at least echo, the artists' culture on Paris's Left Bank. In 1913, they began to sponsor what would eventually become known as the Kokoon Arts Ball.

FIGURE 50. Georgie Leighton Norton at the Cleveland School of Art, ca. 1890. Courtesy of the Western Reserve Historical Society.

FIGURE 51. Students at the Cleveland School of Art, ca. 1890. Courtesy of the Western Reserve Historical Society.

GEORGIE LEIGHTON NORTON (d. Aug. 18, 1923) came to Cleveland from Medford, Massachusetts, in 1891. A graduate of the Massachusetts Normal Art School, she was the first principal and secretary of the Cleveland School of Art. She was instrumental in securing a new building site for the school and is credited with making it into one of the leading art schools in America at the time. She stayed with the school until 1919.

WILLIAM SOMMER (Jan. 18, 1867–June 20, 1949), a painter born in Detroit, moved to Cleveland in 1888 after studying in Europe and apprenticing at the Detroit Calvert Lithography Company. He regularly won prizes for his drawings and watercolors at the early May Shows, though it was only after his death that his work gained national recognition. He was a founding member of the Kokoon Arts Club in 1911. Under the auspices of the Public Works of Art Program in the 1930s, Sommer produced murals in Cleveland's Public Hall, Brett Hall of the Cleveland Public Library, the post office in Geneva, Ohio, and the Akron Board of Education Building.

These "bals masqués" always had romantic and daring themes, such as the Persian Ball (1918) and the Bal Dynamique (1929). The fetes served as an annual gathering of Cleveland's modernist artists, poets, and musicians (see Fig. 53).

The Cleveland Society of Artists, founded in 1913, was a revival of the old Cleveland Art Club. In some ways it was the antithesis of the Kokoon Arts Club, as Charles Shackelton and George Adomeit (see Figs. 54 and 55) formed the group to continue the tradition of academic painting and sculpture in Cleveland. Like the Kokoon Club, the Society of Artists met to draw, paint, hear relevant lectures, and exhibit. Seeing its function as that of a liaison group to further communications between artists, art lovers, and craftsmen in Cleveland, the Society may well have been founded in part to counteract the daring antics of the Kokoon Club.

The Cleveland Society of Artists also helped raise funds for the Cleveland Art School, hosting an annual auction of works to raise money for a scholarship. The group found another means of communication with the art community in 1925, when it began producing a journal called *Silhouette*, which served as a record of the events and sentiments of Cleveland's artists on everything from city planning to the May Show.

Improved relations between artists and the community were important for the growth of the visual arts. If Cleveland artists were somewhat slow to follow the New York and Paris schools in the development of style, the public, which liked landscapes and portraits, was even slower to accept innovations.

Henry Keller, an influential teacher at the Institute of

The **KOKOON ARTS CLUB**, one of the city's most active arts organizations, was founded in 1911 by Carl Moellman and William Sommer. Modeled after avant-garde organizations in New York, the club wished to cultivate in Cleveland the bohemian spirit found in the arts centers of Europe. From 13 members who met twice a week to paint and draw, it grew in later years to a membership exceeding 75. The Kokoon Club held exhibitions of members' work at least twice a year. The first exhibition, in 1911, was described as "exceedingly daring in nature." Members who achieved national recognition included William Sommer, Henry Keller, August Biehle, Rolf Stoll, and Joseph Jicha. To the outside community, the club was known largely for its annual "Bal Masque." The first, held in 1913, was a celebration of Cleveland's bohemian community—artists, musicians, and poets. Featuring unconventional costumes, exotic dances, enormous props, clashing decorations, and unpredictable stunts, the ball was usually monitored by the city's police. The last was held in 1946.

Art, made an attempt to broaden the community's visual horizons in 1913, when he took part in organizing an exhibition of "Cubist" and "Futurist" paintings at the Taylor Department Store. The exhibition in June followed the famous New York Armory Show, and Clevelanders were no more prepared to accept the "new art" than many New Yorkers had been. The *Plain Dealer* loudly proclaimed, "Show Weird Work of Cubist Artists."

A year later, Alexander Warshawsky organized a display of Post-Impressionist works by New York and Cleveland artists. Works by the two Warshawsky brothers and Cleveland artists William Sommer and Frank Wilcox (see Fig. 56) were included in the exhibition. Newspapers had a field day with the show. "BIGGEST LAUGH IN TOWN THIS WEEK, NOT IN THEATER, BUT ART GALLERY," sniped the *Plain Dealer*.

The Post-Impressionist show heightened the feud that already existed between the academic painters of the Cleveland Society of Artists and the avant-garde Kokoon Arts Club. The academics, many of whom hated the show with its distorted shapes and colors and unrecognizable figures, were championed by Frederick Gottwald, who was quoted as

FIGURE 54. Cleveland painter George Adomeit (*left*) with friend, ca. 1924. Courtesy of the Cleveland Museum of Art.

FIGURE 55. *From left to right:* Members of the Cleveland Society of Artists Paul Travis, August Biehle, George Adomeit, and Frank Wilcox, ca. 1955. Courtesy of the Cleveland Press Collection, Cleveland State University.

GEORGE ADOMEIT (Jan. 15, 1879–Nov. 22, 1967) was a noted painter who came to Cleveland with his family when he was three. Adomeit attended Cleveland public schools and in 1894 won a four-year scholarship to the Cleveland School of Art. While at the school, he secured an apprenticeship in lithography. In 1902, Adomeit and W. H. Webster bought the Mason Engraving Company, which they later renamed the Caxton Company, Printers and Engravers. He was elected president and art director of the Caxton Company in 1937 and stayed in that position until he retired in 1956. Adomeit was a member and founder of the Cleveland Society of Artists. His paintings and drawings were exhibited at 40 consecutive May Shows, where he won 24 awards, and have been exhibited nationally at various museums and institutes.

responding to the show as "NEW ART? ALL ROT." Henry Keller came to the support of the Warshawsky contingent (see Fig. 57). While he himself did not embrace the new ideas, he understood the intellectual attraction the new style had for younger artists.

The May Show

In 1916, the visual-arts community was to change forever with the opening of the Cleveland Museum of Art. Reversing the pattern in most cities, Cleveland had an art school long before it had an art museum. As a result, Cleveland artists had more experience drawing from life and the landscape around them than did their contemporaries in other, more established art centers who often trained, as the old masters had, by copying the works found in museums. This may have been one reason the work of Cleveland artists tended to focus on landscapes, cityscapes, and figure studies. Like good writers, Cleveland's painters and sculptors created what they knew.

After 1916, Cleveland artists were faced with a new type of competition in the permanent collection being formed to represent the high points in the history of art. Would the work of long-dead artists be of more interest to the people of Cleveland than the products of its own living artists? Frederic Allen Whiting and his successor, William M. Milliken, intuitively understood the importance of protecting the past while at the

same time supporting the future. In 1919, the museum presented the First Annual Exposition of Works by Cleveland Artists and Craftsmen (see Fig. 58). The yearly event later adopted its famous nickname, "the May Show," and became one of the most popular and controversial exhibits on the museum calendar.

Whiting suggested that the museum host an annual show of works by Cleveland artists at his first meeting with the board of trustees, and by 1919 the museum staff was ready to attempt such a show. Whiting believed the exhibition would spur artistic growth in the community by providing local artists a chance to show works and an opportunity for art patrons in Cleveland to buy Ohio art. The idea had first been suggested to Whiting by members of the Cleveland Art Association under the chairmanship of Frank W. Wardwell.

For the first May Show, each artist was allowed to enter ten items that had been completed within the ten years previous to the show. As many as five items could be entered in any one of the thirty-six categories, including oil and watercolor painting, graphic arts, photography, sculpture, basketry, enamelware, and garden design. Whiting also provided categories for arts and crafts made by the handicapped and for industrial design products—Louis Rorimer was a frequent exhibitor in the May Show.

One of the mistakes made by the museum staff before the first show was the decision to allow artists to display and hang their own works in the gallery. At the appointed time, chaos ensued as artists jockeyed one another for the best positions. From that time on, the museum staff was responsible for the display.

The **CLEVELAND SOCIETY OF ARTISTS** was founded in 1913 by George Adomeit and Charles Shackelton as a means to provide communication between artists and patrons. The society carried on the traditions of two earlier groups, the Cleveland Art Club (1876) and the Cleveland Arts Club (1889). One of its primary activities was an auction held for the purpose of establishing a Cleveland chool of Art scholarship. It also started a collection of works by Cleveland artists before it was disbanded in 1983.

FIGURE 56. Frank Wilcox, well-known Cleveland watercolorist, ca. 1947. Courtesy of the Cleveland Press Collection, Cleveland State University.

FRANK N. WILCOX (Oct. 3, 1887–Apr. 17, 1964), noted painter, printmaker, and teacher, was most famous for his watercolors. Wilcox was a native Clevelander who studied at the Cleveland School of Art with Henry Keller and Frederick Gottwald and in 1913 began a 40-year teaching career himself with the school. He was founder and past president of the Cleveland Society of Artists. He won more than 30 awards from the Cleveland May Show and the 1920 Penton Medal for sustained excellence. Wilcox's work is found in museums nationally. He also wrote and illustrated two publications, *Ohio Indian Trails* (1933) and *Weather Wisdom* (1949).

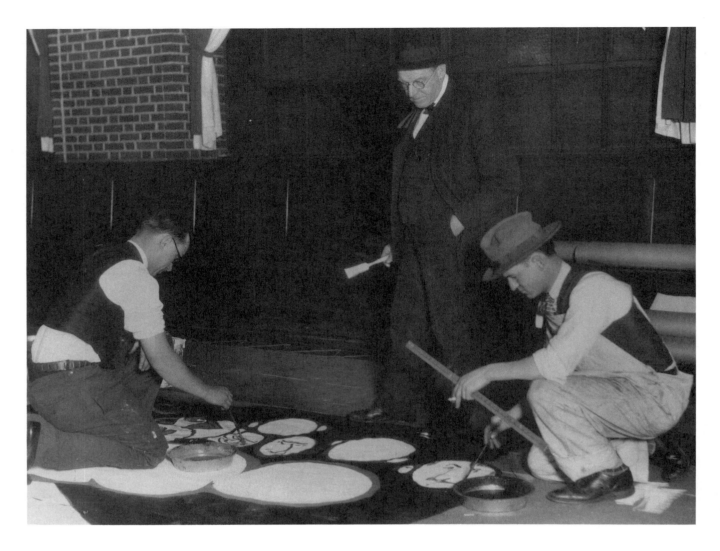

FIGURE 57. Cleveland artists Joseph Jicha, Henry Keller, and Edwin Sommer paint a mural for the Kokoon Club's 1928 Bal Masque. Courtesy of the Cleveland Press Collection, Cleveland State University.

HENRY G. KELLER (Apr. 3, 1869–Aug. 3, 1949) was a well-known painter who came to Cleveland at an early age. He entered the Cleveland School of Art in 1887 and studied there for three years. Upon his return from Europe in 1902, Keller joined the teaching staff of the Cleveland School of Art, remaining there until 1945. He won the Special Award for sustained excellence at Cleveland's first May Show (1919). Keller had 11 shows in Pittsburgh and one-man shows in other parts of the country. In 1929 he was elected into the National Academy of Design.

Though the Cleveland Institute of Art had provided artists with occasions to exhibit, the shows inevitably focused on the students and past students of the school. The institution of the May Show provided a local forum for Cleveland artists on neutral yet officially sanctioned ground. In a 1934 lecture entitled "How a City Can Develop Its Artists," William Milliken described the May Show as a "tremendous success," and explained,

> We had an out-of-town jury, and there was no fear of favor. The things were judged on the basis of their artistic quality— not because this man was important in the art association, or that man was an important person and must be represented. The result of that undertaking had been a clear-cut gain, and as the thing has gone on year after year, we see a growth that is extraordinary.

Milliken was only partially correct. The show had consistently been a tremendous success, but many of the artists in

town obviously felt that the out-of-town judges were not capable of fairly judging their work, and that the show was really more of a social event than a chance for the public to view their work. Beginning with the very first volume and continuing throughout the 1920s, *Silhouette*, the journal of the Cleveland Society of Artists, ran a number of pieces poking fun at the almighty May Show.

> OH WELL
> We find that there's to be a Spring Exhibition again at the Museum. Our guess is as good as yours: Saturday—take your pictures to the Museum; Monday—go and get 'em; Tuesday—Exhibition opens. Good luck to you, old man, and may you bring your pictures up in the style to which the jury is accustomed. (March 1925)
>
> Someone suggested a Salon Refusee [*sic*] to be held somewhere [for works rejected by the May Show jury], maybe in Public Hall or in the new Union Station. The question was voted dropped after some debate. Public Hall wouldn't be large enough. (May 1926)

While these excerpts may not have reflected the opinions of all the artists in Cleveland, they do illustrate the complex relationship which has existed between the Museum of Art and the visual-arts community in general. The May Show was an attempt by Cleveland Museum of Art staff members to alleviate the most difficult problem of an art museum administration—how it relates to the living artists in a community.

The **MAY SHOW** was started in 1919 as the First Annual Exposition of Works by Cleveland Artists and Craftsmen. Proposed by Cleveland Museum of Art director Frederic Allen Whiting, the May Show was a means of spurring artistic growth and development in Cleveland. It also provided an annual review of local artists' work and presented an opportunity for art patrons to buy works. The first shows exhibited only work by Cleveland artists, but in 1961 the show was opened to the entire 13-county Western Reserve area. The May Show was replaced in 1991 by "The Invitational," an exhibition of selected professional artists.

The May Show has been a mixed blessing for the community and for the Cleveland Museum of Art. In the early years, the show was unique in presenting arts and crafts from all segments of society. Displays ran the gamut from oils by trained painters to ceramic figurines by local "dabblers." As such, it truly was an exhibition of all types of art found regionally. After the first show each competitor got a personal letter of criticism from the jury, and cash prizes were awarded for the best works in each category. As the size and scope of the show grew, the jury's critiques and most of the cash prizes were eliminated.

Perhaps the two most positive features of the May Show were that it taught patrons to buy art from home-town artists, and it permitted the Cleveland Museum of Art to acquire a large number of works as well—850 objects between 1919 and 1964. Though these works are seldom displayed as part of the permanent collection, they are a legacy of Cleveland's visual-arts community saved and protected for coming generations.

From the late 1950s, the Cleveland Museum of Art staff and many local artists fought to elevate the status of the May Show. As a result, what had been an exhibition of local art gave way to an exhibition of local artists whose works are more representative of mainstream art trends in the national and international sense. Art in the May Show ceased to define the type of work done in the Cleveland area and instead focused on the works of artists with a broader scope of experience. Rather than competing with one another, Cleveland's artists had to compete with schools of art in New York City and Europe, despite the exhibition's continued focus on regional artists.

In 1991, the Art Museum announced yet another major rethinking of the original philosophy of the May Show—future shows will be juried, invitation-only events. The May Show as a reflection of the wide variety of work done by Cleveland artists is a thing of the past. The museum administration, consciously or otherwise, has decided to shape the development of visual arts in the community rather than continue to serve as a support group.

CHAPTER 7

Halcyon Days

Fine Arts and Civic Virtue in the Roaring Twenties

From E. 107th to East Boulevard, Euclid Avenue was lined with automobiles on Memorial Day 1919. Clevelanders converged on an "Altar of Sacrifice" at University Circle to witness a poignant dedication ceremony led by Mayor Harry L. Davis and commended by former mayor and then Secretary of War Newton D. Baker. A long, double row of oak trees had been freshly planted along Liberty and East boulevards (now Martin Luther King Boulevard) from Lake Erie to Shaker Lakes, each tree representing a citizen lost by the city in World War I. "Oh, let them live for those who died!" implored William R. Rose in a commemorative verse for the *Plain Dealer*:

> Each whispers of the nation's dead,
> Of ghostly hosts, of battles won,
> Of ravaged fields, of poppies red—
> Each rails the requiem of a son.

Clevelanders had finally decided that landscaped parks were an essential feature of the city. The rapid urbanization and industrialization of the city had increased the value of parkland in the eyes of council members. Grey buildings and sooty skies stood in grim contrast to the green trees and multi-hued flowers. Landscaping had a long tradition of being considered a fine art in Europe, but it was a new idea for

Clevelanders. Nonetheless, those who were able to afford fine gardening did so with a passion, or got involved in one of the many cultural garden projects of the 1920s and 1930s.

One of the first of these remarkable projects was the Shakespeare Garden, planted on a hillside east of Doan Brook Valley in Rockefeller Park. The city forester, John Boddy, directed the planting and planning of the garden in 1916 to commemorate the 300th anniversary of Shakespeare's death. Arbor-vitae hedges were designed to imitate Birnum Wood. Among the other "flowery" references found there were "Juliet" roses, grown from cuttings sent to Cleveland by the mayor of Verona, and a cutting of mulberry rumored to have been planted by Shakespeare himself. Two famous Shakespearean performers, Julia Marlowe and E. H. Southern, each planted an American elm at the gateway of the garden. From that time on, famous literary and theatrical personalities would plant memorial trees or place urns in the garden; they included Cleveland's own Effie Ellsler, Edmund Vance Cooke, Sarah Bernhardt, Ethel Barrymore, Otis Skinner, and David Belasco. The Shakespeare Garden was eventually renamed the English Garden and became part of the grand series of cultural gardens along Rockefeller Parkway.

In 1921, the city gathered together in Wade Park to celebrate another anniversary, the sexcentenary of Dante's death. Mayor William S. Fitzgerald and Dr. G. A. Barricelli, Acting Italian Vice-Consul for Cleveland, were joined by representatives of all the arts and educational institutions in town. The minutes of the committee state their high ideals:

> It is suggested that exercises be held on September 14th at Wade Park emphasizing the poetry and music of Italy in commemoration of the six hundredth anniversary of Dante's death. A group of players of stringed instruments and singers, both men and women, have been organized to render appropriate musical numbers. It is suggested that a recognized authority on Dante be secured to make an address eulogizing the poet and describing his works. Citizens of Italian birth or extraction have indicated they are ready and willing to present a bust of the poet to the city.

The committee also voted to request that the Board of Education name or rename a school after the poet, and that a film of Dante's *Inferno* be secured and shown to the public. Schools were asked to hold exercises on Dante. The committee was emphatic in its suggestion "that the educational rather than the spectacular be stressed." Linda Eastman, director of the Cleveland Public Library, took charge of distributing 10,000 special brochures on Dante, and the Cleveland Museum of Art placed a portrait of the poet in a display case with an informative text.

The blending of arts in the Shakespeare Garden and in the Dante Sexcentenary celebration involved a mix of theater,

literature, and art. A spirit of goodwill and interest in all the arts seems to have been characteristic of the fine-arts community in Cleveland from 1915 to 1929. Strong leadership was a key factor in the development of the fine arts in Cleveland during the 1920s; after years of having no established arts institutions in the city, Cleveland had suddenly blossomed to harbor a great number. The new leaders of these facilities were required to establish and meet goals for their institutions as well as for the city.

The director of the Cleveland Museum of Art, Frederic Allen Whiting, had already envisioned the museum as a place where all the arts coexisted and complemented one another. Whiting wanted to offer free concerts at the museum which would allow musicians to experiment with all types of music, giving them an additional venue in Cleveland, and at the same time educating the public. He advocated community singing to help teach the immigrant families English; he fully believed that the arts could be used as a means of acclimatization to the United States for its newest citizens.

Whiting's plans got a tremendous boost in 1920, when an anonymous gift of $250,000 was made to the museum to endow a music program and pay for the installation of an organ. The widow and daughters of P. J. McMyler made the gift in memory of the prominent Cleveland industrialist, although McMyler had never had a closer tie to music than singing in church choirs. Thomas Whitney Surette, from Concord, Massachusetts, was appointed the first curator of the new Musical Arts Department in 1921. He was well-known to Clevelanders, having visited the museum and lectured several times on the topic of music as a social force.

Surette was first and foremost a music educator, and though he presented concerts, his main interest was the education of children through vocal music and choral groups. Surette stayed with the museum for less than a year and was then replaced by his assistant, Douglas Moore, a young composer and performer. Moore's tenure lasted until 1925, when he was hired by the music department of Columbia University. Arthur Quimby next joined the staff and for sixteen years ran the musical arts program and taught at Western Reserve University. Both Moore and Quimby were more interested in concert activities than education, but they continued the educational programs established by Surette.

The Cleveland School of Art had a well-respected educator as its head during the 1920s as well. Henry Turner Bailey had become dean of the school in 1917, at Georgie Leighton Norton's insistence. Like Norton, Bailey was a graduate of the Massachusetts Normal Art School in Boston. During his tenure as director, two new additions were made to the school to accommodate the ever-increasing number of students. Even so, there was often a waiting list to join the classes.

Prior to coming to Cleveland, Bailey had served as state

supervisor of drawing for Massachusetts until becoming editor of *School Arts Magazine* in 1903. From 1906 until his move to Cleveland, he was director for the Chautauqua Summer School of Arts and Crafts and was regarded as one of the nation's foremost art educators.

Bailey wanted the Cleveland School of Art to become an integral part of the Cleveland community, which in the 1920s meant that art must meet and work with industry. To accomplish this goal, he expanded the ceramics department and added departments for printing and reproduction, architecture, costume, and interior design. The architecture department, sponsored in conjunction with the local chapter of the American Institute of Architects, became the Western Reserve School of Architecture in the 1930s.

Like Frederic Allen Whiting, Bailey had energy to spare and did not squander his time. He lectured, taught, and wrote extensively during his twelve years in Cleveland. He and Whiting worked closely together, and a healthy relationship existed between the art school and the art museum; indeed, Bailey taught the first class offered by the art museum and served as consultant to the museum's Education Department for almost ten years. He also helped to organize the John Huntington Polytechnic Institute and served as its director.

The Cleveland Orchestra and music schools were also contributing to the education of the Greater Cleveland area, and the orchestra's national tours under Sokoloff's baton began to make the city nationally known for its musical accomplishments. In many ways, Sokoloff had a more difficult and demanding job than either Whiting or Bailey, being responsible for three separate series of concerts per season: the regular subscription season, the educational young people's concerts, and a pop series designed to add working people to the orchestra's regular audience.

In addition to these "normal" activities, in 1921 Sokoloff began taking his musicians on the road, marking a milestone in Cleveland's cultural development. For its entire history, Cleveland had had to import musicians and orchestras from other cities; in 1921 it took its place among the ranks of cities that provided great music for those less fortunate. Sokoloff took his musicians first to the East Coast—Washington, D.C., Boston, and New York City—an ambitious undertaking for a director of such a young orchestra. In the following years he would take the Clevelanders north to Canada, west to Kansas City, Missouri, and south to Havana, Cuba.

Sokoloff had his own musical and conducting tastes, which were quite different from those of his immediate successors, Artur Rodzinski, Erich Leinsdorf, and George Szell, who were all trained in the Austro-German tradition, stressing both classical and romantic scores. Sokoloff was fanatically fond of romantic and neoromantic composers of the

French, Russian, and nationalist schools—namely Rachmaninoff, Stravinsky, Strauss, and Ravel.

Many orchestras had been started in Cleveland only to fail. Sokoloff had to both train a professional orchestra and entice a regular audience. Cleveland was a conservative town, and if Sokoloff performed the *1812 Overture* to the accompaniment of actual cannons in order to entice the masses, as he did in 1925 at a popular program, he did it to earn the orchestra an audience which could be educated at later performances and by later conductors. The present orchestra, like many throughout the United States, uses this same technique to bring in new audiences by performing the *1812 Overture* with fireworks on the Fourth of July.

Sokoloff recognized the importance of wooing members of Cleveland's immigrant communities to become regular orchestra-goers. In the 1925–26 season, he offered a series of special concerts entitled "Music of Many Lands," held in the new Music Hall and featuring the music of Germany, Hungary, Czechoslovakia, Poland, and other countries. He won the hearts of many members of the ethnic communities by inviting their choral groups and dancers to appear in concerts with the orchestra.

To Cleveland's great benefit, Sokoloff believed in inviting composers to conduct their own music. Clevelanders had the opportunity throughout the 1920s to hear Ravel, Prokofiev, Georges Enesco, and Ottorino Respighi. Ravel directed an entire evening of his music which featured the Cleveland premieres of *Valses nobles et sentimentales, Rhapsodie espagnole*, and *Shéhérazade*. Sokoloff's years were also marked by his dedication to the performance of works by American composers, including Howard Hanson and Douglas Moore. Both Ernest Bloch and Beryl Rubinstein, consecutive directors of the Cleveland Institute of Music, conducted the orchestra in performances of their own compositions.

The orchestra had been founded by Adella Prentiss Hughes and many of Cleveland's music lovers with an educational function in mind, and this function was not forgotten by Sokoloff. Russell Morgan had been appointed assistant supervisor of music for the Cleveland Public Schools early in the 1920s, and during his first year the Cleveland Orchestra and the Board of Education agreed to furnish free instrumental music instruction for 800 students in grades seven through twelve (see Fig. 59).

Proof of Sokoloff's success was made tangible during a tenth-anniversary concert at Public Auditorium on December 11, 1928. At intermission Dudley Blossom announced that John and Elizabeth Severance had pledged $1 million for the construction of a concert hall, if an additional $2.5 million could be raised from the community for an endowment. Elizabeth passed away before the groundbreaking for the new facility in 1929, and John L. Severance, in her memory,

FIGURE 59. Children entering Severance Hall for a concert. One of the major facets of the Cleveland Orchestra's work since its inception has been educational—accomplished principally through a concert series for local schoolchildren. Courtesy of the Musical Arts Association.

FIGURE 60. John L. Severance, well-known supporter of Cleveland's cultural institutions, ca. 1929. Courtesy of the Cleveland Press Collection, Cleveland State University.

JOHN L. SEVERANCE (May 8, 1863–Jan. 16, 1936), noted industrialist and philanthropist, was born in Cleveland, attending the Cleveland public schools and graduating from Oberlin College in 1885. His philanthropic interests included serving as president of the Cleveland Museum of Art and the Musical Arts Association. In 1930, in memory of his wife, Elizabeth, he gave the city $2.5 million to build a hall for the Cleveland Orchestra. Upon his death in 1936, the Cleveland Museum of Art was recipient of his art collection, valued at more than $3 million.

donated another $2 million to see the orchestra hall completed in grand style (see Figs. 60–62). Thanks to Sokoloff, Cleveland possessed an orchestra worthy of its new home.

Severance Hall, which opened to the public in 1931, was the last of the really grand structures planned and built in the 1920s. Cleveland's architectural face changed drastically in the decade with the erection downtown of Public Auditorium, the Cleveland Public Library, and the Federal Reserve Bank—all built as a part of (or near) the Group Plan. These buildings featured sculpted decorative elements on the exterior and painted ones on the interior, many the work of Cleveland's artists and workshops. Although the story of Cleveland's architectural wonders is not within the scope of this book, mention should be made of the legions of stone, marble, bronze, glass, and plaster workers whose creative efforts stand as equal to those produced by the "fine" artists of Cleveland.

A description of one building alone can serve as testimony to the skills of these men and women. When Cleveland was named as headquarters of one of the districts of the newly formed Federal Reserve Bank in 1913, the decision represented the strength of the city as an industrial and monetary center. Cleveland's bankers and organizers did not immediately raise a structure to house the Federal Reserve Bank. Nearly a decade was devoted to soliciting opinions, studying designs, and laying careful plans for a structure symbolic of Cleveland's diversity and strength of talent and resources.

Designed by the Cleveland firm of Walker and Weeks, the heavy, almost squat-looking pink marble structure at

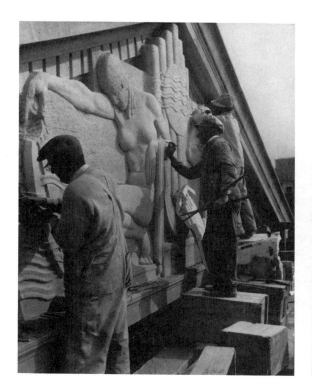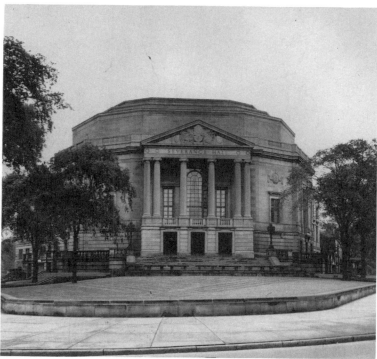

FIGURE 61. Craftsmen working on Severance Hall facade, ca. 1930. Courtesy of the Musical Arts Association.

FIGURE 62. Severance Hall, built as the home of the Cleveland Orchestra, opened to the public in 1931. The concert hall, donated by John L. Severance as a memorial to his wife, Elizabeth DeWitt Severance, was designed by Cleveland architects Walker and Weeks. Courtesy of the Cleveland Press Collection, Cleveland State University.

Superior and E. 6th Street is based on the Palazzo Medici-Riccardi in Florence—the residential palace built by the Medici family at the height of its power in the mid-fifteenth century. The appropriateness of this building to Cleveland as home of the Federal Reserve Bank is overt in its symbolism, conjuring up images of a successful, prosperous, culturally enriched banking family of the Renaissance at a time when Cleveland was going through its own renaissance. A public viewing of the new building was held when it opened in 1923; thirty-five persons per minute passed through monumental doors and by the grandiose statues of Security and Integrity into the grand banking hall, illustrated with murals by Cleveland artist Cora Holden. Portraits of Alexander Hamilton and Robert Morris painted by Alonzo Kimball, also a Clevelander, were on view as well.

Grand as the Federal Reserve Bank was, it was probably not as exciting to most Clevelanders as the buildings that had sprung up on Euclid Avenue between E. 14th and E. 17th. Just after World War I, Joseph Laronge conceived a plan to turn this area into Cleveland's premier entertainment district, with fine shops and theaters providing vaudeville, movies, and legitimate theatrical productions. Laronge teamed up with Marcus Loew of the New York theater syndicate to form Loew's Ohio Theaters. The State and Ohio theaters opened in February 1921, the Allen Theater began operations in April of the same year, and the Palace Theater opened in November of 1922.

The State Theater opened with *Polly with a Past*, starring Ina Claire, supported by Ralph Graves, a Cleveland actor. Before the movie, patrons lingered in the lavish Italian Renaissance lobby, said to be the longest of any theater in the world. The Ohio Theater, the first of the upper Euclid Avenue houses devoted to live drama, presented *The Return of Peter Grimm*, starring David Warfield, as its opening performance. The Allen Theater was primarily a motion picture facility, and the Palace Theater served the vaudeville audience.

Just across the street, Dan R. Hanna had erected an office complex containing the 1,500-seat Hanna Theater, which opened in March 1921, with a production of *The Prince and the Pauper*. It was dedicated to the memory of Hanna's father, Senator Marcus A. Hanna, theater aficionado and former owner of the Euclid Avenue Opera House. After the latter's demise in 1922, the Hanna eventually replaced it as the major venue in Cleveland for touring Broadway companies. While the Ohio was converted into a nightclub and later a movie house, the Hanna survived for sixty years as downtown's only live, serious theater.

Hanna audiences in the 1920s could see Walter Hampden in *Cyrano de Bergerac*, Helen Hayes in *Coquette*, and Ethel Barrymore in *Scarlet Sister Mary*. During the extraordinarily creative 1930s, the Hanna hosted *The Barretts of Wimpole Street* with Katharine Cornell, *Design for Living* with Noël Coward and the Lunts, *The Green Pastures* with Richard B. Harrison, *Abe Lincoln in Illinois* with Raymond Massey, and *The Little Foxes* with Tallulah Bankhead. Many of its productions were part of the New York Theatre Guild's subscription series. Occasionally a Broadway producer would eschew the traditional New Haven or Boston tryout and open a show in Cleveland. Among the Hanna's notable world premieres were Maxwell Anderson's *High Tor* in 1936 and Rodgers and Hammerstein's *Me and Juliet* in 1953.

Thus the 1920s were good years for theater in Cleveland. New theaters brought, of course, a wide variety and quality of performances before the Cleveland public. Whether they took advantage of it or not, Clevelanders had the opportunity to become more discriminating in their tastes regarding professional theater. Under the regime of Frederic McConnell, assisted by K. Elmo Lowe, the Play House assumed the responsibility of educating local audiences. During the 1920s it became more of a Shaw house than even the Theatre Guild, mounting twenty-six productions of fifteen different plays by the Irish playwright. *Candida* was clearly the popular favorite, with five showings in the 1920s and two more in the 1930s. *The Admirable Bashville*, *Androcles and the Lion*, and *Arms and the Man* were each given three times, although *Man and Superman*, *Major Barbara*, and *Saint Joan* weren't to be seen on E. 86th at all. Following Shaw in popularity among the moderns were Pirandello and Galsworthy, represented during

the 1920s by four plays apiece. Also noteworthy were productions of Capek's *R.U.R.* and the Soviet play *Red Rust*. Shakespeare proved a steady drawing card, with nineteen productions of a dozen works between the two world wars.

American playwrights were introduced slowly by the Play House, not coming into their own until the 1930s. O'Neill's *Beyond the Horizon* was done early and often (four times in the 1920s), but only two more of the Irish-American master's works were seen during the entire period. Oddly enough, the most popular American dramatist on the Play House stage between the wars was Elmer Rice, whose *The Adding Machine* received four revivals. Five other Rice plays were given, including the world premiere of *Not for Children*. Maxwell Anderson and S. N. Behrman were each represented by three plays during the period. John Houseman's only creative dramatic effort, a collaborative piece entitled *A Very Great Man*, received its world premiere at the Play House in 1932.

Besides its regular audiences, the Play House also undertook the education of younger Clevelanders. Its Youth Theater was started as the Curtain Pullers by Esther Mullin in 1933, the same year it began an annual Shakespeare Festival for secondary students. An adjunct program with Western Reserve University's theater department offered students tuition-free training in return for help in staging Play House productions.

Opera was of interest in Cleveland as well, enough so that in 1920 the Studio Club, under the direction of Francis Sadler, began giving light operas in local theaters. The Cleveland Opera Company, as it later came to be known, performed throughout Cleveland in the twenties and thirties until it was disbanded in 1937. In 1924 the company was chosen to premiere an "all-American" opera, *Alglala*, by Franceso de Leone, a composer from Akron, and Cecil Fanning. Accompanying the singers was a forty-piece orchestra made up of members of the Cleveland Orchestra conducted by F. Karl Grossman. During the thirties the group was funded as part of the Federal Music Project and performed at schools and churches, as well as in Public Hall and the new Cain Park Theater.

For the most part, however, Clevelanders continued to rely upon outside importations for operatic fulfillment. Chicago's Civic Opera came three times in the mid-1920s with such attractions as Boito's *Mefistofele* with Chaliapin, and Massenet's *Thaïs* with Mary Garden. The only complete staged performances of Wagner's tetralogy *The Ring of the Nibelungs* ever given in Cleveland came twice during the same decade, from the Wagnerian Opera Company at Masonic Hall in 1923 and the German Grand Opera Company at Music Hall in 1929. There was also a Russian Grand Opera Company in 1922, which brought Rimsky-Korsakov's *Snow Maiden* as well as *Boris Godunov* and *Eugene Onegin*.

The mainstay of local operagoers was provided in 1924 by a civic group headed by Newton D. Baker, which arranged for an annual one-week appearance by New York's Metropolitan Opera Company in the cavernous new Public Hall. Formally organized in 1927 as the Northern Ohio Opera Association, the sponsors took pride in Cleveland's status as the chief stop on the Met's spring tour, where productions were often viewed by crowds of more than 8,000. Critics groused about the barn-like ambiance of the setting, but audiences thrilled to the singing of such artists as Rosa Ponselle, Lily Pons, Kirsten Flagstad, Lauritz Melchior, Leonard Warren, and Ezio Pinza. Repertoire tended to remain ultra-conservative, headed by such perennial warhorses as *Aïda*, *Carmen*, and *La Bohème*, although audiences were occasionally tempted with such tidbits as *The Bartered Bride*. An annual fixture for more than sixty years, the Met paradoxically gave Cleveland a week of the best opera it had to offer, but also may have retarded the nurturing of a strong locally based company.

The branch of the fine arts slowest to develop in Cleveland was dance, particularly ballet. However, considering again Cleveland's New England conservatism and the relative youth of ballet as an acknowledged art form, the delay is understandable. With the exception of foreign folk-dance groups, ballet or dance as the featured performance on Cleveland's stages did not appear with any regularity until the 1920s.

The Russian Ballet with Anna Pavlova and Mikhail Mordkin had appeared at the Hippodrome Theater as early as 1911. Pavlova returned to Cleveland in 1914 at the Ohio National Guard Armory to benefit the Huron Road Hospital. Early in 1916, Adella Prentiss Hughes decided that Clevelanders would like ballet if they had a chance to understand it (see Fig. 63). She made arrangements for a performance of Diaghilev's Ballets Russes in Cleveland, and then she went to work at home.

Hughes organized the "Cleveland Campaign" to prepare her audience for the ballet prior to its arrival. She was well aware that some of the stories, costumes, and movements in the ballet would not go over well with the conservative Cleveland audience. In her own words, "Our visit . . . [to New York] . . . revealed to me that the realistic pagan dances into which the company threw themselves with abandon would be more than shocking for a large section of my audience." Hughes focused instead on the "artistic qualities" of the performance.

Hughes, with the Musical Arts Association, arranged a private showing of watercolors by the Russian theater designer Leon Bakst at the Hotel Statler. Bakst and Sergei Diaghilev had been associated with one another since the 1890s, and between them knew most of the avant-garde artists, poets, and playwrights in Europe. Raymond O'Neil, the

FIGURE 63. A blending of the arts: Program for the "Carnaval De Danse and Charity Ball," directed by music impresario Adella Prentiss Hughes, displays the craftsmanship of Cleveland artist Charles Burchfield, ca. 1914. Courtesy of the Musical Arts Association.

first director of the Cleveland Play House, gave a lecture on the modern watercolors to make them more palatable. In addition to the formal show, Marie Burt Parr gave three "Lectures Musicales" on the Russian ballet and on Bakst's influence on modern art.

By the time the Ballets Russes actually arrived in Cleveland to perform, Hughes had her audience well trained. They knew the music, they understood the stage design and the development of the Ballets Russes itself, and they were delighted with the performance. Diaghilev later told Hughes that the Cleveland audience had been the most appreciative and best-prepared audience for whom they had performed.

World War I interrupted the travel of ballet groups to the States, but Cleveland was ready for dance when the war came to an end. Throughout the 1920s, ballets from Russia, Paris, and London made appearances at Masonic Hall, Public Hall, and the Hanna Theater, many under the auspices of Hughes and the Fortnightly Musical Club.

The Cleveland Conference for Educational Cooperation

By the early 1920s, four of Cleveland's most important educational institutions were located in the Wade Park area— the Cleveland Museum of Art, the Cleveland School of Art,

Western Reserve University, and Case Institute of Technology. The leaders of these institutions, Frederic A. Whiting, Henry T. Bailey, Dr. R. E. Vinson, and Dr. C. S. Howe, had come to realize the natural advantages that awaited the citizens of Cleveland if the various arts and educational institutions worked together to try to improve and expand their services to the community.

Early in 1924 Frederic Whiting approached Dr. Frederic P. Keppel, president of the Carnegie Corporation in New York City, about conducting a survey of Cleveland's educational and cultural institutions to see if there was indeed a need for such a cooperative venture. The trustees of the Carnegie Corporation were interested at the time in the problem of adult education in America, their primary concern being that as labor hours were shortened, the adult population needed constructive ways to fill its time. Just as Cleveland was looking for some organization to fund its much-needed survey, the Carnegie Corporation had been searching for an American city in which the adult education problem could be studied.

Influenced by a track record that included Cleveland's groundbreaking Community Fund, Keppel promised to recommend a $10,000 grant for the city if all the educational agencies in Cleveland would band together in a cooperative effort. The formal appeal for funds was made to the Carnegie Corporation by the Cleveland Conference for Educational Cooperation on January 25, 1925. Eighteen of the vital educational institutions in the city subscribed to the plan, including Case School of Applied Science, the Cleveland Institute of Music, the Cleveland Kindergarten Training School, the Cleveland Museum of Art, the Cleveland Museum of Natural History, the Cleveland Public Schools system, the Cleveland School of Education, the Musical Arts Association, the Cleveland Play House, the Cleveland School of Architecture, the Welfare Federation of Cleveland, the Western Reserve Historical Society, Western Reserve University, the YMCA, the YWCA, the Cleveland School of Art, the John Huntington Polytechnic Institute, and the Cleveland Public Library; the grant was awarded in March of the same year.

The Cleveland Conference was composed of active members (usually the head or director), advisory members (usually two important patrons or trustees), and two to three associate members from each institution. Despite the problems and personality conflicts involved in coordinating a group this large, the Conference began to discuss grand plans rather quickly.

In February 1926 the Cleveland Conference members started to discuss the possibility of a west side facility that would be a joint building for the various fine-arts groups which were predominantly located on the east side of the city. By June the Conference had identified the Carnegie West

Branch of the Cleveland Public Library as the site for a joint venture between the library, the Cleveland Museum of Art, the Cleveland Museum of Natural History, and the Western Reserve Historical Society. For each of the first three weeks of the month, one of the institutions would set up a display and offer an art, natural history, or history lecture relating to it; the fourth week would be dedicated to a performance by a small musical group.

The idea was brilliant if a little impractical in terms of moving objects in and out of display cases and back and forth from the west side to the east side. Nevertheless, the project did get off the ground, only in time to fall victim to the financial setbacks of the Depression. Other plans the Conference made that never materialized were a project to investigate the cultural contributions to American life of various local groups and a program to encourage talented children in the fine arts and to establish a young playwrights' workshop.

As the 1920s progressed, the majority of Cleveland's cultural institutions either were already located in the Wade Park area or were thinking of locating there. Directors and trustees alike began to envision the area as Cleveland's cultural center. As early as October 1926, in a report to the Carnegie Corporation, the "Educational Group Plan" was being discussed. The Cleveland Conference for Educational Cooperation, from late 1926 on, became, in actuality, the "Cleveland Educational Group Plan project," with the main goals of the larger members of the Conference focused on locating as many of Cleveland's cultural facilities in the Wade Park area as possible.

As a result of the relationships which developed under the auspices of the Cleveland Conference, what is now the University Circle area was able to add the Cleveland Museum of Natural History, the Cleveland School of Art, the Garden Club of Cleveland, the Fine Arts Gardens, Lakeside Hospital, the Cleveland Music School Settlement, Severance Hall, and ultimately the Cleveland Institute of Music to the list of its residents.

CHAPTER *8*

Weathering the Storm

Private Endeavor and Public
Art during the Depression

The 1920s had seen remarkable cooperative programs developed among the various fine-arts institutions, as well as the independent progress of each individual institution. Despite a diminished momentum due to the financial setbacks of the Great Depression, the 1930s were a decade of continued growth for the fine arts in Cleveland. This growth was primarily the result of continued community support, changes in leadership positions at the major cultural institutions (museum, art school, and orchestra), and federal government programs instituted to support the arts and artists of the United States—the Public Works of Art Project (PWAP), four arts projects of the Works Progress Administration (WPA), and the National Youth Administration. The literary life of Cleveland was given a boost in the 1930s by the occasional presence of such writers as Langston Hughes, who worked closely with Karamu House, and Hart Crane; however, these men did most of their recognized work outside of Cleveland, and Hughes was already living in New York City during this influential period.

The existing fine-arts institutions had had a good ten years to establish the importance of their facilities. By 1930 each had become a vital force in the Cleveland community. So much time, manpower, and spirit had been invested in creation of the art museum, the art school, the Music School Settlement, the orchestra, Karamu House, and the Cleveland

Play House that despite financial difficulties, these institutions were not allowed to perish. Many important founding patrons passed away in the late 1920s and 1930s, including Jeptha Wade, John L. and Elizabeth Severance, Dudley S. Blossom, Samuel Mather, and Francis Fleury Prentiss, but someone always stepped forward to replace them.

There were changes in leadership on a more direct level as well. In 1930 Frederic Allen Whiting resigned as director of the Cleveland Museum of Art to become president of the American Association of Museums. He was replaced by William M. Milliken, a talented young curator whose brilliant connoisseurship was responsible for the museum's display and acquisition of part of the important Guelph Treasure in 1931. While Whiting was interested in education, Milliken was interested in creating an internationally renowned collection. However, education was not neglected under the new director. When Rossiter Howard, who had been head of education since 1921, left the museum to take a similar position in Philadelphia at the Pennsylvania Museum of Art, he was replaced by Thomas Munro, who had earned his doctorate at Columbia University studying under the important American educational reformer and philosopher John Dewey.

Henry Turner Bailey retired from the Cleveland School of Art in 1930 and was replaced by Henry Hunt Clark, who had come to Cleveland from a position as director of the Boston Museum School's department of design. Clark was faced with the difficult task of guiding the art school through the financially trying years of both the Depression and then World War II. Just a year after his arrival, enrollment had dropped 30 percent overall and close to 20 percent among students registered full-time. Clark was assisted by businessman and connoisseur Ralph M. Coe, who became president of the board of trustees the same year Clark arrived.

In 1933 Nikolai Sokoloff and the Cleveland Orchestra parted company. Sokoloff left to conduct the New York Orchestra, and from 1935 to 1938 he directed the Music Project of the Works Progress Administration. Artur Rodzinski replaced Sokoloff as conductor of the Cleveland Orchestra, making his debut on December 29, 1932. Well-trained in the works of both classical and romantic composers, Rodzinski had studied in Vienna at the famous Academy of Music and brought with him to Cleveland a love for opera. The combination of Rodzinski's vigorous and flamboyant style, his opera productions, and the orchestra's grand, new Severance Hall attracted many new fans during the 1930s.

The Cleveland Institute of Music also got a new head. Ernest Bloch had left the school in 1925, but he was not officially replaced with a full-time artistic director until 1932, when Beryl Rubinstein was appointed to fill the position. Rubinstein (see Fig. 64), a pianist and composer, had joined the Institute staff in 1921 as a faculty member in the Piano

FIGURE 64. Beryl Rubinstein with student at the Cleveland Institute of Music, ca. 1938. Courtesy of the Cleveland Press Collection, Cleveland State University.

BERYL RUBINSTEIN (Oct. 26, 1898–Dec. 29, 1952), prominent pianist, composer, and teacher, joined the faculty of the Cleveland Institute of Music in 1921 and served as its director from 1932 to 1952. During his time at the Institute, he was known for bringing world-renowned musicians to the faculty. As a composer, Rubinstein produced many works, along with an opera, *The Sleeping Beauty,* which premiered in New York in 1938 and was the final opera performed in the Cleveland Orchestra's Severance Hall series in the Artur Rodzinski era.

Department. He was elevated to chair of that department in 1925 and to dean of faculty in 1929. In 1932 he was the obvious choice for director.

The Cleveland Music School Settlement had continued to grow and expand its programs during the 1920s under the directorship of Mrs. Martha Ramsey. In June 1933, Mrs. Ramsey and her husband decided to return to their home in New York, despite the appeals of the trustees. Ramsey was replaced by Emily McCallip, who had worked under similar conditions at the Philadelphia Settlement of Music (1916–24) and the Curtis Institute of Music (1924–33). At the time of her arrival, the Music School Settlement had already begun collaborating with other settlement houses in the city to provide music education; as the Depression years progressed, more and more

unemployed adults turned to the settlement houses' programs to fill idle hours.

With these impressive leaders at the helms of Cleveland's major fine-arts institutions, the years of the Great Depression were hardly depressing in terms of art, music, literature, and theater in the city.

The Cleveland Museum of Art

By the time Frederic Allen Whiting departed the Cleveland Museum of Art in 1930, he had established huge art and music education programs that at times threatened to take over the museum. As a result of his work with the Cleveland Conference, Whiting and the museum staff had begun several programs to focus activity on areas outside of or apart from the permanent collection—at branch libraries, in the museum gardens, and the Extension Department's displays at local schools and libraries. The museum's annual reports for the twenties reflected the all-encompassing interests of its director. Each report began with a fairly extensive summary by Whiting that indicated a clear interest in and knowledge of exactly what was going on in each department of the museum. From there he went on to discuss national and international issues peripheral to the museum's activities, as well as important events occurring at other institutions.

During the Whiting years, the museum had moved toward a decentralization of efforts to include a broad spectrum of arts-related activities. These activities were disseminated to as wide a cross-section of the community as possible, with an emphasis on children's education. During the first ten years of Milliken's tenure, this emphasis was reversed; a streamlining of the museum's activities, directed by Milliken, aimed to focus on the development of the permanent collection. The streamlining was financially necessary, of course, but it also served Milliken's purposes quite well.

The museum still maintained a large education program and received important grants to study children's art abilities. The fame of the education department was in part Rossitor Howard's legacy, but it was also due to the scholarly reputation of the new curator, Thomas Munro. During the 1930s Munro slowly reformed the museum's policy toward education, so that classes and activities were evenly distributed between adult education and children's programs, many held in cooperation with Western Reserve University. By 1937 no fewer than six members of the museum staff were offering courses in connection with the university. Because of a drastic drop in the McMyler endowment, however, educational activ-

ities as well as some recitals were curtailed in the Musical Arts Department.

The decline in purchase funds caused by the Depression does not seem to have greatly affected the quality of museum acquisitions during the 1930s, although there is no way of measuring the works of art that "got away" during these financially troubled times. Milliken, who was on good terms socially with the major figures on the board, was not above shedding tears at acquisitions meetings if it appeared that the trustees might not approve a purchase. The six pieces of the Guelph Treasure procured for the museum on Milliken's recommendations, and two additional pieces received as gifts, would have been an outstanding purchase at any period during the museum's existence and are of particular note as Cleveland was the only American museum to purchase a significant portion of this famed treasure (see Fig. 65). Their display drew 97,000 visitors to the museum, 8,200 on opening day. As a result of this purchase, Cleveland has one of the finest collections of medieval German art outside of that country.

A name which began to appear more and more fre-

FIGURE 65. William Milliken and a piece from the famous Guelph Treasure, ca. 1958. Courtesy of the Cleveland Public Library.

WILLIAM M. MILLIKEN (Sept. 28, 1889–Mar. 14, 1978) was the second director of the Cleveland Museum of Art. He came to Cleveland in 1918 and was appointed curator of decorative arts at the museum. Milliken succeeded Frederick Whiting as director in 1930, serving until 1958. Two major accomplishments during the Milliken years at the museum were the purchase of the Guelph Treasure in 1930 and the success of the May Show. The Guelph Treasure, nine pieces of medieval art dating back to the tenth century, brought the museum international stature. The May Show, an annual exhibition of local artists, provided the opportunity for the community to buy locally crafted art pieces.

quently in museum records during the thirties is that of Cleveland philanthropist Leonard C. Hanna, Jr. Hanna was an art, theater, and music connoisseur and collector extraordinaire, and had served as a member of the committee that had appointed Milliken as director. In 1936 Hanna subsidized an exhibition of Vincent Van Gogh's works in which the sale of reproductions exceeded all previous records.

The museum celebrated its twentieth anniversary by sponsoring what was billed as the "official" exhibition of the Great Lakes Exposition in 1936. The Exposition was designed to celebrate the centennial of Cleveland's incorporation as a city, and to provide a much-needed escape from the dreariness of life during the Depression. There were exhibitions and displays, an art gallery, gardens, concerts, and even an Aquacade with water ballet shows featuring Johnny Weissmuller and Eleanor Holm. Though the Exposition provided temporary work for many of the city's artists, performers, and architects, the real support for Cleveland's fine-arts community came from other sources.

Cleveland's Artists during the Depression: Local, State, and National Relief Programs

Throughout the thirties, the May Show continued annually to present to the public the work of regional artists. Milliken broad-mindedly allowed artists to create as many duplicates of pieces as they desired to sell to the art patrons. Every dollar spent not only helped the individual artist but also helped to ensure the survival of the visual arts in Cleveland. Milliken even supported Mrs. B. P. Bole, Mrs. Malcolm McBride, and Miss Julia Raymond in organizing a group called the Pick-Quick Club. "You can become a member," said an invitation mailed to Cleveland families during the 1930s,

by purchasing a painting, a piece of sculpture, a print or an example of any of the artcraft produced by a Cleveland artist or craftsman. . . .

If you feel your house is already overflowing with works of art, there are lots of things you can do with still more. You can loan or give them to schools or libraries; you can use them for handsome presents to your friends, but preferably you will keep most of them for your own, locating them on your own walls and adding to them annually (or semi-annually), gradually acquiring a collection—and a reputation as a connoisseur.

The purpose of this club, therefore, is wholly altruistic, and it is our hope, through membership in it, to increase our own understanding of contemporary art; and we think it would be exhilarating now and again to come to tea at one of the member's houses and meet each other's purchases.

The club will be officially known as the Cleveland Pick-Quick Club, and the members of it as "Pickles."

P - Painting
I - Illustration
C - Carving
K - Keramics
L - Lace
E - Etching
S - Sculpture

Wouldn't you like to be a "Pickle?"

Unfortunately for Cleveland's many artists, there weren't enough "pickles" around to provide a living. Instead, the Roosevelt administration recognized the plight of artists as well as that of other workers and in 1933 began the first tentative steps at government intervention to reverse the devastating effects of the Depression. During the first year, 4,000

FIGURE 66. Mural painted by William Sommer and funded by the WPA, located in Brett Hall of the Cleveland Public Library. Courtesy of the Cleveland Public Library.

artists were employed in the creation of 700 murals and 15,000 other art objects as part of the Public Works of Art Project directed by the Treasury Department. Appointed regional director of the PWAP, William Milliken quickly hired 72 local artists. Within three months he was able to display 130 examples of their work at his Cleveland Museum of Art, of which 30 went on to a national show of the best 3 percent of the PWAP in Washington.

One of the first works commissioned was a mural cycle to decorate the Public Auditorium. Sixteen scenes were to be designed around the general theme "The Resources of the City." Jack Greitzer and Michael Sarisky were two of the artists hired to work on the project at salaries ranging from twenty-five to forty dollars per week. Cleveland artists also produced murals for the Cleveland Public Library—William Sommer's contribution depicted Public Square in the mid-nineteenth century (see Fig. 66). Other artists produced maps, sculptures, and figurines for local schools.

With the organization of the Works Progress Administration in 1935, PWAP was superseded by the Federal Art Project, directed locally by Carl Broemel. For the next seven years, 350 local artists worked on projects ranging from a three-story mural in Lincoln High to hundreds of silk-screened metal cutouts of police officers warning motorists to slow down in school zones. According to one critic, the muralists' use of brilliant colors and simple, formal shapes continued the regional style begun by their predecessors on the PWAP. On a much more intimate scale, a series of character statuettes from *Alice in Wonderland* by ceramicist Edris Eckhardt won first place in the 1936 May Show and prompted orders for copies for schools and libraries throughout the country (see Fig. 67).

The federal government naturally wanted tangible results of its programs, and large-scale murals and three-dimensional works best fit their criteria. Nevertheless, Cleveland artists managed to organize a print workshop under the direction of artist Kalman Kubinyi, who became the local project's fourth and last director (see Fig. 68). Prints and printmaking were low on the list of federally funded projects because of the ephemeral nature of paper and the high cost of printing equipment. Kubinyi, however, was a teacher at the John Huntington Polytechnic Institute and had access to a press. He successfully directed both fine artists and commercial artists; among them were Frank Fousek, Sheffield Kagy, and Paul Kucharyson. Among the 6,000 separate plates produced by the graphic-arts unit was an intense series on the unemployed by Dorothy Rutka.

For many Clevelanders, the entire idea of federal funding was abhorrent, even as they realized its necessity. Cleveland had a reputation of taking care of its own citizens and had set the standard for the rest of the nation in terms of civic

FIGURE 67. Edris Eckhardt and sculpture, ca. 1942. Courtesy of the Cleveland Press Collection, Cleveland State University.

EDRIS ECKHARDT (Jan. 28, 1910–), world-famous sculptor and glassmaker, was born in Cleveland and attended East High School. She graduated from the Cleveland School of Art in 1927 and began winning prizes in the May Show in 1933. Already nationally known for her works of characters from children's books, Eckhardt in 1939 was chosen in a wide competition by Eleanor Roosevelt to sculpt a portrait of Huckleberry Finn. While ceramics director of the Federal Art Project in Cleveland, she completed 30 pieces of sculpture. In 1953, Eckhardt revived the Egyptian method of fusing gold between sheets of glass, thereby producing the first gold-glass in two thousand years. She became internationally recognized for the process.

responsibility with the founding of the Cleveland Welfare Federation and the Community Fund. Clevelanders were proud of their ability to endow and maintain their own civic, cultural, and religious institutions. The stock market crash, however, had made the city dependent upon federal monies to sustain important benevolent, social, and cultural institutions and organizations.

The Musical Arts in Cleveland during the 1930s: Artur Rodzinski and the Cleveland Orchestra

Taking over the podium from Nikolai Sokoloff, Artur Rodzinski managed to banish the Depression at least temporarily from the art deco interior of Severance Hall. The new home of the Cleveland Orchestra had been designed to accommodate fully staged operatic performances as well as symphonic concerts, and the flamboyant maestro soon put it to the test. A Depression-induced suspension of the annual Metropolitan Opera tour was an added incentive. Even today,

the Rodzinski regime at the Cleveland Orchestra is remembered for the series of operas done as part of the regular concert seasons from 1933 through 1937 (see Fig. 69).

Not one to approach things gradually, Rodzinski began the venture during his first season with Wagner's *Tristan und Isolde.* Despite the participation of such vocalists as Elsa Alsen, Paul Althouse, and Rose Bampton, *Plain Dealer* critic Herbert Elwell singled out Rodzinski as "in many ways . . . the greatest star of them all." Four other Wagnerian music dramas were heard at Severance in those years, as well as Verdi's *Otello,* Wolf-Ferrari's *The Secret of Suzanne,* and Strauss's *Elektra* and *Der Rosenkavalier.*

Easily the high point of the entire opera series, however, was the first performance outside Russia of Dmitri Shostakovich's sensational *Lady Macbeth of Mzensk.* Rodzinski imported a cast of Russian soloists from New York for the premiere on January 31, 1935. "As a matter of fact," cracked Wes Lawrence of the *Plain Dealer,* "the whole opera is what you may call a bit risque, so it is just as well you cannot understand the words." In the graver opinion of the *Cleveland Press,* the language bar-

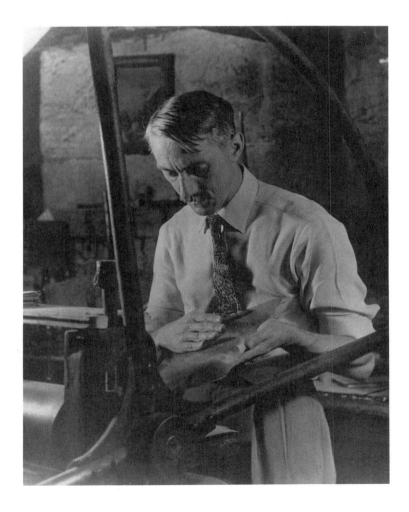

FIGURE 68. Cleveland printmaker Kalman Kubinyi in his studio. Courtesy of the Cleveland Museum of Art.

KALMAN KUBINYI (July 29, 1906–Sept. 1973), born in Cleveland, was one of the city's great printmakers. After graduating from the Cleveland School of Art in 1927, Kubinyi studied in Europe, learning the craft of printmaking from his uncle. Returning to Cleveland, he taught graphic arts at the John Huntington Polytechnic Institute, the Cleveland School of Art, and the Cleveland Museum of Art. In the 1930s, Kubinyi became director of the Cleveland WPA Federal Art Project, serving in that capacity until 1940. He moved to New England in 1950 and became president of the New England Chapter of Artists.

FIGURE 69. Artur Rodzinski, musical director of the Cleveland Orchestra from 1933 to 1943, endeavored to bring classical works to a Depression-weary Cleveland audience with great success. Photo by Geoffrey Landesmann, courtesy of the Archives of the Cleveland Orchestra.

FIGURE 70. Musicians of the WPA Federal Music Project copying music at the Cleveland Public Library., ca. 1936. The WPA Federal Music Project provided work for unemployed musicians. The program was directed nationally by former Cleveland Orchestra conductor Nikolai Sokoloff. Courtesy of the Cleveland Public Library.

rier also provided insurance against any Soviet propaganda lurking in the work. "The idea!" huffed a Severance Hall dowager after the opera's much-heralded love scene. "Putting a thing like that on the stage before our very eyes."

Nevertheless, Cleveland enthusiastically applauded the effort and had the added satisfaction of seeing Rodzinski take the same forces to the Metropolitan Opera House for the work's New York premiere. For years, the Met had been bringing opera to Cleveland; at last, Cleveland was able to return the favor. Actually, resumption of the Metropolitan tours in 1937, combined with the cost of producing opera at Severance Hall, caused cessation of opera at that venue.

The programs of the Cleveland Orchestra were affected by the Depression in other ways besides funding. The Federal Music Project, under the direction of Nikolai Sokoloff from 1935 to 1938, stressed to conductors around the nation that they should emphasize the works of American composers. Rodzinski was happy to comply. Clevelanders heard works by Walter Piston, Samuel Barber, and Roy Harris during the 1930s, and before Rodzinski left Cleveland, they were introduced to the works of William Schuman, Jerome Kern, and Aaron Copland as well (see Figs. 70–72).

Not all of the events concerning the orchestra in the 1930s were happy ones. John L. Severance died nearly destitute on January 16, 1936, as a result of reversals due to the stock market crash. He had been a generous benefactor of both the orchestra and the art museum. Less than three years later Dudley S. Blossom passed away. Blossom had long been connected with the orchestra, and as president of the Musical Arts Association, he had spearheaded the matching-funds campaign for the construction of Severance Hall.

The orchestra was not without friends, however. In 1937 Fynette Hill and Elroy John Kulas established the Kulas Foundation to help promote music and music education in northern Ohio, as well as to sponsor a training program for young conductors. Their generosity also extended to Baldwin-Wallace College in 1938, when they donated $50,000 for the construction of a music building. The resulting Kulas Memorial Arts Building provided a suitable location for the Baldwin-Wallace Bach Festival, which had been instituted by Dr. Albert Riemenschneider. For several days each year from 1933 to the present, scholars and music lovers alike have converged on the Berea campus to hear concerts culminating in the performance of one of the master's great choral works.

The Theatrical and Literary Scenes

In 1927 the Gilpin Players acquired property adjacent to the Playhouse Settlement and remodeled the building into a small theater which was given the name "Karamu," from a

Swahili word meaning "a place of joyful meeting" (see Fig. 73). Theatrical productions had come to be more and more the focal point of activities at the Settlement House. Because of Russell and Rowena Jelliffe's unpopular stance on racial integration, the activities at Karamu often received more criticism than praise. The Gilpin Players began producing the works of relatively unknown playwrights, particularly those who dealt with black and interracial themes. In the thirties, they produced works by black playwrights such as Andrew M. Burrus, Willis Richardson, Countee Cullen, and Rudolph Fisher, as well as works by more recognized authors such as Shaw and O'Neill.

At times the theatrical presence became so strong that one could easily overlook the other strengths of the Jelliffes' program. An art-gathering expedition to Africa by local artist Paul Travis (see Fig. 74) was cosponsored by the Gilpin Players and the African Art Sponsors. When Travis returned in 1928, the art and artifacts he had collected were distributed among the Cleveland Museum of Art, the Cleveland Museum of Natural History, and, of course, Karamu House. Not everyone in the community looked favorably upon the collection, as many refused to recognize African art as an art form, and some feared that the primitive art might result in American blacks' being labeled as equally primitive.

One Karamu triumph that all could celebrate was the appearance of the Karamu Dancers at the 1940 New York World's Fair. Started by Oberlin graduate Marjorie Witt Johnson, the mostly female group used modern dance to interpret its African heritage and urban American experience. Among those who praised their performance in New York were Ruth St. Denis and Martha Graham.

Another highlight of the Depression decade at Karamu was a theatrical collaboration with the settlement's most famous "alumnus," the noted black writer Langston Hughes. A graduate of Central High School, Hughes had been encouraged to write by supportive teachers and by Rowena and Russell Jelliffe at the Playhouse Settlement. He began publishing poetry in 1921 and moved to New York, where he became part of the "Harlem Renaissance" with other black artists such as Countee Cullen and Paul Robeson.

Besides novels and poetry, Hughes also experimented with playwriting. Following the Broadway success of *Mulatto*, he chose Karamu to produce several of his plays in the late 1930s, including *Little Ham*, *Troubled Island*, and *Joy to My Soul* (see Fig. 75). When the final act of *Front Porch* failed to arrive in time in 1938, the show went on with a third act largely concocted by Rowena Jelliffe.

For a time some of the Gilpin Players performed as part of the local unit of the Federal Theatre, one of the four WPA arts projects. Among the productions done by the Cleveland project were its own *Living Newspaper* and *Triple-A Plowed Under*, a Living Newspaper originally done in New York.

FIGURES 71 and 72. Cleveland's major musical organizations were complemented by a host of smaller ensembles throughout the twentieth century, including the Orpheus Male Chorus, shown here en route to Europe, ca. 1923 (courtesy of the Cleveland Public Library), and the Cleveland Women's Orchestra, here rehearsing with Hyman Schandler ca. 1975 (courtesy of the Cleveland Press Collection, Cleveland State University).

The **ORPHEUS MALE CHORUS**, started in 1921 by Charles D. Dawe, was conceived when Dawe was interrupted by hammering outside his studio while giving a vocal lesson. When Dawe complained, the carpenter, Robert Walker, explained that the noise didn't matter because the student had no voice. Challenged by Dawe, Walker sang. Dawe was impressed and suggested that if the carpenter had any friends who could sing as well, he should bring them around. Walker brought 18 others with him, thereby creating the Orpheus Male Chorus. Under Dawe, the chorus grew to 90 members and traveled to competitions in Wales, where it won the Second Male Voice prize in 1923 and the Chief Male Voice competition in 1926. Dawe directed the chorus for 36 years. It disbanded in 1964.

The **CLEVELAND WOMEN'S ORCHESTRA** was formed in 1935 to give women with a desire for a musical outlet the opportunity to participate in an orchestral experience. Founded by the late Hyman Schandler, the Cleveland group is among the oldest ongoing women's orchestras in the country. The orchestra performs a minimum of 10 benefit concerts annually throughout Cleveland, in locations such as nursing homes, hospitals, senior centers, and social-service agencies. Each year the Cleveland Women's Orchestra presents a spring concert at Severance Hall.

FIGURE 73. Exterior view of Karamu House, ca. 1930s. Courtesy of the Western Reserve Historical Society.

KARAMU HOUSE is a settlement house nationally known for its dedication to interracial theater and arts. It was begun as the Playhouse Settlement in 1915 by Russell and Rowena Jelliffe, who bought two houses on E. 38th Street next to the Grant Park playground and began their work. Their enterprise soon became known as the Playhouse Settlement. They soon turned to theater as a way to interact with the children and evoke their talents, producing *Cinderella* in 1917 with a racially integrated cast. The Jelliffes incorporated the Neighborhood Association in 1919 and continued to provide services to the community and to black migrants arriving in Cleveland. The arts became increasingly important to the settlement. The Dumas Dramatic Club was formed in 1920, becoming the Gilpin Players in 1922. In 1927 a separate building was acquired, and the Karamu Theater was started. The theater burned in 1939, but efforts to rebuild were put off until 1949, when construction of a new theater was financed through a donation by Leonard Hanna. The theater was Karamu's keystone, yet programs in painting, woodcarving, and jewelry-making continued to be offered. In 1970, with the rise of Black Nationalism, the course of Karamu's interracial mission changed. White participation diminished, and black theater performed by blacks and aimed at a black audience came to the forefront. This step led to the formation of a professional black theater company in 1982, but the company disbanded

Cleveland was one of twenty-one Federal Theatre units to participate in a simultaneous nationwide premier of Sinclair Lewis's *It Can't Happen Here* on October 27, 1936, the only time in American theatrical history that such an experiment was ever attempted. Following that high point, however, cuts in funding reduced the Cleveland unit to a Federal Theatre for Youth, which toured local schools and playgrounds with several productions (see Fig. 76).

With the growth of Cleveland's suburbs between the wars, community theaters also arose to supplement the offerings of the Hanna and the Play House. Two of the city's oldest suburban groups were the Lakewood Little Theater (now Beck Center) and Cain Park Theater in Cleveland Heights.

Lakewood Little Theater began with a company, and Cain Park Theater began with a theater; this difference was manifested in the way the two groups developed. The Lakewood group originated as the "Guild of the Masques" under director Richard Kay in 1929. The company produced plays in whatever space it could find until 1938, when the incorporated group purchased the old Lucifer movie theater on Detroit Avenue. Cain Park, on the other hand, began with a magnificent stone and brick amphitheater built by Italian stonemasons as part of a WPA project. Dina Rees Evans, the director of the Cain Park theater from 1938 to 1950, utilized local talent to present plays, musicals, light opera, and band concerts, only later forming a company with the help of students from local colleges and universities (see Figs. 77–78).

Two of Cleveland's most distinguished writers flourished in the 1920s but died prematurely in the next decade. Poet Hart Crane (1899–1932) did most of his writing after

leaving Cleveland, the city he had moved to from Garretsville with his mother. After attending East High School and working briefly as a reporter for the *Plain Dealer,* he moved to New York City. He began making a reputation for himself in the early 1920s with poems published in such literary magazines as *Dial, Seven Arts,* and *Poetry.* His collection of poems entitled *The Bridge* (1930), which used the Brooklyn Bridge as a metaphor for American life, won him a Guggenheim Fellowship. Crane's meteoric career ended abruptly, however, with his suicide at the age of thirty-three (see Fig. 79).

later that same year, with Karamu returning to its "multicultural" roots. In its 75th year, Karamu continued to offer arts education, community theater, and community services.

FIGURE 74. Paul Travis sketching. Courtesy of the Cleveland Institute of Art.

PAUL B. TRAVIS (Jan. 2, 1891–Nov. 23, 1975), painter, teacher, and adventurer, was born in Wellsville, Ohio. Coming to Cleveland in 1913, he entered the Cleveland School of Art and studied under Frank Wilcox and Henry Keller. He began teaching full-time at the art school in 1920 and continued until he retired in 1957. One of the highlights of his career came in 1927-28 when Travis, sponsored by the Gilpin Players of Karamu House and the African Art Sponsors, made a seven-month trip to Africa. He collected various pieces of African art which were then given to Karamu House, the Cleveland Museum of Art, and the Cleveland Museum of Natural History. Travis participated regularly in Cleveland's May Show, and his work has been exhibited nationally.

FIGURE 75. Langston Hughes and actors at the
Karamu Theater. Courtesy of Karamu House.

FIGURE 76. Handbill for the Gilpin Players'
production of *One Hundred in the Shade.*
Courtesy of the Western Reserve Historical
Society.

JAMES LANGSTON HUGHES (Feb. 1, 1902–
May 22, 1967), noted black poet, playwright, and
novelist, came to Cleveland in 1916. His writing
career began while he was a student at
Cleveland's Central High School. Hughes's first
poem, "The Negro Speaks of Rivers," was
published in the NAACP's *Crisis* in 1921. In 1930
he published his first novel, *Not without Laughter,*
followed by *Scottsboro Limited* (1932) and *The
Ways of White Folks* (1934). He received a
Guggenheim Fellowship in 1935. The Gilpin
Players of Karamu Theater produced six of his
plays in the late 1930s. Considered a major
twentieth-century writer, Hughes continued to write
in various styles until his death.

A writer who maintained much closer ties to Cleveland was Charles S. Brooks (1888–1934), first president of the Cleveland Play House. A graduate of West High, Brooks retired early from the family stationery business to pursue a life of writing and travel. He published several collections of essays, and two of his plays were premiered at the Play House. His *Prologue* (1931) is probably Cleveland's outstanding example of childhood recollections.

Clevelanders were influential in the formation of the Ohio Poetry Association, which was founded in Cleveland Heights in 1931 by Rachel Mack Wilson, Edmund Vance Cooke, Albert C. Fox, Alice C. Redhead, and Edwin Meade Robinson. This group, which met monthly for dinner, discussions, and lectures, was active in the support and encouragement of poets young and old alike. The OPA sponsored annual concerts featuring prizes for peace poems, lyric poetry, Shakespearean sonnets, modern poetry, high school poetry, and ballads. They also awarded scholarships to Cleveland College for talented writers (see Fig. 80).

Like their colleagues in theater, art, and music, unem-

The Dumas Dramatic Club, formed in 1920, was the acting theater of the Playhouse Settlement of Russell and Rowena Jelliffe. In 1922, after a visit from actor Charles Gilpin, the club changed its name to the **GILPIN PLAYERS**. Early productions were usually one-act plays performed by interracial casts.

FIGURE 77. Cain Park Theater complex in Cleveland Heights. Courtesy of the Cleveland Press Collection, Cleveland State University.

FIGURE 78. Artists assemble the set for a WPA Federal Youth Theatre production in the 1930s at Cain Park. Courtesy of the Cleveland Press Collection, Cleveland State University.

The **CAIN PARK THEATER** complex began producing musicals, operettas, and concerts under the supervision of Dina Rees Evans in 1938, but after two successful decades, public interest waned in the 1950s. A revitalization effort was begun in the 1970s, culminating in the construction of a permanent canopy over the open-air amphitheater. In 1979 the United Artists movie *Those Lips, Those Eyes* was filmed at Cain Park.

ployed writers were aided locally in the 1930s by a unit of the Federal Writers Project. Their most monumental achievement was a newspaper index and digest called *Annals of Cleveland,* which managed to cover the years 1818–1876 before termination of the project during World War II. A *Foreign Language Newspaper Digest* was also published by the Cleveland project, but a projected volume on Metropolitan Cleveland for the famous American Guide Series never got past the manuscript stage.

FIGURE 79. Cleveland poet Hart Crane. Courtesy of the Western Reserve Historical Society.

FIGURE 80. Opened by Robert and Ann Levine (*foreground*) in 1937, Publix Book Mart was one of Cleveland's most popular bookstores into the 1970s, regionally known for its selections in poetry, the arts, and the humanities. Courtesy of the Cleveland Press Collection, Cleveland State University.

HART CRANE (July 21, 1899–Apr. 27, 1932), described as a "lyrically" romantic poet, came to Cleveland in 1909 with his mother, Grace Hart Crane. His first work was published in a periodical called *Bruno's Weekly* when he was 16 years old. After attempting college and serving briefly as a reporter for the *Plain Dealer,* Crane moved to New York, where he became a nationally known literary figure. He was a passionate wanderer whose last adventure took him to Mexico in 1931. While sailing back to America to settle family affairs in 1932, Crane jumped ship and drowned. His body was never found.

Traditions Continue

Winning a War and Confronting Cultural Change in the Postwar Era

The Cleveland Museum of Art *Bulletin* for February 1942 featured the following statement from the museum's head of education, Thomas Munro, concerning the institution's role in wartime:

> Museums have a contribution to make in the present crisis—mainly through building public morale. As our allies have shown, good morale can have far-reaching military consequences. . . . Like the church, the library, the concert-hall, and the theater, the museum is a place where people in these anxious days can forget their worries for a time, and have their spirits renewed by a brief reminder of eternal values.

Munro's comments characterized the general response of the fine-arts institutions to the Second World War. Each had lost many of its employees and audience, but each continued to function.

Perhaps the most seriously affected of Cleveland's fine-arts groups was the Cleveland Orchestra. Artur Rodzinski had resigned at the end of the 1942–43 season to direct the Philharmonic-Symphony Orchestra of New York, and the trustees faced the 1943 season having lost twenty-two musicians to the armed forces. Given that the nation was at war, the board of trustees was divided about how to continue.

A number of suggestions were offered—from reducing the group to a chamber orchestra to canceling the orchestra's

season altogether. Fortunately there were enough trustees who recognized, as Thomas Munro did, the morale-boosting potential of the orchestra, and a search was begun to find a conductor to replace Rodzinski. The trustees, including the still-powerful seventy-three-year-old Adella Prentiss Hughes, passed over Rodzinski's associate conductor, Rudolph Ringwell, and looked instead toward two promising conductors at the Metropolitan Opera, Erich Leinsdorf and George Szell.

Hughes, along with Elisabeth Severance Prentiss (John L. Severance's sister), favored Leinsdorf, who was Viennese-born and -trained and fifteen years Szell's junior. Other candidates had no chance against such a powerful coalition, and Leinsdorf was appointed as the third conductor of the orchestra in 1943 (see Fig. 81). However, he had little chance to make a lasting impact on the Cleveland Orchestra, since he too was called to active service in 1943, having taken American citi-

FIGURE 81. Erich Leinsdorf, Cleveland Orchestra musical director from 1943 to 1946. Leinsdorf's tenure was cut short by his military service, and as a result the orchestra podium was at times occupied by various guest conductors. Photo by Geoffrey Landesmann, courtesy of the Archives of the Cleveland Orchestra.

FIGURE 82. George Szell conducts the Cleveland Orchestra during a rehearsal. Courtesy of the Western Reserve Historical Society.

GEORGE SZELL (June 7, 1897–July 30, 1970) became conductor for the Cleveland Orchestra in 1946 and continued in that capacity until his death. Under his leadership, the orchestra toured the U.S., Canada, Europe, and the Far East. He was known as a stern taskmaster, but was greatly respected by fellow musicians. At the time of his death, the Cleveland Orchestra had gained a reputation as one of the finest in the world.

zenship in 1942. For much of Leinsdorf's tenure with the orchestra (1943–46), his place at the podium was filled by guest conductors, including George Szell. Leinsdorf and the orchestra jointly agreed to part ways as 1945 drew to a close, and in January 1946 Szell was named music director of the Cleveland Orchestra (see Fig. 82).

Today the name George Szell still evokes reverence in music circles; people refer to the "golden years" and the "magic quality" of Szell's conducting. Though a stern taskmaster, from 1946 until 1970 Szell led the Cleveland Orchestra from one pinnacle of performance to another, until it, and he, had achieved not only national but also international fame. Robert C. Marsh, in his history of the Cleveland Orchestra, refers to Szell as "The Master Builder."

Before accepting his mandate to rebuild the orchestra, however, Szell demanded and received absolute power from the trustees. He increased the personnel from 94 to 107 musi-

cians and lengthened the season to forty-nine weeks. Within five years the results were dramatically manifest. "The Cleveland Orchestra, long an excellent one, seems to have taken on added musical quality under this conductor," wrote composer-critic Virgil Thomson of a New York appearance in 1950. "The Cleveland Orchestra, in fact, seems to [this listener] one that bears comparison with the best we know."

Thomson's praises were soon echoed from the music capitals of Europe. The Cleveland Orchestra returned from its triumphant first European tour in 1957 to a cheering crowd at Hopkins Airport and a motorcade to Severance Hall, where another crowd, a band, and a civic reception awaited. The orchestra was chosen by the State Department to tour the Soviet Union in 1965, and two years later it was invited to appear at three of Europe's most prominent music festivals, in Salzburg, Edinburgh, and Lucerne.

Szell also reconstituted the Cleveland Orchestra Chorus by hiring Robert Shaw as choral director and associate conductor. He insisted that Severance Hall be remodeled in 1958 to create a state-of-the-art performance and recording hall worthy of the orchestra he had created. To showcase his orchestra in America's musical capital, he launched an annual Cleveland Orchestra subscription series in New York's Carnegie Hall the same year. One of Szell's final dreams, a summer facility to enable the orchestra to perform the entire year, was realized in the opening of the Blossom Music Center two years before his death. In the midst of these new achievements, the Cleveland Orchestra continued to adhere to its educational mission, playing special concerts for over 100,000 schoolchildren yearly.

All of this didn't come without a price, however, and a part of the cost might be reckoned in the prickly, imperious personality of the music director. Szell fired a dozen musicians outright on taking the helm, and a dozen more found it expedient to sign on with other orchestras. "For two or three," in the words of a 1963 *Time* cover piece, "the chilly sight of Szell on the podium was an inspiration to give up music for the used-car business." Even the audience occasionally felt the sting of Szell's reproach, as the conductor wasn't beyond laying down his baton and stalking off stage at the sound of a few coughs. After one such incident which interrupted a performance of Tchaikovsky's *Romeo and Juliet,* Szell returned to conduct so furiously that *Plain Dealer* critic Herbert Elwell doubted "whether anybody ever expected Romeo and Juliet to make love at a faster tempo." That Cleveland paid the price is a tribute to its taste as well as its maturity.

The Szell phenomenon was much more than simply the case of a man who was able to take an already fine orchestra and transform it into a world-class performing ensemble. George Szell accomplished this feat during a period of general economic decline in Cleveland. Certainly in the first years

after the war, Cleveland's economy was boosted by industrial growth, but problems in the city mounted in the 1950s and 1960s. Wealthy and middle-class citizens moved to the suburbs and continued to enjoy the cultural and financial opportunities of downtown Cleveland while contributing nothing to the city's support. The number of slums increased, and race relations were strained. As the local and national press focused on the negative aspects of Cleveland, George Szell and the Cleveland Orchestra were the most potent and best-known symbols of the city's better side.

Of the five music directors of the Cleveland Orchestra, Szell had the longest career. He came to Cleveland when he was forty-nine, a successful and accomplished conductor. The city was not merely another rung on the ladder of his career; rather, Szell proved himself to be committed to both Cleveland and the orchestra. For twenty-five years, the musical life of the city was shaped by and focused on the Cleveland Orchestra and this man, whose style and accomplishments became the yardstick by which all other conductors would be measured in Cleveland.

The 1940s and 1950s were good years for other performance-oriented groups as well. In 1938 the Music School Settlement had finally moved into permanent quarters in the University Circle area, in a forty-two-room residence that had once belonged to Edmund S. Burke, governor of the Federal Reserve Bank. At the end of World War II, the school had forty teachers and a $40,000 budget. In 1948, Howard Whittaker was appointed director of the school, a position he held for thirty-six years (see Fig. 83).

Whittaker was responsible for the extension of Music School services to the larger community. With a grant from the Cleveland Foundation in 1953, the school began to provide music instruction to local social-service organizations, including hospitals, orphanages, and facilities for the handicapped. The extension program was directed by Richard Kauffman and was a truly pioneer venture in the use of music therapy. In 1958, a branch of the settlement school was opened in the West Side Community House to meet the needs of those across the river. Less than fifteen years later, the Cleveland Music School Settlement was providing services to thirty-five other agencies in town.

One of Whittaker's extracurricular efforts was the founding and presidency of the Lake Erie Opera Theater. Intended to explore areas of the repertoire neglected by the touring Metropolitan Opera, the company utilized Severance Hall and members of the Cleveland Orchestra. Among the works performed between 1964 and 1970 were Stravinsky's *The Rake's Progress,* Prokofiev's *Love for Three Oranges,* Poulenc's *Dialogues of the Carmelites,* and Strauss's *Capriccio.*

The Cleveland Play House escaped from the practice of deficit spending in the 1940s and continued to produce plays

ten months out of the year. The professional staff consisted of thirteen actors and nine technical people, ably assisted by volunteers and theater students from local colleges and universities. In 1949 the Play House added new quarters by taking over the Second Church of Christ Scientist at the corner of Euclid and E. 77th. The interior of the church was remodeled to create a 560-seat auditorium with a thrust stage ideally suited for Shakespearean productions. The professional staff of the Play House more than doubled in the 1950s as middle-class audiences packed the theater, which became an equity company in 1958.

By the 1940s and 1950s, Cleveland had a number of different venues for amateur, student, and professional actors to exercise their talents. In addition to the Play House, Cain Park, and Lakewood Little Theater, Western Reserve University and John Carroll University had active drama programs. Theater as an acknowledged branch of formal study had long been taken seriously by the members of the Cleveland Play House, but after World War II it became a valid course of university study as well.

Under the chairmanship of Barclay Leathem, the pro-

FIGURE 83. Trustees of the Cleveland Music School Settlement. *From left to right:* Margaret Sharp, Howard Whittaker (director), Margarita Jolles, Dorothy Humel Hovorka, and Hyman Schandler. Courtesy of the Cleveland Music School Settlement.

HOWARD WHITTAKER was appointed director of the Cleveland Music School Settlement in 1948, serving until 1984. Under his direction, the settlement expanded activities and became a vital force for the arts in Cleveland, helping to establish the Lake Erie Opera Theater in 1964 and the Cleveland Summer Arts Festival in 1967. In 1953, with a grant from the Cleveland Foundation, the settlement began a program to extend its music instruction services to social-service agencies. This extension program was a pioneering effort in the use of music therapy.

FIGURE 84. The Gilpin Players perform at Eldred Hall, ca. 1940. Courtesy of the Cleveland Press Collection, Cleveland State University.

The **ELDRED THEATER,** located in Case Western Reserve University's Eldred Hall (dedicated to Henry B. Eldred), staged its first performance, Strindberg's *Spook Sonata*, in 1939. The Rockefeller Foundation provided $35,000 toward the enlargement and rebuilding of the Eldred Theater, which housed dramatic productions of Western Reserve University's drama department. The Eldred Theater presented operas, plays, and revues performed by various acting companies, including the Eldred Players, the University Players, and the Gilpin Players of Karamu House. Many productions were directed by Barclay Leatham.

gram at Western Reserve in particular kept Cleveland aware of postwar theatrical developments. Leathem served as an adviser in 1948 for Cleveland's first television station (WEWS), where productions from Reserve's Eldred Theater were among the first shows televised. At Eldred, Nadine Miles was particularly active in directing such productions as Brecht's *Galileo* and *The Good Woman of Setzuan,* Sartre's *The Flies,* and T. S. Eliot's *Murder in the Cathedral.* Working with Western Reserve's Fine Arts Program and the Cleveland Philharmonic Orchestra, Miles also gave Clevelanders a chance to see and hear the Virgil Thomson–Gertrude Stein opera *The Mother of Us All* in 1949.

Karamu began the 1940s without a theater. Its stage had burned down in 1939 from what may or may not have been arson, and efforts to rebuild it were interrupted by World War II. Just after the fire, however, the Cleveland Play House and Western Reserve University stepped forward to provide temporary facilities for the Gilpin Players (see Fig. 84).

Nevertheless, the 1940s were good years for the visual

arts at Karamu. Art objects created by the members had been sold since 1926 in a small craft shop called the Bokari, next to the Playhouse Settlement. In January 1943, an exhibition of Karamu artworks by twenty-eight artists opened at the Association of American Artists' gallery in New York. Karamu members had worked closely with members of the Cleveland Museum of Art staff to prepare objects for the show, which was an immediate success and earned Karamu a good friend in the honorary national chairman of the exhibit, Mrs. Eleanor Roosevelt.

The problem of a permanent theater for Karamu was solved by one of Cleveland's most generous benefactors, Leonard Hanna, Jr. With his help and that of the Rockefeller Foundation and other patrons, a new theater complex was planned at E. 89th and Quincy. "The Karamu project is one of the most civilizing endeavors existent in the United States today," said former Clevelander Burgess Meredith at the groundbreaking. The complex was everything the Jelliffes had envisioned, including the 223-seat Proscenium Theater, the 140-seat Arena Theater (Cleveland's first theater-in-the-round), an art room, a dance studio, meeting rooms, and offices (see Fig. 85).

Karamu quickly put its new facility to good use, as Gian Carlo Menotti's *The Medium* opened there on December 9,

FIGURE 85. Breaking ground for a new Karamu Theater. *From left to right:* Harold T. Clark, Charles W. White, with Russell and Rowena Jelliffe in background. Courtesy of the Cleveland Press Collection, Cleveland State University.

1949. Zelma George, wife of Cleveland attorney Clayborne George, sang the opera's title role there sixty-seven times and then took her portrayal to New York at the request of the composer himself. "Good news is always pleasant to report," said Vernon Rice in the *New York Post*, "and it becomes my extreme good fortune to report today that there arrived last night around the corner from Broadway an actress who can sing and a singer who can act." Mrs. George returned to Cleveland after her New York triumph, however, except for occasional diplomatic missions such as joining the American delegation to the United Nations.

Under the direction of Benno Frank, it was a golden age for music at Karamu, with productions of Orff's *Die Kluge*, Martinu's *What Men Live By*, Bernstein's *Candide*, and Handel's *Julius Caesar*. The drama program also thrived under another husband-and-wife team, Reuben and Dorothy Silver.

To many minds, theater was synonymous in postwar America with musical theater—a reflection of the growing popularity of the musical extravaganzas appearing on Broadway. While the Hanna booked touring companies of the great Broadway shows during the regular season, Cleveland acquired a unique summer musical stock company in Warrensville Heights in 1954. Dubbed Musicarnival, it featured a circular stage beneath a large, festive tent.

The $15,000 tent theater seated 1,500 people who flocked to hear musicals such as *Oklahoma!* and *The King and I*, produced by John L. Price. In its second season, the theater grossed over $245,000, and audience response soon warranted a new, sturdier tent and even a paved parking lot. During the adventurous first years, Price even made occasional forays into opera, including a production of Douglas Moore's *The Ballad of Baby Doe* with temporary Clevelander Beverly Sills.

With the exception of the Karamu Dancers, Cleveland audiences' exposure to ballet and modern dance continued to come from outside the community in the form of traveling companies, principally the Ballet Russe de Monte Carlo in the 1940s. However, toward the end of the 1950s, the formation of several dance companies began a movement toward the creation of a professional ballet company.

The three most important organizations which date from this time are the Cleveland Modern Dance Association, founded in 1956 to promote modern dance in Cleveland; the Cleveland Ballet Center Company, founded in 1958; and Dance Horizons, Inc., founded in 1960. The latter two groups were local dance schools that merged in 1963 to form the Ballet Guild, under the direction of Alex Martin, previously a member of England's Royal Ballet. Martin and his twenty-eight dancers developed a repertoire of twelve ballets that were produced and supported by the Guild's Women's Committee and by membership fees. The new company was without a home but did stints at the Cleveland Museum of Art,

Karamu House, and the Cleveland Play House. In addition to its own performances, the new company sponsored performances by international touring companies.

Although the performing arts managed to survive the stringencies of wartime to bounce back stronger than ever in the 1940s and 1950s, the same cannot be said for the visual-arts community in Cleveland. Inevitably, perhaps, as the permanent collection at the art museum grew richer and stronger, the focus of the community shifted from local artists to the museum as a source of civic pride. Despite the continuation of the annual May Show, the gap between collectors and creators began to widen.

World War II, of course, disrupted both the School of Art and the Cleveland Museum of Art. Staff members, faculty, students, and audiences left the city to join the war effort, and enrollment at the art school for 1941–42 dropped below the Depression's lowest enrollment. Classes were added to the curriculum, some funded by the Cleveland Art Association, to help artists prepare for military service (mapmaking, medical illustration, camouflage), and students were able to complete the curriculum in three years instead of four. A summer course in occupational training was added, as it had been in World War I, to train those who would work with returning veterans. One of the former students (and later an instructor) called to war was noted enamelist Edward Winter. After a stint preparing educational posters for the army, Winter returned to Cleveland, where he and his wife, Thelma Frazier Winter, a noted ceramic sculptor, played a large role in both the school and the local arts community in the postwar period.

Henry Hunt Clark retired in 1946, having seen the school through potential catastrophes during the Depression and World War II. He was replaced by Laurence Schmecke-bier, the first midwesterner to hold the position. Schmeckebier was director for less than ten years, but during that time he managed to strengthen the ties between the art school and industry; at the same time he managed a school filled to over-flowing with students forming the postwar boom. One of his primary goals was to raise the professional standards of the school's graduates, and during his first year Schmeckebier started an optional fifth-year BFA. The change of the school's name to the Cleveland Institute of Art in 1948 provided the formal recognition of the new standards.

The art school needed room to grow, however, if it was going to maintain higher standards. Schmeckebier began a building-fund campaign and undertook a full-scale study to determine the needs of faculty, staff, and students. Eventually architects were chosen—the Cleveland firm of Garfield, Harris, Robinson and Schafer—to design the new building. Though Schmeckebier left the art school before the actual building was completed, he had developed a student body

better equipped to face the often-exacting demands of post-war industrial design.

In 1954 Joseph McCullough became the first alumnus of the art institute to be appointed its director (see Figs. 87–88). At his side was George Gund, president of the board of trustees, who told McCullough, "You worry about the school, I'll worry about the money." For McCullough, the latter half of the decade was devoted to seeing the new structure on East Boulevard completed and filled to capacity. When opened, it ranked as one of the best-equipped art schools in the nation, with twenty painting studios, a two-story sculpture studio, and shops or studios for weaving, ceramics, printmaking, enamelwork, metalware, photography, and mural painting. A library, offices, a 600-seat auditorium, two exhibition galleries, a forge, a foundry, and a welding shop completed the list of necessities.

McCullough was to see the school through trying years, as it attempted to gain regional accreditation. He expanded the curriculum to include more academic courses, and in the 1960s he hired eighteen full- and part-time faculty members to teach the required social sciences and humanities courses. Curiously enough, sixty years earlier, academic encroachment had spurred the school to reestablish its independence from Western Reserve University. The art school had come full circle.

Not coincidentally, there were fewer demands made on the staff of the museum during the war and postwar period,

FIGURE 86. Class is dismissed at the old Juniper Road building of the Cleveland School of Art. Courtesy of the Cleveland Press Collection, Cleveland State University.

FIGURE 87. Joseph McCullough, director of the Cleveland Institute of Art (1955-1990), stands in the doorway of the Factory. Formerly a Ford assembly plant, the Factory is located on Euclid Avenue just east of Mayfield Road. The space was purchased by the Institute in 1981 and was converted into classrooms and studio space for students. Courtesy of the *Cleveland Plain Dealer.*

FIGURE 88. The McCullough Building, otherwise known as the "Factory," provided striking evidence of the Cleveland Institute of Art's great expansion in the 1980s. Courtesy of the Cleveland Institute of Art.

since art objects required less attention than did students. Business continued as usual during World War II, except for a decline in visitors due to gas rationing. The museum staff made preparations to protect Cleveland's art treasures in case the city should come under attack. Boxes were constructed to house objects, and a treasure room in the basement was protected by three floors of concrete (these precautions were continued throughout the Cold War years). Each office was issued a broom and dust cloths, so staff members could perform their own janitorial work in place of the regular cleaning staff, many of whom were serving in the armed forces. A Victory vegetable garden replaced flowers at the museum, and staff worked diligently to tend the plants.

Director William Milliken was justified in his concern for the works of art in the permanent collection. Beginning with the purchase of the Guelph Treasure in the 1930s, Milliken had insisted that the museum collect only pieces of the highest quality. He had had to fight the trustees occasionally on this point, but the quality of the collection continued to climb throughout the 1930s via gifts from patrons such as Leonard Hanna, Jr., John L. Severance, and John D. Rockefeller, Jr.

Just as the Cleveland Orchestra attained international status and acclaim under George Szell, the Cleveland Museum of Art did so with the combined efforts of its director, William Milliken, education curator Thomas Munro, and the board of trustees under presidents William G. Mather (1936–49) and Harold T. Clark (1950–62). The period from

The **CLEVELAND INSTITUTE OF ART** was founded as a professional arts school for women. It opened in 1882 in the home of Sarah M. Kimball as the Western Reserve School of Design for Women. The school sought to train students for careers, blending interest in decorative arts with much-needed design training for industry. In 1892, after an attempted merger with Western Reserve University, the school regained independence as the Cleveland School of Art. Under the direction of Georgie Leighton Norton, a new building was constructed in 1904 on Juniper Road in University Circle. By 1913 an endowment for the institution had been established. The Cleveland School of Art became the Cleveland Institute of Art in 1948, and in 1956 a new building was opened on Bellflower Road. Expansion occurred again in 1981, when an old automotive assembly plant on Euclid Avenue was renovated into classrooms and studio space. An internationally recognized school, the Cleveland Institute of Art operates an extramural program in southern France.

FIGURE 89. Noted Cleveland sculptor Max Kalish in his studio with bust of Mayor Tom L. Johnson, ca. 1912. Courtesy of the Cleveland Press Collection, Cleveland State University.

MAX KALISH [Max Kalichik] (Mar. 1, 1891–Mar. 18, 1945) was a nationally known sculptor who came to Cleveland with his family from Lithuania in 1898. Interested in art at a very early age, he won a scholarship to the Cleveland School of Art when he was 15 and graduated at 19, winning first prize for life modeling. In 1910, Kalish went to New York and studied at the National Academy of Design. In 1912 he went to Europe, returning to Cleveland in 1915. His work was exhibited nationally and dealt with many subjects, among them famous persons in the fields of opera, music, medicine, religion, and labor.

1940 to 1960 was one of expansion, collection building, and institutional growth, yet Milliken never forgot Whiting's mandate to support local art and artists. Even after being appointed director, the May Show remained one of Milliken's pet projects.

Milliken's support of local artists at the museum level was not limited just to the May Show. Throughout his years, the museum presented a number of shows of local interest. In 1946 works by Cleveland School of Art graduates Max Kalish (see Fig. 89) and Alexander Warshawsky were shown, and the museum held memorial exhibitions (often in conjunction with the Institute of Art) for several of the grand old men of the Cleveland School, including Henry G. Keller (1950), William Sommer (1950), and Carl Gaertner (1953).

The permanent collections of the Cleveland Museum of Art, like those of any museum in the United States, are the products of judicious buying and generous gifts from individ-

uals. An important factor in forming the collection was that benefactors such as Leonard C. Hanna, Jr., Elisabeth Severance Prentiss, Mr. and Mrs. Liberty Holden, Ralph T. King, and John L. Severance all ensured that Milliken was aware that their collections would eventually become museum property. When Milliken advised them on their purchases, he was in turn serving the museum's ultimate interests. Their purchases, furthermore, allowed Milliken to concentrate on acquisitions in fields other than those "covered" by these friends of the museum. According to Milliken himself, the three most important acquisitions of his tenure were the Guelph Treasure, Filippino Lippi's *The Holy Family with St. Margaret and St. John,* and Watteau's *La Danse dans un Pavillon.*

Added to these sources, however, were a number of "special interest" groups that made themselves responsible for filling various gaps in the collection, so that the museum's own purchase funds could be used elsewhere. Two of the most important of these groups were the Print Club of Cleveland, founded in 1919, and the Textile Arts Club, founded in 1934.

The Print Club had a distinguished list of members that included William G. Mather, Judge William B. Sanders, Leonard C. Hanna, Jr., Ralph M. Coe, Salmon P. Halle, and Malcolm McBride, as well as the club's founder, Ralph T. King. Many of these men served on the board of trustees as well. Among the early activities of this group was the appropriation of funds to establish a print department at the Cleveland Museum of Art.

By the late 1930s the museum had begun to run out of space. This issue plagued the museum throughout the 1940s and 1950s and was particularly apparent during the spectacularly successful 1948 display of art objects from the Kaiser Friedrich Museum in Berlin, which had been part of a cache hidden by the Nazis only to be discovered by General Patton's army. Lines of spectators waiting to see the exhibition stretched out to Euclid Avenue.

Mrs. Edward B. Greene, daughter of Jeptha Wade II, had contributed $20,000 for a building fund for an addition as early as 1937. In 1944, a building committee was appointed with Leonard C. Hanna, Jr., as chairman. As with the 1916 building before it, several years of complicated fundraising procedures passed before the new project got off the ground; the Hanna Fund contributed nearly $4 million to the effort. Ground was broken for a new wing in 1955; the museum closed for most of 1957 to facilitate construction, and the new addition was opened with great fanfare in 1958 (see Figs. 90–91).

Unfortunately, between groundbreaking and the opening, Leonard C. Hanna, Jr., had passed away. More than any other single patron or trustee of the Cleveland Museum of Art, Hanna had helped Milliken create a world-class collec-

FIGURE 90. The north entrance of the Cleveland Museum of Art, facing Wade Oval, ca. 1985. The north entrance and the education wing, designed by architects Marcel Breuer and Hamilton Smith, were completed in 1970. Courtesy of the Cleveland Museum of Art.

FIGURE 91. The first addition to the Cleveland Museum of Art, designed by J. Byers Hays and Paul C. Ruth, was completed in 1958 and doubled the size of the museum. William Milliken, Henry T. Clark, Mayor Anthony Celebrezze, and George Wade participate in the 1955 groundbreaking. Courtesy of the Cleveland Press Collection, Cleveland State University.

tion. At his death in 1957, he left his residual estate to the museum—$34 million as well as his own personal art collection, valued at $1.5 million. These gifts came on top of an estimated $4.5 million in gifts and building endowments received by the museum during Hanna's lifetime (see Fig. 92).

One month after the new addition was dedicated, Wil-

FIGURE 92. Leonard C. Hanna with friend, ca. 1938. Courtesy of the *Cleveland Plain Dealer*.

LEONARD C. HANNA, JR., one of Cleveland's major philanthropists, contributed over $90 million to cultural and charitable institutions in and around the city. Hanna was an avid collector, theatergoer, and patron of the arts. He joined the Cleveland Museum of Art's advisory committee and in 1920 served as a trustee of the Accessions Committee. In 1941 he incorporated the Leonard C. Hanna Fund, which was responsible for dispensing millions of dollars to institutions in Ohio, including Karamu House, the Cleveland Play House, and the Cleveland Museum of Art. At his death in 1957, Hanna left an endowment of over $33 million to the Cleveland Museum of Art.

FIGURE 93. Dr. Sherman E. Lee, director of the Cleveland Museum of Art, 1958-1983. Photo by Fabian Bachrach, courtesy of the Archives of the Cleveland Museum of Art.

liam M. Milliken retired from his position as director. He had helped to make the Cleveland Museum of Art an internationally acclaimed collection while at the same time encouraging

local artists. Much of this success was due to his connoisseurship, but it was also due to his social position in the Cleveland community. Milliken knew how to deal with the members of the museum's board of trustees, because he traveled in the same social circles they did. There is a sense in the history of the museum around this time that the old guard was passing and the museum was entering a new era, as indeed it was. The 1960s brought the first indications of changing patterns of patronage, as federal grants and corporate sponsorship replaced Cleveland's wealthy first families in ensuring the survival of the museum.

Whiting had been an educator and administrator. Milliken was a connoisseur. He visited Italy and dined with Bernard Berenson; he was an art historian of the old school. Sherman Lee, the new director appointed in 1958, was a noted scholar of Asian art with experience and connections in the art world but without Milliken's entrée into Cleveland's society circles (see Fig. 93). Whiting had established the museum, while Milliken had built the collection. Lee was chosen to continue that task at a time when the Hanna bequest elevated the Cleveland Museum of Art to one of the most richly endowed institutions in the country.

CHAPTER *10*

Traditions Change

New Institutions, New Funders,
and New Frontiers

In the early 1960s, the Women's City Club of Cleveland presented a series of lectures on the fine arts in Cleveland at mid-century. The consensus of interested citizens and patrons of the arts attending the lectures was that the city was losing many of its best and brightest young artists, authors, and performers to cultural centers such as New York City, where their talents received recognition. Klaus G. Roy, author of the program notes for the Cleveland Orchestra, suggested that Cleveland should emulate European cities and regularly recognize its creative artists.

Martha Joseph took the initiative and organized the Cleveland Arts Prize, an annual tribute to Cleveland's outstanding creative artists first awarded in 1961. Prizes were given for significant contributions to the visual, architectural, musical, and literary arts (see Fig. 94). While the Arts Prize contributed to public awareness of creative artists resident in or connected with Cleveland, such recognition was not enough to keep talented professionals in the city or to encourage amateurs to experiment with the creative arts.

This problem is exemplified by a comparison of the careers of two native Cleveland novelists, Herbert Gold and Don Robertson (see Figs. 95 and 96). Scion of a distinguished local newspaper dynasty, Robertson, after an initial trilogy on the Civil War, set most of his novels in Cleveland and Ohio. Probably the most memorable was his fictional account of the

FIGURE 94. "WCLV at 20 years"—the broadcast crew at WCLV's Terminal Tower studios in 1982. *From left to right:* Robert Conrad, president; Tony Bianchi, operations manager; Dennis Miller, vice-president; and Rebecca Fischer, morning host. Founded in 1962, WCLV is internationally recognized in classical music broadcasting. In 1973, WCLV received the Cleveland Arts Prize "Special Citation Award" for its outstanding contributions to the cultural life of Cleveland. Photo by T. Simon, courtesy of WCLV-FM.

East Ohio Gas disaster in *The Greatest Thing since Sliced Bread* (1965). *Paradise Falls* (1968) and *Praise the Human Season* (1974) were set in a fictitious Ohio town.

Despite an impressive track record of a dozen books, Robertson experienced difficulty finding publishers in the 1980s and lost his journalistic livelihood with the closing of the *Cleveland Press*. After a couple of years in Houston, he returned to his hometown and managed to find publishers as diverse as local bookseller John T. Zubal and megahit novelist Stephen King for another half-dozen novels. Battling health problems, he nevertheless had plans for several more books in his self-styled "gritty naturalist" tradition.

A native of Lakewood, Herbert Gold, on the other hand, has found San Francisco more congenial to the practice of literature. Far from denying his Cleveland roots, he patterned the bestseller *Fathers* (1966) on the character of his own father and recalled the area warmly in the autobiographical *My Last Two Thousand Years* (1972). Yet on return visits Gold lamented the dispersion of local creative talent to the suburbs, leaving his hometown with "no community of artists" comparable to the one he belonged to in San Francisco. Though Cleveland

FIGURE 95. Native Cleveland author Herbert Gold. Courtesy of the Cleveland Press Collection, Cleveland State University.

FIGURE 96. Cleveland author Don Robertson. Courtesy of the Cleveland Press Collection, Cleveland State University.

Cleveland has produced a number of notable novelists, including **HERBERT GOLD** (Mar. 9, 1924–) and **DON ROBERTSON** (Mar. 21, 1929–). Gold, famous for his works which are set in Cleveland, used Cleveland's World Publishing Company to produce his books. Robertson has written many nationally recognized fictional works. One of his most recent novels was *Prisoners of Twilight* (1989).

had developed an enviable cultural life, the central city had been permitted to "become a dumping ground for the poor."

Another problem, national rather than local in scope, was finding new sources for funding arts-related projects. The federal government began to recognize the scarcity of arts groups in the 1960s, and by 1964 had established the National Council on the Arts. A year later, the National Endowment for the Arts and the National Endowment for the Humanities were organized to provide funding for programs. The Ohio Arts Council was founded that same year. These three groups, along with local institutions such as the Cleveland Foundation, the Kulas Foundation, and the George Gund Foundation, were major sources for funding cultural programs in Cleveland during the 1960s and 1970s. Corporate funding began in the 1950s and during the next three decades slowly assumed a greater role in sponsoring art-related programs. In the 1990s most institutions viewed corporate funding as the single most important source of financial support for the fine arts.

The twenty years between 1960 and 1980 saw a proliferation of new amateur and professional arts-related groups in Cleveland and its suburbs. Some were successful, while oth-

FIGURE 97. Cleveland poet d.a. levy at the Juvenile Courthouse. He had been charged with reading immoral poetry to minors. Courtesy of the Cleveland Press Collection, Cleveland State University.

FIGURE 98. Cleveland poet Daniel Thompson at Junkstock, a day-long festival dedicated to poetry, music, and performance art, ca. 1985. Courtesy of the *Cleveland Plain Dealer*.

DARRYL ALLEN LEVY [d.a. levy] (Oct. 29, 1942–Nov. 24, 1968) was a native Cleveland poet noted for his role in bringing the counterculture movement to the city. He established Cleveland's first underground newspaper, the *Buddhist Third Class Junkmail Oracle*, and published a journal called *The Marijuana Quarterly*, which advocated the legalization of marijuana and caused considerable trouble for Levy. In 1966 he was charged with obscenity, which eventually led to his arrest in 1967. After a depressing two-year battle with the legal system, Levy committed suicide in 1968.

ers struggled to survive financially. All, however, were grass-roots movements to fill perceived gaps in the fine arts left by Cleveland's major cultural institutions. These years also saw Cleveland's independent artists move into the realm of the avant garde and the controversial. Some poets, such as d.a. levy, succeeded in shocking the community with both their verse and their lifestyle (see Figs. 97–98).

Dobama Theatre was founded in 1960 by Don Bianchi and two partners, whose first names provided the anagram of the company's name. As the other two founders dropped out, Marilyn Bianchi assumed a more active role with her husband. A reaction against the often petty squabbles found on the community theater circuit, Dobama was based on two principles: first, that amateur companies had a responsibility to produce good theater of high quality; and second, that personality and politics had no place in the theater.

Over the past thirty years the members of the Dobama Company have maintained their high standards; 90 percent of their productions have been either United States or Cleveland premieres. In the early 1970s the theater company purchased a defunct bowling alley on Coventry Road and remodeled it for

its purposes. Marilyn Bianchi passed away in 1977, but two annual programs survive as her legacy—a week of free theater performances at the end of each season and the "Marilyn Bianchi Kids' Play Writing Festival." In a true spirit of encouragement, each child receives an award for his or her work, and the best plays are produced by the theater (see Fig. 99).

The Great Lakes Shakespeare Festival was founded in Lakewood in 1962. The Parma Fine Arts Council and the Jewish Community Center provided the financial backing for the thirty-member company, which presented six different plays during its first season in the summer of 1962. Despite the enthusiasm of its company and administrators, a series of talented director/producers, and a two-year, $20,000 grant from the Cleveland Foundation, the festival has been running with a deficit almost since its inception, though the accumulated debt has been trimmed considerably in recent years.

In 1982, the company took up new quarters in the renovated Ohio Theater downtown in Playhouse Square (see Fig. 100). Its eight-hour production of Dickens's *The Life and Adventures of Nicholas Nickelby* was well received in the inaugural season but didn't fare as well when revived two years later. With the resignation of Vincent Dowling, festival director from 1976 to 1984, and his subsequent departure for Ireland's Abbey Theater, Gerald Freedman was brought in from New York as the new director, and the festival's name was changed to the Great Lakes Theater Festival. Utilizing his Broadway connections, Freedman has given Cleveland a star-studded production of *Arsenic and Old Lace* and appearances by Hal Holbrook, Olympia Dukakis, Ruby Dee, and Piper Laurie.

FIGURE 99. The Dobama Theatre is located on Coventry Road in Cleveland Heights. Since 1977 it has offered a week of free theater in memory of former director Marilyn Bianchi. Courtesy of Dobama Archives.

FIGURE 100. Vincent Dowling (*on ladder*) at the Ohio Theater home of the Great Lakes Theater Festival on Playhouse Square, ca. 1982. Courtesy of the *Cleveland Plain Dealer*.

DOBAMA THEATRE was founded in 1960 by Don Bianchi. After two productions staged at the Chagrin Valley Little Theater on a short-term rental basis, Dobama opened its own theater in 1963 at E. 75th and Euclid in the Quad Hall Hotel. In 1971, Dobama renovated a bowling alley on Coventry Road in Cleveland Heights, which remained its home into the 1990s. Dobama has offered a variety of productions, most of which have been world, American, or Cleveland premieres. The productions have reinforced a basic premise of the theater—to bring responsible production to superior playscripts that otherwise might not be seen.

The **GREAT LAKES THEATER FESTIVAL** opened as the Great Lakes Shakespeare Festival in 1962 with a 30-member acting company. In 1982 it moved its headquarters from Lakewood, Ohio, to the Ohio Theater located in Playhouse Square. It has been directed by well-known persons, including Arthur Lithgow, Vincent Dowling, and Gerald Freedman. In 1985 the festival became known as the Great Lakes Theater Festival in recognition of its broadened repertory.

The Cleveland Play House continued to produce a full season of shows each year, but many considered its repertoire too conservative for modern audiences—a criticism rarely heard in Cleveland's theatrical history, but one which was soon to become prevalent throughout the city with regard to all areas of the arts. During the 1970s the Play House, like the Shakespeare Festival, began to operate at a deficit, and the number of productions was cut from fifteen or twenty to thirteen per year. Nevertheless, its recovery in the 1980s has been nothing short of miraculous.

Commissioned to design a new theater in 1982, Cleveland native Philip Johnson, with the generous support of Kenyon Bolton, gave the Play House an architectural fantasy, unifying the new house and the Play House Club under one roof with the two older theaters on E. 86th and giving the community the most complete regional complex in the nation. The company was similarly revamped when Josephine Abady was imported from the Berkshire Theatre Festival as the new artistic director in 1988. Although Abady took some initial criticism for disbanding the resident acting company, she won new converts with such projects as the Reynolds Price trilogy *New Music* (see Fig. 101 and Color Plate 16).

The theaters which suffered the worst reversals during the 1960s were those magnificent creations of the 1920s in Playhouse Square. By 1969 all but the Hanna Theater had closed their doors to the public. Moviegoers in the 1960s pre-

FIGURE 101. Cleveland Play House artistic director Josephine R. Abady is shown here with Play House managing director Dean Gladden (*far right*) and Otar Djangisherashvili, the director of the New Experimental Theatre of Volgograd, Russia, during the Cleveland Play House's 1992 International Theatre Exchange, which featured a presentation of Tennessee Williams's *A Streetcar Named Desire* performed entirely in Russian. Photo by Roger Mastroianni, courtesy of the Cleveland Play House.

The **CLEVELAND PLAY HOUSE**, one of the nation's oldest regional theaters, is housed in an award-winning complex designed by Philip Johnson. Under the leadership of Artistic Director Josephine R. Abady, the Play House has won national acclaim for its commitment to classic and contemporary plays from the American repertoire.

ferred to avoid downtown altogether, choosing to patronize the smaller theaters in their safe, suburban neighborhoods.

In the 1970s a Cleveland Public Schools administrator named Ray Shepardson enlisted the aid of businesses, city officials, patrons of the arts, and the members of Cleveland State University's drama department in his battle to save Cleveland's landmark theaters. By the early 1980s, three of the grand theaters had been renovated and were in use. The newly organized Cleveland Opera, the Cleveland Ballet, and the Great Lakes Theater Festival now call the theaters on Playhouse Square home and have been significant forces in the revitalization of this historic entertainment district.

Members of Karamu Theater and Karamu House were disturbed by a number of events during the sixties and seventies. In 1963 Russell and Rowena Jelliffe retired from their positions after close to fifty years with the settlement. Since they had founded the house in 1915, there had always been elements of Cleveland's community, both black and white, who opposed the Jelliffes' efforts. Some blacks felt that the programs at Karamu House exploited black artists and performers for the benefit of white audiences.

As the Black Power movement gained in intensity during the civil rights struggles of the 1960s, it became evident to many in the community that Karamu was being guided away from its multicultural origins toward encouraging black arts for the black community. Whites who still had ties with the institution were discouraged from participation; this Afrocentric focus lasted through the 1970s. After an abortive attempt in 1982 to form a professional theater company, Karamu administrators began to rethink the original purpose of the Jelliffes' mission, and activities at Karamu House returned—to an extent—to a broader, multicultural base under a new director, Margaret Ford Taylor, who assumed her position in 1987.

Local dance enthusiasts finally achieved a long-standing goal in the 1970s with the organization of the Cleveland Ballet. In 1972 two former dancers with the American Ballet Theater in New York City, Ian Horvath and Dennis Nahat, bought the Cleveland Dance Center, a small ballet school operating in the basement of the Masonic Auditorium. With their own money and funds raised by the Ballet Guild of Ohio, the two dancers managed to form a small, nonprofessional company. They moved their school and new company to the Stouffer Building and renamed it the School of Cleveland Ballet. Some students were aided by Cleveland State University, which offered them academic credit for ballet classes.

Eventually Nahat and Horvath approached the Cleveland Foundation for funding and received seed money to found a professional company of sixteen dancers, who were recruited from schools and companies across the country. By the summer of 1975, the fledgling company was practiced

enough to give lecture-demonstrations and previews around the city prior to its first public appearance at the Hanna Theater in November 1976 (see Fig. 102).

The new Cleveland Ballet performed to taped recordings for its first seasons, but it quickly gained the services of the equally new Ohio Chamber Orchestra. In 1981 the Cleveland Ballet presented its first full-length performance, *The Nutcracker*. Tchaikovsky's ballet was an immediate success with Cleveland audiences and within a few years was considered an indispensable part of the city's holiday celebrations. That this traditional ballet became such an important annual event for Clevelanders is, again, a sign of the conservatism that has so often marked Cleveland's cultural history. Horvath resigned as co–artistic director in 1984, leaving Dennis Nahat in full command of both the ballet and the School of Cleveland Ballet. During that same year the ballet moved to its new home in the State Theater, becoming an essential element in the Playhouse Square renovation.

One of the nation's first modern dance companies outside of New York was the Cleveland Modern Dance Association, founded in 1956 and incorporated as a nonprofit educational organization a decade later. A grant from the Cleveland Foundation in 1973 permitted the association to hire Phyllis Levine as executive director for a three-year period. Part of Levine's job was to coordinate the nationally known dancers who had been hired by the association to teach creative dance and movement to students in the Cleveland Heights–University Heights school districts. These activities were part of the "artists in the schools" program funded by the National Endowment for the Arts and the Ohio Arts Council.

FIGURE 102. Dancers of the Cleveland Ballet perform for children of the Cleveland Public Schools. Courtesy of the Cleveland Press Collection, Cleveland State University.

The **CLEVELAND BALLET** was started as the School of Cleveland Ballet in 1972 by Ian Horvath (d. Jan. 5, 1990) and Dennis Nahat and made its formal debut in 1976. The company is known for its eclectic style, performing classical works such as *The Nutcracker, Coppélia,* and *Romeo and Juliet* as well as lesser-known modern works. After earning a favorable reputation with its national tours, the Cleveland Ballet made its European debut at the 1990 Edinburgh Festival.

Another modern dance organization founded during this period was the Footpath Dance Company formed in 1976 by Alice Rubenstein, a modern-dance instructor at Hiram College and Case Western Reserve University. It was the first modern dance company from Greater Cleveland to perform both nationally and internationally. In addition to performing, Footpath offered classes in modern dance for both children and adults.

In 1977, Footpath received a grant from the Ohio Arts Council to increase its number of performances, and four years later the first male was accepted into the company. In the early 1980s the company tried to build a larger following in Cleveland, primarily through lunchtime performances held at the now-razed Engineers Auditorium and financed by the Cleveland Foundation in 1981 and 1982. In August 1986, Footpath was one of the first American modern dance companies to be invited to compete at the prestigious Danse à Paris competition in France. (See Fig. 103.) Despite its success, the company disbanded in 1990.

As theater and dance flourished, so did the companion art of music. George Szell was still at the helm of the Cleve-

FIGURE 103. The sure-stepping Footpath Dance Company runs along the Lorain-Carnegie Bridge rail, ca. 1989. Courtesy of the *Cleveland Plain Dealer*.

FOOTPATH DANCE COMPANY, a nonprofit, nationally touring dance troupe, was formed in 1976 by Alice Rubenstein. Initially the company consisted of only women, but in 1981 Footpath accepted its first male dancer. In 1986 the company participated in Danse à Paris, marking the first time American dance companies were selected for this international competition held in France. Footpath performed in Cleveland until 1990, when, because of financial difficulties, the company disbanded.

land Orchestra in the 1960s, and Victor Babin had become the director of the Cleveland Institute of Music in 1961. In 1968 the orchestra began a new phase in its history when a summer home for the ensemble opened at the Blossom Music Center in Northampton Township (see Fig. 104).

Babin and Szell had a good working relationship. When Babin wanted to create a full orchestra at the music school, he went to Szell for help. Szell responded by sending the Cleveland Institute of Music one of his finest conducting assistants, James Levine, who would later become music director of the Metropolitan Opera. Babin also established a cooperative relationship between the Institute and Case Western Reserve University's music department; in 1969 he was made an adjunct professor at the university.

There was a high standard of professionalism among musicians in Cleveland in the 1960s, and Babin brought distinguished musicians to the Cleveland Institute of Music faculty. One such project was the founding of the Cleveland Quartet. Having secured funding to provide an in-residence string quartet for the Cleveland Institute of Music, Babin approached one of the violin instructors at the Institute, Donald Weilerstein, appointed him first violin, and charged him with assembling the rest of the group. Weilerstein located his

FIGURE 104. The Cleveland Orchestra began the 1968-69 season by presenting its inaugural performance at Blossom Music Center, located in Cuyahoga Falls in Summit County. The music center serves as the orchestra's summer home, attracting large audiences from the Cleveland-Akron area. Courtesy of the Musical Arts Association.

soon-to-be colleagues—Peter Salaff, Martha Strongin Katz, and Paul Katz—during a summer residency at the music school in Marlboro, Vermont, in 1969. The quartet made its debut in Marlboro as the New Cleveland Quartet and was immediately offered the resident quartet position at the Cleveland Institute of Music. Despite the name, its stay in Cleveland was brief. Although it moved to the University of New York at Buffalo after only two years at the Institute, the name and acclaim of the Cleveland Quartet continue to pay homage to its place of origin.

The Ohio Chamber Orchestra was founded in 1972 in conjunction with the seventy-fifth anniversary of Baldwin-Wallace College. Over the years this ensemble has served as the assisting orchestra for the Cleveland Ballet, the Cleveland Opera, and the Robert Page Singers in addition to regular subscription concerts, educational programs, and community concerts. Topped only by those of Cleveland and Cincinnati, the Ohio Chamber Orchestra today is the third-busiest orchestra in the state.

Cleveland's music scene changed irrevocably when George Szell passed away in 1970, followed just two years later by Victor Babin. Martha Joseph, the first lady of Cleveland's music circles, was named interim director in Babin's place until concert pianist Grant Johannesen was chosen as director in 1974. Lorin Maazel, formerly of the New Philharmonia of London, was given the awesome task of directing the Cleveland Orchestra after Szell's death.

Music director for the decade from 1972 to 1982, Maazel (see Fig. 105) may have been the most underappreciated by local audiences of the Cleveland Orchestra's conductors; certainly he had the toughest act to follow. His assumption of duties coincided with yet another period of decline in the city during the decade, when Cleveland became the first major American city to default on its financial obligations since the Depression.

Maazel was a prophet without honor in his own town, since many of the audience unreasonably expected a replica of George Szell. In 1971, when he was first appointed director, Maazel sent a message to the members of the orchestra stating his intentions, part of which read,

> This orchestra is an ensemble of awesome excellence, unsurpassed in our day. I know of no greater honor than to be called to collaborate in maintaining this standard and measuring up to the challenge of a new decade. I have accepted this honor not without much reflection upon my ability to fulfill your expectations, those of the community, and my own. May I assure you that having agreed to try I shall give my heart to the job and shall serve you and our art with enthusiasm and dedication.

Ten years later a staff writer for *Time* magazine (November 2, 1981) noted that under Maazel's direction, the orchestra "has

FIGURE 105. Lorin Maazel, musical director of the Cleveland Orchestra 1971-82. Maazel's term as director was highlighted by a noteworthy expansion of the orchestra's musical series "Great Composers of Our Time," featuring visiting guest composers, and critically acclaimed performances of their works. Photo by Peter Hastings Photography, courtesy of the Archives of the Cleveland Orchestra.

become the most beautifully balanced American ensemble, with the richest, warmest sound." "I would argue with anyone who says the 1981 Cleveland Orchestra is less a virtuoso ensemble than was the 1970 model," maintained Robert Finn of the *Plain Dealer.*

During the Maazel decade, a number of new series were inaugurated, including the "Great Composers of Our Time," which began in 1974 and brought to Cleveland the works of such living composers as Aaron Copland, Boris Blacher, Sir Michael Tippett, Olivier Messiaen, Krzysztof Penderecki, Alberto Ginastera, and Leonard Bernstein. Five of the seven composers featured spent a week in Cleveland participating in ancillary musical and educational events.

Other series included concerts at Cleveland's Public Auditorium, sponsored in conjunction with the *Cleveland Press,* which joined the orchestra with choir members from local high schools, and the Friday Early Matinee series which began in 1972. In honor of the United States Bicentennial, the Musical Arts Association, at Maazel's suggestion, commissioned seven composers to create works specifically for the Cleveland Orchestra. George Szell may have been gone, but

Clevelanders got a dynamic and imaginative conductor in his place.

Although the Metropolitan Opera Company discontinued its annual tour in 1986, two young locally based companies were positioned to fill the breach. Cleveland Opera had begun as the New Cleveland Opera Company in 1976. Organized by David and Carola Bamberger of New York and John Heavenrich, it progressed from a junior high auditorium through the Hanna Theater to the State Theater in Playhouse Square. An early production of Benjamin Britten's *The Little Sweep* won a local television Emmy for Best Production of Cultural Significance, while the world premiere of rock musician Stewart Copeland's *Holy Blood and Crescent Moon* in 1989 (see Fig. 106) brought the company national attention, if small critical acclaim. Having started on a shoestring budget, Bamberger carefully nurtured his company into a multimillion-dollar operation, though in the process he has been criticized for the extremely conservative, predominantly Italian flavor of his repertoire.

For more adventurous offerings, Clevelanders had

FIGURE 106. The Cleveland Opera presents Stewart Copeland's opera *Holy Blood and Crescent Moon*, 1989. Courtesy of the Cleveland Opera.

CLEVELAND OPERA, organized in 1976 by David and Carola Bamberger, was formed as the city's resident opera company. Its productions have covered nearly the full range of world music theater. Cleveland Opera performs throughout the state with annual productions for community groups, schools, social-service institutions, and senior citizen centers.

Lyric Opera Cleveland in the summer. Organized as the Cleveland Opera Theater Ensemble in 1974, the company featured long intermissions, allowing picnic suppers on the lawn adjoining its home in the Cleveland Institute of Music auditorium. For musical appetites, directors Anthony Addison and Michael McConnel served such fare as Britten's *Albert Herring,* Berlioz's *Beatrice and Benedict,* and Monteverdi's *The Return of Ulysses.*

The Problem with Art

In the past thirty years, perhaps no branch of the fine arts has been as controversial as the visual arts in Cleveland. The city is like most other major midwestern centers, with a majority of citizens who "may not know what art is but they know what they like." From public sculpture to performance art, modern art forms can hardly be said to have taken Cleveland by storm.

In 1957 Howard Wise opened the Howard Wise Gallery of Present Day Painting to try and introduce the works of contemporary European and American artists to Cleveland, but he was still too early. In 1961 Wise packed up his pictures and moved to New York City. Part of the failure of Clevelanders to appreciate modern art has been attributed to the lack of a central artists' district like Greenwich Village and Soho in New York City.

The real reasons for Cleveland's conservative tastes may lie more in the fact that while art has often been valued as an educational tool, not as much emphasis has been placed on raising the artistic literacy of the general public. Groups such as the Cleveland Center for Contemporary Art, founded in 1968, the New Organization for the Visual Arts (NOVA), founded in 1972, and Spaces gallery (1977) have, however, all made gigantic strides in educating the general public during the last two decades (see Fig. 107).

Humans are commonly taught to avoid confrontation, but modern artists in Cleveland and elsewhere often design intentionally confrontational works in an attempt to evoke human response and human interaction with art. This is nowhere better illustrated than in the comparison of two attempts to enrich Cleveland's meager store of public sculpture. In the mid-1970s the George Gund Foundation commissioned modern sculptor Isamu Noguchi to create a piece for the front of the new Justice Center. *Portal,* which stands thirty-six feet tall and is composed of fifteen tons of steel piping, was completed at a cost of $100,000. While Sherman Lee, the director of the Cleveland Museum of Art, referred to it as one of the most important public monuments in the United States, the general public, for the most part, disliked the work. To a

FIGURE 107. The sea of the city. Performance art at the 1983 Cleveland Arts Festival sponsored by Cleveland's New Organization for the Visual Arts. Courtesy of NOVA.

The **NEW ORGANIZATION FOR THE VISUAL ARTS (NOVA)**, originally formed as the Art Community Co-op, was created in 1972 to promote and develop the arts in Cleveland. NOVA's purpose has been to increase professional opportunities for Cleveland artists and to work toward aesthetic improvement in the community as a whole. It provides a slide registry for members' works and a sales and rental committee responsible for promoting sales of individual pieces and renting small exhibits to local businesses. NOVA annually sponsors an arts festival—Art in Special Places—in which participating artists open their studio spaces to the public.

city raised on primarily representational public sculpture, Noguchi's conceptual art seemed a foreign presence invading downtown (see Fig. 108).

Less than ten years later, Claes Oldenburg was commissioned by Sohio to create a sculpture for the front of its new headquarters building on Public Square. His design for a giant rubber hand stamp, entitled *Free Stamp,* was controversial from the time it was first announced. *Free Stamp,* in some people's opinion, would destroy the traditional city square look of Public Square. Proponents of the project were pleased to think that Cleveland would finally have a public work by an internationally renowned sculptor.

After Sohio was purchased by British Petroleum, the Oldenburg commission was rejected by the new officers. The finished work was never raised on its intended pedestal, though it has since found a home in Willard Park. With both the Noguchi and the Oldenburg, Clevelanders, whether or not they liked the finished or proposed sculptures, had to decide for themselves what did or did not constitute art. This in itself

FIGURE 108. Isamu Noguchi's *Portal,* ca. 1977. Courtesy of the Western Reserve Historical Society.

PORTAL, installed in 1976 at the Ontario Street entrance of the Justice Center, was created by Isamu Noguchi and funded by the George Gund Foundation. This 15-ton, 36-foot-high, carbon-steel pipe sculpture caused considerable controversy, as some Clevelanders could not conceive of it as meeting their definition of art.

was a step forward in understanding the complexities facing artists in the twentieth century. Clevelanders began to learn about modern art despite themselves.

Less confrontational works on public view in Cleveland are the more generally accepted public sculptures by Oberlin sculptor Athena Tacha in Playhouse Square and on the campus of Case Western Reserve University. In addition, in recent years relations between Cleveland artists and the public have improved with the establishment of the Murray Hill Arts Association, the closest thing Cleveland has to a Soho (see Figs. 109–110). The general public is invited annually to tour studios and become familiar with the works of Cleveland artists in the district's popular "Art Walk," first held in 1986. The 1989 relocation of the Cleveland Center for Contemporary Art in new facilities adjoining the Cleveland Play House will, it is hoped, make that collection accessible to a large section of the public, while at the same time helping to revitalize the neighborhood.

Still the two most powerful forces in art education for the city of Cleveland remain the Cleveland Institute of Art

FIGURE 109. A weaver's studio in the Murray Hill School, ca. 1986. Courtesy of the *Cleveland Plain Dealer.*

FIGURE 110. The Murray Hill Arts Walk in front of the Murray Hill School, ca. 1992. Courtesy of Janet Century Photography.

MURRAY HILL, Cleveland's Little Italy, evolved into one of the city's leading arts centers by the 1980s. One building, the former Murray Hill School, houses work space for artists of various disciplines, including dance, photography, painting, and crafts. The Murray Hill Arts Association, also located in Little Italy, holds an annual Art Walk, which involves participation of private art studios and galleries in the Murray Hill and University Circle areas.

and the Cleveland Museum of Art. The relationship between the two institutions has changed over the years, and in the early 1990s, they are more isolated from one another than at any point in their history. Meanwhile, the Cleveland Museum of Art was developing closer ties with the art history department at Case Western Reserve University.

The Cleveland Institute of Art made the five-year B.F.A.

mandatory in 1969, becoming the only institution of its kind in the United States to do so. The following year the Institute received its coveted accreditation from the North Central Association of Colleges and Schools. In 1975 the enrollment for the school, which was designed to accommodate 400, exceeded 500 students. To rectify the situation, the Institute purchased and remodeled the old Ford Motor Company assembly plant on Euclid Avenue. Under McCullough's directorship, students were given both the time and the space to train themselves for professional careers in the arts.

Under Sherman Lee, the staff of the Cleveland Museum of Art achieved renown for the scholarship of their published catalogs. In addition, Lee was instrumental in building one of the finest collections of Asian art in the world outside of the Far East. Lee was also a vital force in the attempt to educate the Cleveland public about modern art. At his urging, the trustees of the museum appropriated $15,000 for the purchase of avant-garde art in 1960, and in the same year they organized an educational exhibition tracing the various stages from representational to abstract art. In 1962, Edward B. Henning became the first curator for contemporary art at the museum. Since the 1960s, the museum has continued to collect representative examples of contemporary art, to the mingled delight and dismay of its visitors.

The museum celebrated the American Bicentennial with "The European Vision of America." This important show, cosponsored with the National Gallery in Washington, D.C., and the French government but curated in Cleveland, featured 340 objects depicting early America as seen by Europeans. Another historic event which involved the Museum and the other major arts and educational institutions of the University Circle area was the 1979 festival "The Persistence of Surrealism." A blending of all the disciplines and the brainchild of Case Western Reserve history professor Jack Roth, this festival incorporated musical performances by the Cleveland Orchestra and the Cleveland Institute of Music in conjunction with the museum's exhibit "The Spirit of Surrealism." Activities of this festival furnished the substance for a 1982 award-winning PBS documentary entitled "Pursuit of the Marvelous: The Persistence of Surrealism," distributed worldwide by the BBC (see Color Plate 15).

Epilogue

In the 1990s, Cleveland can claim as its own one of the world's finest orchestras, an internationally renowned art museum, the first successful interracial theater company, and private institutes devoted to the study of both music and art. Many of these institutions opened the decade with seventy-fifth-anniversary celebrations, an admirable track record for a city which won't observe its bicentennial until 1996 (see Color Plate 17).

The Cleveland Ballet and the Cleveland Orchestra made grand tours of Europe in 1990, playing in cultural centers across the continent—London, Edinburgh, Paris, Amsterdam, Brussels, Salzburg, and Munich. And, as was noted in the Introduction, the Cleveland Orchestra began serving a prestigious residency with the Salzburg Music Festival beginning in 1992.

The conservatism with which Cleveland has responded to the fine arts is the city's boon and bane. Careful planning, programming, and consistent devotion to educational programs have resulted in cherished institutions which serve the needs of a community more regularly exposed to theater, music, visual art, and dance than many United States cities of similar size. Unfortunately, this conservatism has also resulted in a stultification at times of modern trends in these same fine arts which would allow Cleveland to become a vital center for the production of its own native talent.

Whatever the city's artistic preferences, there were signs indicating that postindustrial Cleveland at least was becoming aware of the increased importance of the arts in the life of the general community. According to a report released in 1993 by the Cleveland Arts Consortium, the city's nonprofit arts

and cultural institutions had contributed 7,300 jobs and $190 million in spending to the area's economy in 1989. Entitled "The Arts & the Economy of Greater Cleveland," the report was prepared under the auspices of Case Western Reserve University's Center for Regional Economic Issues. It reported an attendance of 3.9 million people at cultural events in Cleveland, while a separate study had shown only 2.5 million spectators for the city's three professional sports teams during the same year. In a similar effort to explore the potential of the arts in Cleveland, Mayor Michael R. White in 1992 had formed the Council of Cultural Affairs, a seventeen-member volunteer advisory board.

The 1980s once again saw a new crop of leaders take over as the heads of Cleveland's major cultural institutions. Evan Hopkins Turner, past director of the Philadelphia Museum of Art and nephew of Cleveland's first city manager, succeeded Sherman Lee as the director of the Cleveland Museum of Art (see Fig. 111), to be succeeded himself a decade later by Robert P. Bergman, former head of the Walters Art Gallery of Baltimore. Joseph McCullough stepped down from his position as director of the Cleveland Institute of Art once during the decade, only to be called back when his suc-

FIGURE 111. Dr. Evan Hopkins Turner, director of the Cleveland Museum of Art from 1983 to 1993. Photo by Howard Agriesti, courtesy of the Cleveland Museum of Art.

cessor and the Institute found one another incompatible. He tendered his resignation again in 1990 and was replaced by Robert Mayer. David Cerone, former head of the violin department of the Curtis Institute of Music, succeeded Grant Johannesen as director of the Cleveland Institute of Music. And Lorin Maazel, who stepped down in 1982, was followed as music director of the Cleveland Orchestra by former director of the Hamburg State Opera Christoph von Dohnányi in 1984 (see Fig. 112).

These new movers and shakers have not yet had time for their roles in the city's future to be fully assessed, but one can note that they arrived during a period of transition in the city. During the decade of the 1980s, downtown Cleveland began to come back to life as the city shifted from an industrial to a service-oriented economy. Clevelanders began to regain something of the pride and sense of purpose they had lost in the 1960s and 1970s. Efforts at renewal and renovation were made in many parts of the city—the Flats, the Warehouse District, the Mid-Town Corridor, Ohio City, Tower City,

FIGURE 112. Christoph Von Dohnányi, musical director since 1984 of the Cleveland Orchestra. Photo by Jack Van Antwerp, courtesy of the Archives of the Cleveland Orchestra.

and Playhouse Square—spurred by a sense of nostalgia for Cleveland's golden years, when it was one of the most thriving industrial centers in the nation.

Through development projects as well as grants and endowments, Clevelanders began to give the city a giant cosmetic facelift. What remains to be seen is whether these new districts and the many arts organizations found in them will be able to survive. Cleveland still faces some very serious problems, not the least of which is the continuing issue of decentralization (i.e., suburbanites who work and play in the city but do not pay taxes in it).

The recession of the early 1990s raised new uncertainties for the fine arts. Nowhere was this more graphically illustrated than in the Cleveland Museum of Art's decision to close the Extension Division of its Education Department as part of a program to meet a growing operating deficit in 1992. This decision was painful for both the museum and its friends because for seventy-five years the division had produced internationally recognized art museum outreach programs that were studied and emulated by museum education departments around the world. What effects the changing economic climate would bring to other cultural institutions were yet to be seen as the city moved toward its 200th anniversary in 1996.

To many Clevelanders, the key to a complete civic revitalization was the city's once-proud public school system, which seemed to regress further even as the rest of the city rebounded. Significantly, however, one of the few bright spots in the entire system has been the Cleveland School of the Arts, a magnet school opened in 1981. Presently serving artistically inclined students in grades four through twelve, the school had a full enrollment of 700 with a waiting list of hundreds more. Its Vocal Jazz Ensemble went to Japan in 1991 to represent the United States in the International Entertainment and Music Festival. More important, its students scored above the national norms on most standardized tests.

Located conveniently near University Circle, the Cleveland School of the Arts benefited from a creative partnership with most of the city's cultural institutions. Artists from the Great Lakes Theater Festival, the Play House, the Cleveland Orchestra, the Cleveland Ballet, and other organizations performed and conducted master classes at the school. Its students attended classes on scholarship at the Institute of Art, the Institute of Music, and the Cleveland Music School Settlement.

By participating with the Cleveland Public Schools in these new initiatives, Cleveland's arts organizations have built upon a tradition of pioneering educational efforts. Indeed, the future of the fine arts may well depend upon these and other programs to create an ever widening audi-

ence and to demonstrate to the public the importance of the fine arts to the health and vitality of the community in the coming century. One of the last amenities to appear in Cleveland, the fine arts may yet turn out to be the city's salvation.

BIBLIOGRAPHY

Alexander, J. Heywood. *It Must Be Heard: A Survey of the Musical Life of Cleveland, 1836–1918.* Cleveland, Ohio: The Western Reserve Historical Society, 1981.

Chapman, Edmund H. *Cleveland: Village to Metropolis.* Cleveland, Ohio: The Western Reserve Historical Society, 1964.

Clark, Edna. *Ohio Art and Artists.* Richmond: Garrett and Massie, 1932.

Danforth, Roger T. *The Cleveland Play House, 1915–1990.* Cleveland, Ohio: Emerson Press, 1990.

Eglington, Guy. "Western Museums Take Cleveland for Their Model." *Art News* 24, no. 26 (April 3, 1926): 1–2.

Flory, Julia McCune. *The Cleveland Play House: How It Began.* Reprint. Cleveland, Ohio: Press of Western Reserve University, 1965.

Grossman, F. Karl. *A History of Music in Cleveland.* Cleveland, Ohio: Case Western Reserve University, 1972.

Hay, John. *The Bread-Winners.* Gregg Press Reprint, 1967.

Hoffman, Jay, Dee Driscole, and Mary Clare Zahler. *A Study in Regional Taste: The May Show, 1919–1975.* Cleveland, Ohio: The Cleveland Museum of Art, 1977.

Hughes, Adella Prentiss. *Music Is My Life.* Cleveland, Ohio: World Publishing Company, 1947.

Leedy, Walter C. *Cleveland Builds an Art Museum: Patronage, Politics and Architecture, 1884–1916.* Cleveland, Ohio: Cleveland Museum of Art, 1991.

Levine, Laurence W. *Highbrow, Lowbrow: The Emergence of Cultural Hierarchy in America.* Cambridge, Massachusetts: Harvard University Press, 1988.

McCarthy, Kathleen D. *Noblesse Oblige: Charity and Cultural Philanthropy in Chicago, 1849–1929.* Chicago, Illinois: The University of Chicago Press, 1981.

Marling, Karal Ann. *Federal Art in Cleveland, 1933–43.* Cleveland, Ohio: Cleveland Public Library, 1974.

Marsh, Robert C. *The Cleveland Orchestra.* Cleveland, Ohio: World Publishing Company, 1967.

Milliken, William Mathewson. *Born under the Sign of Libra.* Cleveland, Ohio: Western Reserve Historical Society, 1977.

Oldenburg, Chloe Warner. *Leaps of Faith: History of the Cleveland Play House, 1915–85.* Cleveland, Ohio: C. W. Oldenburg, 1985.

Rarick, Holly. *Progressive Vision: The Making of Downtown Cleveland, 1903–1930.* Cleveland, Ohio: The Cleveland Museum of Art, 1986.

Rose, William Ganson. *Cleveland: The Making of a City.* Cleveland, Ohio: World Publishing Company, 1950.

Ryder, James F. *Voightlander and I.* Cleveland, Ohio: Imperial Press, 1902.

Selby, John. *Beyond Civil Rights.* Cleveland, Ohio: World Publishing Company, 1966.

Thomas, Rose Fay. *Memoirs of Theodore Thomas.* New York: Moffat, Yard, 1911.

Van Tassel, David D., and John J. Grabowski. *The Encyclopedia of Cleveland History.* Bloomington: Indiana University Press, 1986.

Whittlesey, Colonel Charles. *The Early History of Cleveland, Ohio. Including Original Papers and Other Matters Relating to the Adjacent Country with Biographical Notices of the Pioneers and Surveyors.* Cleveland, Ohio: Fairbanks, Benedict and Company, 1867.

Wicks, Katherine Gibson. *Children's Art Classes at the Cleveland Museum of Art.* Cleveland, Ohio: The Cleveland Museum of Art, 1948.

Wittke, Carl. *The First Fifty Years: The Cleveland Museum of Art, 1916–1966.* Cleveland, Ohio: A Joint Publication of the John Huntington Art and Polytechnic Trust and the Cleveland Museum of Art, 1966.

Wixom, Nancy Coe. *Cleveland Institute of Art: The First Hundred Years, 1882–1982.* Cleveland, Ohio: Cleveland Institute of Art, 1983.

Zverina, Silvia. *And They Shall Have Music: The History of the Cleveland Music School Settlement.* Cleveland, Ohio: Cobham and Hatherton Press, 1988.

INDEX

HOLLY RARICK WITCHEY, a graduate of Case Western Reserve University,
is also the author of *Progressive Vision: A History of Downtown Cleveland.*
She lives in San Diego, where she is Associate Curator
of European Art at the San Diego
Museum of Art.

■

JOHN VACHA taught history and journalism for thirty years in the
Cleveland Public Schools and at Cuyahoga Community
College. Now retired, he does freelance work
for the *Encyclopedia of Cleveland History*
and a variety of national and
local publications.

Book and Jacket Designer ■ Sharon L. Sklar

Copy Editor ■ Jane Lyle

Production ■ Harriet Curry

Typeface ■ Palatino/Helvetica

Typesetter ■ Weimer Graphics, Inc.

Printer and Binder ■ Maple Vail Book Manufacturing Group